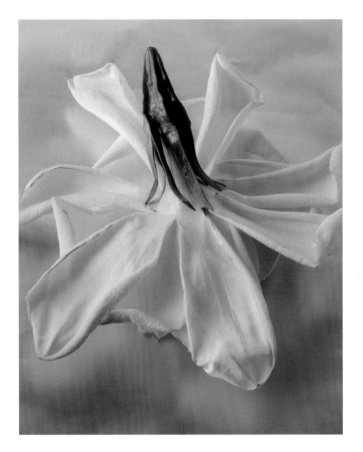

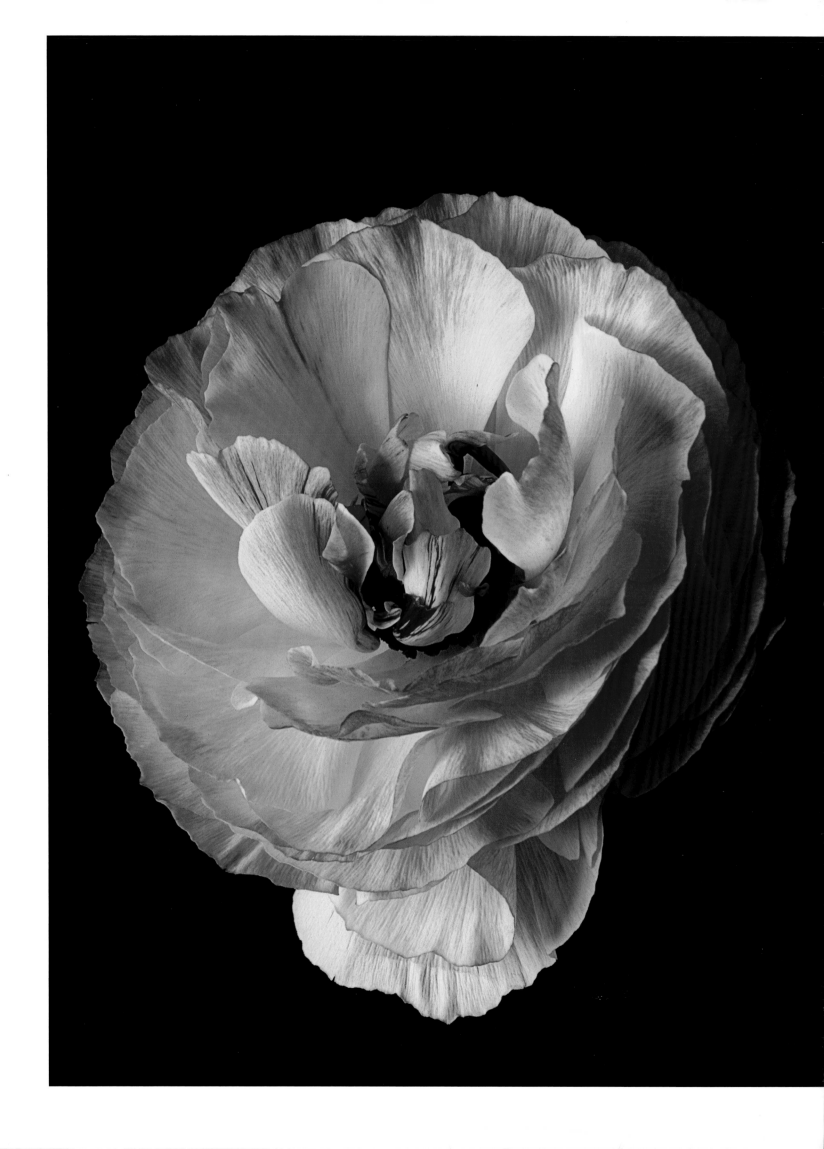

FLOWER

Christopher Beane

TEXT BY
Anthony F. Janson

ARTISAN/NEW YORK

For Rosemary

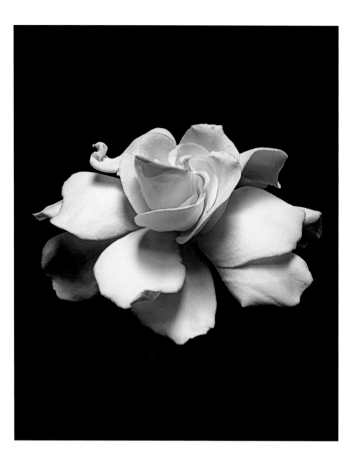

Above: PLATE 3 *Gardenia with Horn,* 2005
Frontispiece: PLATE 2 *Ranunculus Gold,* 2003
Page 1: PLATE 1 *Upside Down Gardenia,* 1995–96

Published by Artisan

A Division of Workman Publishing Company, Inc.

225 Varick Street

New York, NY 10014-4381

www.artisanbooks.com

Library of Congress Control Number: 2007937477

ISBN-13: 978-1-57965-352-1

Designed by Jan Derevjanik

Printed in Singapore

First printing, March 2008

1 3 5 7 9 10 8 6 4 2

CONTENTS

———————

Preface: New York's Wholesale Flower Market
6

Christopher Beane: A New Species of Flower Photographer
10

From Tradition to Deconstruction: The Early Black-and-White Photographs
16

Early Maturity: The First Color Photographs
32

The Orgy Series
46

Breakthrough: The Peony Series, 1999–2003
60

The Photographer as Painter
72

The Ranunculus
84

Tutti Frutti
90

Why Must the Beautiful Die?
100

Of Branches, Vines, and Decorative Panels
136

Postscript: Through a Looking Glass Darkly
158

Publisher's Note: Anthony F. Janson
163

List of Plates
164

NEW YORK'S WHOLESALE FLOWER MARKET BY JAMES GAVIN

Each day around dawn, a desolate block on the unfashionable northern side of Chelsea springs to life. Shops light up; trucks appear from out of the dark bearing cymbidiums from New Zealand, amaryllises from Holland, poppies from Italy. Soon the dingy sidewalks are awash in color, fragrance, and energy. Dark purple gladiolas, black calla lilies, red peonies, Hawaiian orchids.

Customers stream in: florists, designers, events planners who can spend up to six figures at a time. But the sellers are blue-collar workers with a tiring job. Moving the buds from courier to customer requires very fast work, with everything done before the flower wilts.

Perishable as its goods are, the Flower Market on 28th Street seemed like Manhattan's hardiest perennial for about a century. But in 1995 this commercial region, which has housed New York's wholesale flower distributors since 1850, was rezoned to permit residential development: luxury hotels and condos began to tower above and (in some cases) replace the low-rise businesses. The market, which has stretched up and down Sixth Avenue and east to Broadway, would ultimately shrink to a single block. Now, the din of cars and construction fills the air.

Zezé, owner of Zezé Flowers, Manhattan's choicest flower shop, recalled the old 28th Street: "People did the business because they loved the life. Today they want it to be fast and easy. They don't have that passion." But in the mid-1990s, Zezé met a young salesman who was an exception. Christopher Beane was a tall, skinny, bearded former art student with bracelets and wild hair who worked at a high-end wholesaler on Flower Row.

Beane went to work on 28th Street to support his fledgling photography career, and ended up with much more than a weekly paycheck, leaving each day at noon with a bundle of the shop's most provocative blooms to photograph in his tiny studio. There he created the seductive images reproduced here, his first book. "I'm looking for something that's beautiful, but that also has a disturbing quality," Beane told Sarah Coleman of *View Camera* magazine. Dark openings beckon you: a tongue reaches out of a red ranunculus; an eye stares out from deep within a pink one.

Many great photographers—Horst, Edward Steichen, Irving Penn, Robert Mapplethorpe—have shot flowers as a sideline, bringing their own peculiar insights to these inanimate objects. But Beane develops intense short-term relationships with each flower, often drawing your eye to one striking detail, "something that's overlooked, since the overlooked details can be the most amazing." Many of his images are set against a black abyss; they seem to float. Others are nearly overwhelmed by a background of Murano glass. "These are kaleidoscopic, brilliantly colorful landscapes that the flower floats in, and sometimes contrasts with," explains Beane. In any setting, he makes you marvel at what the earth created.

Beane took up photography as an adolescent pastime. With a Pentak K1000 bought from a department store, he began taking still-life pictures, such as apples and bottles perched on a windowsill. By the time Beane had graduated from Rhode Island School of Design (RISD) in 1992, he'd switched from still lifes to portraits of human models, but he found unconventional ways of presenting them. He rarely showed faces, and liked to depict the body in conjunction with nature (see plate 5).

Beane knew he belonged in New York, but once he arrived in 1993 a larger necessity loomed: financing his photography while paying the rent. Within a year, he and the

PLATE 4 *Spider Chrysanthemums*, 1999

flower market "found each other," he says: "I thought, this would be a great way to have a morning job—you start at 4:00 AM and work till noon, the pay is decent, then I'd have my afternoons available to photograph."

For the next six years Beane inhabited what he calls "an early-morning underworld buzzing with activity, while most New Yorkers were still hours from awakening." The cast of characters included Gary Page, co-owner of Fischer & Page and an Englishman and former soccer teacher, and Rita Bobry, a former SoHo florist. How does she recall Beane from those days? "Just very sweet. Handsome, scruffy, sloppy-looking—he never really combed his hair. He looked like he'd just rolled out of bed."

Every morning Beane was plunged into a whirlwind: "filling up shelves, adding up stem numbers, greeting customers," he says. One customer, Olivier Giugni, found him to be "completely different from all the other people in the market. He was educated, and he had sensitivity." Floral designer Ron Guialdo was equally impressed. "He showed you things your eyes hadn't seen." This made Beane ideal for a wholesaler that had distinguished itself by importing the rarest and most striking flowers in the market. First thing in the morning, he recalls, "I would do a quick scan of what the market selections had brought . . . buckets of peonies, kumquats on branches, cut jasmine that overflowed the shelves. I'd look for the most novel, the most wild, the most bizarre, something I hadn't seen before, that would make me say, let me get this on film."

He took his finds home and began experimenting. Gradually he found his own voice amid a centuries-old tradition of artists who had sought to immortalize flowers in their fleeting prime, or after it had ended. Beane raced through each workday in the market, eager to retreat to his ten-by-fourteen-foot studio—one room in his small apartment—to photograph his selections in the afternoon light. As Beane recalled, "there was no time to waste—the flower was at its perfect moment, and in another half hour the

sun's movement would have changed the whole mood of the flower." Some of his first efforts were formal still-lifes, depicted starkly in black and white. But he grew eager to reach beyond the clichés of flower photography and began experimenting with different styles and methods—placing flowers against an eerie black background to reveal their intricacies with no table or vase to distract. It also offset the loveliness of the blooms with a touch of the macabre.

Orgies, Georges Marbeck's 1999 volume of erotic images by dozens of artists, stimulated Beane to create his own multilayered imagery, which led to the Orgy series. As Beane put it, "It was about the infinite composition possible within the four-by-five frame." Beane broke apart flower petals and rearranged them in clusters. They look like masses of limbs colliding; the satiny, voluptuous folds evoke bodily openings. He achieves nuance by varying exposure time, which is only possible by using film. He likens exposure length to "painting with light, and each second is a brushstroke." Too much light can destroy the mystique.

Beane loves the ranunculus, and has produced hundreds of photographs of them. Each ranunculus, he says, has something special: "the color, or the way it moves. They start off as tight little balls, then they slowly unfold" to reveal an extravagance of closely arranged petals. The spare elegance of the orchid attracts him just as much. Noticing how orchids adapt to their environment in the wild like chameleons, he created his Camouflage series, in which he lays flowers against decorative paper. The idea came, in part, from Andy Warhol's camouflage paintings (flowers hidden in army-fatigue designs).

In 1996 Gary Page left Fischer & Page and started G. Page, a few doors down. He brought a handful of his old employees, including Beane. "They made the shop into a sort of disco scene," recalled Rita Bobry, who worked there too. "It was wild. Gary was buying beautiful but ridiculously expensive flowers, and they had house music playing at five in the morning. Beane," she said, "really displayed and

lit the flowers beautifully. No one in the wholesale market had ever cared about how the flowers were lit. They'd be on the floor in boxes or on tables under fluorescent lighting."

For some time Beane had been selling photos out of his bedroom, which served as a studio. "I used to roll out big prints on my bed. I had ripped out the kitchen, since I don't cook, and that became my darkroom." Using the designer's flair that dazzled his flower colleagues, Beane installed a glass mosaic floor, added Moroccan lights (which illuminate without exposing photo paper), and hung sun-blocking drapes with botanical designs. He yearned to work full-time on his pictures, and in 2000 he quit his day job. Page agreed to keep him on full salary and benefits in exchange for a print a month. He hung them all over the walls of his sprawling third-floor office on 28th Street. For Page, "A lot of photographers take shots of flowers, and they're stiff. It's like dressing up a fashion model. Christopher doesn't do that. When I look at these pictures, I always get excited. People come into the office for the first time and go, 'Wow! Where did you get *that?*'"

Largely through word of mouth, Beane's career began to take flight. He acquired a studio on 28th Street and entered a rich phase of creativity. Beane experimented with pop art in his Tutti Frutti series and, in the summer of 2004, a sabbatical in a farmhouse in Connecticut triggered what Beane calls his Farmhouse series.

The photographer himself seemed hyperactively vital. Then, in the summer of 2005, a longtime problem of his, severe leg pain, flared up. The day it got so bad he couldn't walk, his partner, Marc Romain, carried him to the hospital; Beane was diagnosed with stage four lymphoma. He was thirty-eight years old. Later he thought of a photo he'd taken of a petrified, frozen cattail. It looked like a spine covered with tumors, which was what he had.

Beane lay in New York's Mount Sinai Hospital for eight months, painfully thin, unable to even stand. It seemed ironic that someone so fascinated by nature's most delicate objects, with their abbreviated life spans, would himself be

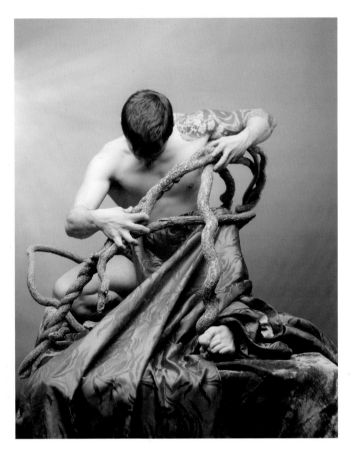

PLATE 5
Forrest with Bittersweet Vines, 1992

cut down in his prime. But unlike his subjects, he survived, miraculously. "He made a big effort to be super-positive," said Harold Tittmann, his RISD classmate and now a Connecticut-based architect. "I'd go and see him when he was in the emergency room or intensive care and he still had a good sense of humor. There were days when I would walk out thinking I'd never see him again."

Sending reminders of 28th Street, his friend Zezé stayed unceasingly loyal: "I sent him flowers every week, because you get good energy from them. They make a person feel good. I sent him peonies from my garden, I sent him beautiful roses. One day he called me and said, 'I took one picture.'" That was Beane's first step back. By the summer of 2006 he was home and in a wheelchair. In early 2007 he graduated to crutches. In May 2007 he resumed his work.

christopher beane

A NEW SPECIES OF FLOWER PHOTOGRAPHER

PLATE 6
Iris Study, 1996

Christopher Beane is a unique photographer. No one has created such a large body of work, with such variety and inventiveness, or at such a high level of quality, by such a young age. One has to look back to Edward Steichen, one of the founders of modern photography in America, to find someone who accomplished anything of like importance. Within our own time, the only photographer of comparable stature was perhaps Robert Mapplethorpe.

Beane's color photographs, properly matted and framed, are so large and have such potent hues that they directly challenge the primacy of painting as art. A single image can easily dominate a room, including every painting in it. Even his early black-and-white photographs, although smaller, are surprisingly powerful.

The range of Beane's work is equally remarkable. No creative photographer has taken pictures of such a wide variety of flowers or shown them in so many different ways. Nor has any other photographer so deliberately and consistently stepped outside the normative view of flowers as objects of beauty to explore them as they fade and ultimately decay. Beane manipulates his images in ways that challenge our understanding of photography, art, and reality at many levels.

As with all great art, there is far more than meets the eye, and this can be bewildering. In *Multicolored Mum* (opposite), he places a dyed bodega chrysanthemum over a dahlia and shoots against a multicolored background of oozing, cheap nail polishes. In doing this, he shatters our preconceptions of flower photography.

While each of Beane's photos is magnificent, his works, his technological and aesthetic breakthroughs, and his significance are more fully appreciated with at least some

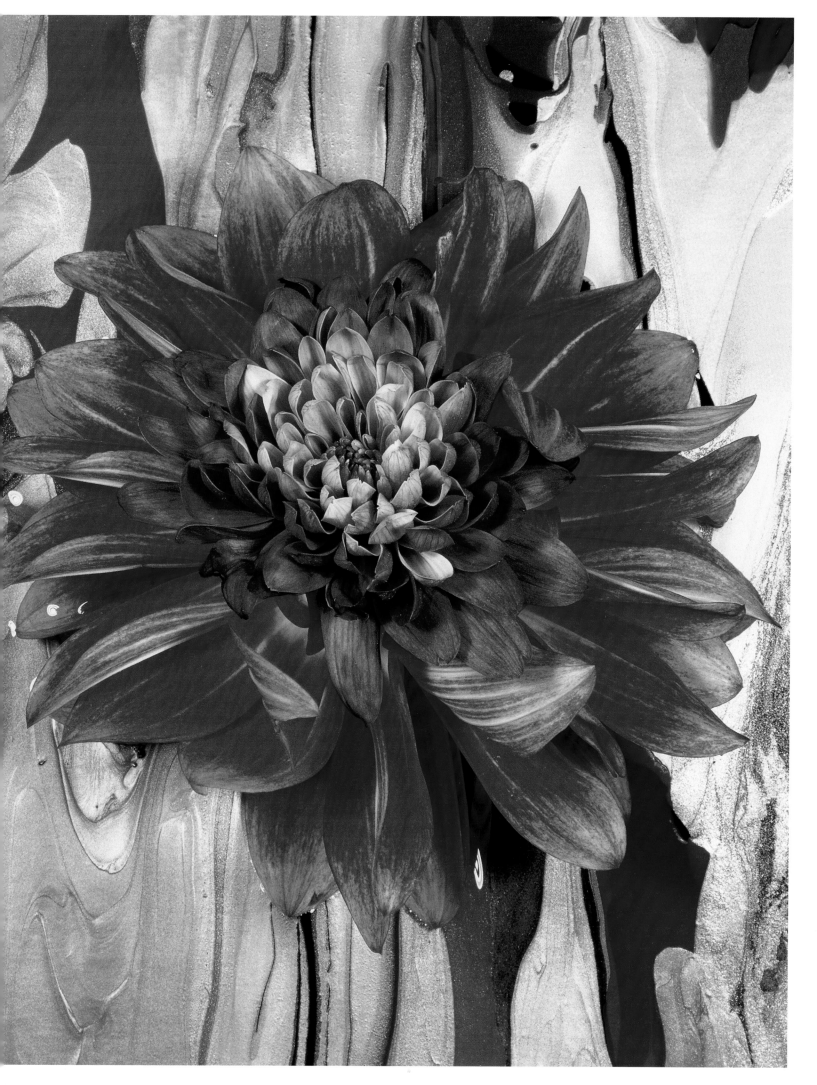

PLATE 7 *Multicolored Mum,* 2003

understanding of both the history of photography as an art form and the portrayal of flowers in art. The space limitations of this survey format simply do not do these topics justice because Beane's works break new ground in both areas. I hope the reader's curiosity is piqued enough for further study of these topics, including Christopher's work itself. For now, a quick overview must suffice.

LIGHT INTO IMAGE: the birth of flower photography

Almost from the beginning, photography has had a cloud over its head. Writing twenty years after the daguerreotype was invented in 1839, the critic Charles Baudelaire condemned photography for supplying an exact reproduction of nature, and stated that it could never rise to the level of art because it relies on technology—not on the imagination.

Baudelaire's views have continued to have traction for two reasons. First, photography was invented mainly by artists who were seeking new artistic tools to produce "real art," according to accepted artistic standards of the time. These professionals judged photographs by how closely they resembled painting styles and never sought to use the full potential of the media.

Second, photography takes exclusive ownership of image-making away from art professionals and puts it in the hands of the average person. When Eastman Kodak introduced a practical line of roll-film cameras for amateurs around 1888 (the first roll-film camera and the name Kodak were invented in 1881 by David Houston), photography was no longer limited to the domain of art professionals. For most, the average experience of the photograph takes place at the lowest common denominator: the snapshot memento of a place or person.

However, a photograph, whatever its origin, is not a simple representation of objective reality. Ultimately, it is always a projection of the photographer's understanding of himself and his world, just as the creative act is such an expression for a painter, printmaker, or sculptor. Even the most basic step—the perception of the subject to be photographed—involves filtering information received through past experience, imagination, and understanding so that we can interpret its significance. No two people see or interpret beauty or reality in the same way. Within our frame of reference, we constantly determine what to include. Just as important, we decide what to leave out.

What photographers on both sides of the Atlantic gradually discovered is that the most successful photographs are not records of people, places, and events pure and simple but images subtly altered to lend them a heightened sense of reality imbued with mystery and personal significance. Prime examples are the photographs of Edward Weston, who, around 1930, fused realism and abstraction to create what he called "pure" photography. His finest works of vegetables, such as bell peppers or cabbage leaves, are composed and lighted so dramatically that we hardly recognize them at first and are forced to see them through new eyes that "take one into an inner reality . . . a mystic revelation."

Beyond the subtleties of our frame of reference, as reflected in the composition, there are other reasons that photographs alter reality. The lens may distort or flatten forms, and change color and tonal values. Exposure times may critically alter an image. Also, one should not minimize how hard it can be to make a fully satisfactory print.

Beane's photographs—the result of his technical abilities and creative imagination—may finally end any misconception about photography as an art form. Also, his images evolve as he matures. In some stages, flowers are manipulated beyond all recognition at first glance, and yet retain their pure form. The photographs in this book show a new species of flower—one of magic and power—and an artist fully mature and in control of his medium, with a luminosity rivaling the masters of painting.

COMMERCE AND LUXURY: the birth of flower painting

Many of the flowers that figure most prominently in Western art, and that we consider as the most beautiful, were once entirely unknown in the West. They were introduced to us from exotic places such as China, Afghanistan, and Iran during the second half of the sixteenth century. They were rare and so costly that for a long time only the wealthy could afford to purchase them for their private gardens. Many of the flowers photographed by Beane belong to this group. Flowers introduced to the Western flower bed during this period include the tulip (native to Iran and the Middle East and first seen in Germany in 1559), the peony and the ranunculus (both from Asia), the hyacinth (native to the Mediterranean), and the late-coming poppy from Afghanistan and Iran.

While these flowers were being introduced to the West in a "First Great Age of Discovery," so too was a new, more scientific way of thinking about the world. Dutch flower painting of the first half of the seventeenth century embodied the uneasy balance of conflicting forces underlying the baroque era. As the European imagination struggled to understand an increasingly severed relation between the senses and the mind (our eyes tell us that the sun, stars, and planets revolve around the earth, but science asserts otherwise), the age of baroque shifted the symbolic meaning of flowers in art. Previously, flowers were given a religious significance, reflecting the influence of Catholic theologians in the early fourteenth century. But Protestant thinkers used the temptations provided by sensual objects to remind people that these delightful pleasures, like life itself, are brief. Under the overall term *vanitas* (the vanity or idleness of all earthly things), a moral significance was assigned to nearly everything.

The Dutch artists responded to this changing world by devising a new method of painting based on careful observation of the visible that is utterly convincing. Although emphasis was placed on harmonious colors and composi-

tions, the ensemble always featured the most expensive flowers, with nearly equal attention paid to each one. There is usually a lavish arrangement of tulips, ranunculus, irises, hyacinths, peonies, and anemones, plus the latest discoveries. These were truly virtuoso displays, and with good reason. The high prices of these flowers drove the market for flower painting, which was expected to provide an accurate record of their appearance.

What is surprising is that despite their vivid realism, such pictures always present a fictitious reality. These flowers could never have been seen together, because they do not bloom at the same time! Instead, they were assembled from detailed studies and given a heightened reality through the skillful play of colors and sharp contrast of light and dark value. This fictitious reality is also seen in Beane's photography, such as in his study of sweet peas and vines (see plates 8 and 9).

Also, although these early painters had mastered the ability to represent a flower or bouquet accurately, their images were unconvincing representations of life. It fell to the leading flower painters of the eighteenth century, Rachel Ruysch and Jan van Huysum, to bring flowers to life. They enlivened their compositions through sweeping arrangements that suggested movement. In van Huysum's perfectly realized floral arrangements, each brushstroke subtly varies the color and texture of every petal in every bloom, so that the painting seems to be alive from within. In short, the painter's brush, placed in the hand of an artistic genius, conveyed an illusion of inner life more real than a true copy from nature. (Beane, using methods discussed later, also succeeds in imparting motion and life to plants.)

Instead of focusing on significant artistic aesthetic developments, such as those mentioned above, the history of photography is usually told in terms of technological advances that have steadily made the process of photography easier. However, these technological improvements tell us little about what is really important: how photography has changed the way people view and think about the world

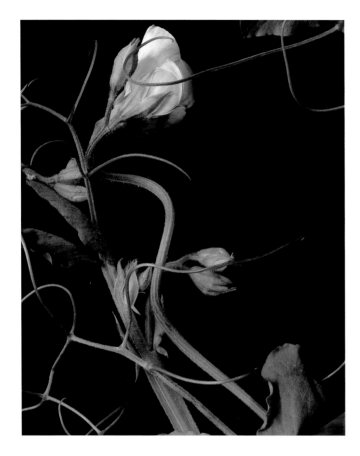

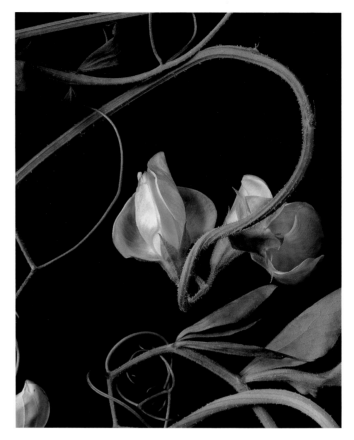

PLATE 8
Study of Sweet Pea Vines #1, 2000

PLATE 9
Study of Sweet Pea Vines #2, 2000

around them. Perhaps this is because surprisingly few photographers have responded to the challenges and opportunities afforded by technological developments. They have, for the most part, studiously adhered to the traditions and stale conventions in which they were trained.

This conservatism is especially true of still life and flower photography, which has occupied a minor niche that reproduces traditional compositions. Fox Talbot's earliest "photogenic drawings" of flowers from 1835 simply exposed a flower placed over silver oxide–coated paper to light. Daguerre's first photograph in 1839 imitates a subject popular in painting, the artist's nook. In the late nineteenth century, flower photography continued to mimic flower paintings and the hand-colored, engraved horticultural books of the sixteenth through the eighteenth centuries. Because of its sideline status, flower photography since the mid-twentieth century has largely been the domain of commercial professionals illustrating books and magazines. Usually the best flower pictures are taken by photographers as an occasional excursion from their day-to-day work.

The number of flower photographers worldwide who can be called truly creative are few. The best-known example in this country is Harold Feinstein, a protégé of Edward Steichen. Shortly after World War I, Feinstein took what is widely regarded as the first modern flower photograph, because it broke decisively with the pictorialist tradition; over the course of his long career he built up perhaps the finest portfolio of flower images of any photographer.

Of course, photographers at that time, such as Weston, created impactful images. However, much of their effectiveness lies in the uniform sharpness achieved by using the smallest possible lens opening to gain the maximum depth of field. Weston's success in this area led to the establishment of the West Coast society known as Group f/64, named after the smallest aperture. It became the leading school of photography in this country, and its influence remains pervasive.

Among its founders was Imogen Cunningham, whose flower photographs in black and white, from 1923 to 1925, were recognized by Weston as masterpieces of their kind. As with most photographers, flowers were but one of many subjects Cunningham pursued during her long career. She always maintained an objective, almost detached view of them, and her approach remained primarily formal rather than aesthetic. There is a certain irony that she was primarily responsible for making the calla lily, once the favorite symbol of the aesthetic movement during the late nineteenth century, the most photographed flower of the twentieth century, because it lends itself so well to abstraction.

Two exceptions to this formality are men whose floral images, blur an interpretive boundary. The late Robert Mapplethorpe was a classical purist. His photographs of male and female nudes are fraught with barely disguised sexual overtones. His numerous flower images are close to Cunningham's in their spare compositional elegance, but they often partake of the suggestive qualities found in his nude figures. His fabulous talent cannot be denied. The Japanese photographer Araki specializes in quirky female nudes, frequently shown in bondage. Not surprisingly, his flower photographs are imbued with the same dark psychology.

With these few exceptions, most photographers relied on visual formulas that were defined in the 1920s and '30s. An independent vision of photography remained to be created. Beane may be the first true modern art photographer. He uses to their full advantage all the technological developments, and he has both broken from and incorporated elements of modern painting in his compositions. Beane, like the earlier Dutch painters, assembles reality. He challenges the viewer by making the clearly impossible undeniable in his photographs. Beane also stands apart from other flower photographers. Indeed, to become a great artist he needed to "unlearn" much of what he had been taught and to develop an unbreakable will focused on achieving his goals. The Renaissance Italians called this *fortezza*.

from tradition to deconstruction

THE EARLY BLACK-AND-WHITE PHOTOGRAPHS

PLATE 10
Calla Lily with Fiddleheads, 1995–96

To make an original contribution, all artists must unlearn much of what they have been taught in art school. It is the only way to achieve the independence necessary for creativity. To people who are rebellious by nature, the process comes naturally; others must slowly learn to question the truisms of conventional knowledge and replace them with new models based on personal experience. Even the most radical artists, however, necessarily start from the tradition of the art form they have chosen. For the first few years, their work will be at its most conventional. The question is only: How quickly will it evolve in an independent direction?

Thus it is no surprise that Beane's earliest works, from the mid- to late 1990s, tend to be more indebted to the photography of the past, without overrelying on it. At that time, his working method was closest to that of Group f/64. He used exclusively black-and-white film in a four-by-five camera, with a high-quality lens at its smallest aperture, to gain maximum, almost uniform, depth of field, and did his own darkroom work using a paper suited to the tonal characteristics of his Schneider-Kreuznach lens, which produces a long gray scale, rather than sharp contrasts of black and white. In a few cases, such as *Bearded Iris in Late Afternoon* (plate 23) or *Campanula* (plate 16), the photographs are nearly outright imitations of early pieces by the Stieglitz school, even when not consciously intended as such. In others, they are "in the manner of." Such is the case with two photographs from the mid-1990s, *Wanatah Protea* (plate 21) and *Iris Bud* (plate 24), which recall the stark scientific objectivity of early photographs by Karl Blossfeldt and Imogen Cunningham. A photomontage of calla lilies (see plate 25)

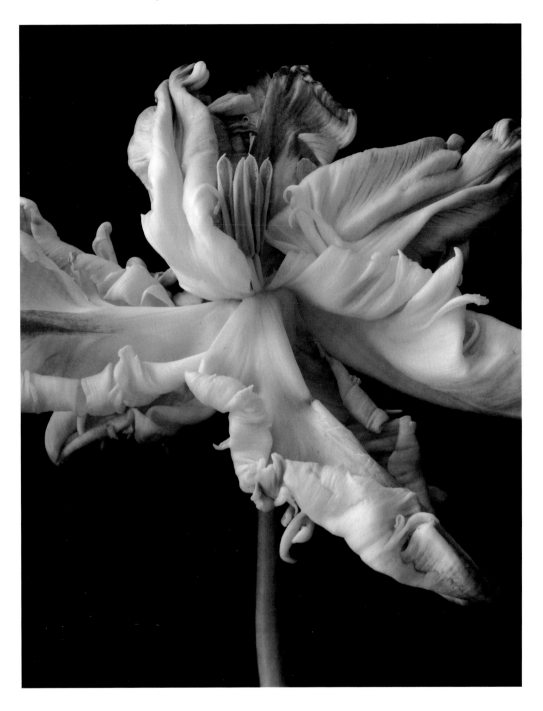

PLATE 11
Weber Tulip, 1995

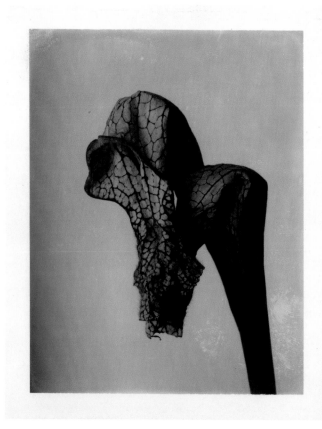

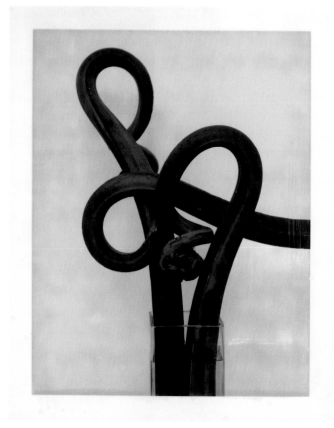

PLATE 12
Swamp Lily, 1995–96

PLATE 13
Unfolded Tree Ferns, 1995–96

18

is as beautiful as the classic one by Francis J. Bruguière entitled *Flower Abstraction* (ca. 1936–40), which Beane did not know about until I showed it to him.

After these initial efforts, something interesting begins to happen. Beane introduces flowers that few photographers before him had paid attention to, notably the milkweed, a humble flower indeed (see plates 17 and 18). At the same time, he creates unconventional variations on standard imagery. In *Swamp Lily* (opposite), the head of the lily hangs like that of a tired, forlorn nag.

In *Calla Lily with Fiddleheads* (plate 10), a calla lily, that favorite flower of the American school since Cunningham, suddenly "sprouts" graceful fiddlehead fern pods, which look like musical clefs. These were playfully inserted by the photographer to create a "fictitious flower," in the same spirit as Joan Fontcuberta's *Cala Rasca* (1983): a photographic witticism equivalent to Marcel Duchamp's "improving" a reproduction of Leonardo da Vinci's *Mona Lisa* by adding a mustache and a beard. When Beane photographs a rose (see plate 15), it is not the fresh, dewy bloom we are accustomed to seeing, but one that is withered and dead beyond recognition. He is even willing to stand flower photography on its ear by showing a gardenia upside down (see plate 1).

In these images, Beane consciously rejects the rules of making a successful flower photograph. (More was to come.) He moved from subtle manipulation and alteration of plants to outright deconstruction of their forms. This new approach is first seen in *Black and White Bromeliad* (plate 14), a photograph of bromeliad leaves that have been stripped from the plant and rearranged to form an uncomfortably aggressive, confrontational image, inspired by one of Richard Serra's sculptures at the Guggenheim Museum in Bilbao. When we first see the photograph, we aren't even certain what it shows: these could just as well be leather straps. A flower photograph inspired by an abstract sculpture and engaged in the larger world of ideas is a unique contribution of Beane's.

At first glance, a reader may see deconstruction in Beane's hands as nothing more than the artist's tearing up plants and recombining their parts according to the his whim. As is so often the case in art, there is far more than initially meets the eye. Deconstruction is one of the fundamental concepts of postmodern theory. Beginning in the late 1960s, it became a broad intellectual assault against traditional learning within every academic discipline. The underlying intent of deconstruction is a thinly disguised effort by radical thinkers to undermine Enlightenment thought, which provided the basis for democracy and Western ideas; deconstructionists view such thought as elitist, colonialist, racist, and sexist, and consider nearly any alternative as inherently superior.

Because it is text based, deconstruction is most effective in the visual arts when combined with words. (Perhaps the most notable examples are the provocative works of Barbara Kruger, which use reproductions of frightening photographs and brief, punchy slogans intended to disturb the viewer.) The problem with deconstruction is its predictability. Once its principles are grasped, the game is easy to play and the outcome is known in advance.

The real value of deconstruction for art lies in the freedom it grants the individual artist to transform imagery and remove it from everyday reality, disguising its appearance, recombining different parts, and altering colors. To a photographer like Christopher Beane, who was seeking new approaches to express a personal vision, it had an extraordinary liberating effect. As he once said in describing his goal: "I'm looking for something that's beautiful, but that also has a disturbing, ethereal quality." Deconstruction justified the experimental direction he was already exploring, while opening up a vast arena of possibilities that suddenly became as legitimate as anything handed down by tradition. It was an opportunity that he began to seize at every chance.

Beane shows a genius for altering plants into nearly human, yet disturbingly alien, life forms. He is hardly the

first person to show a tulip fully open, but whereas others maintain the rigid symmetry of conventional flower photography, he delicately slit part of the receptacle of a Weber tulip that holds the petals in place, so that they splay outward in odd directions (see plate 11). (He does something comparable in two photos of carnations—plates 19 and 20—by gently peeling the base to reveal their tiny antennae.) The result is a Weber tulip that looks like a running figure from Greek sculpture in monstrous guise, like an archaic Medusa.

The resemblance to Greek sculpture is even closer in a series showing iris pods. As they dry, these pods become tough and twist into strange shapes, which explode open to reveal their orange seeds. Beane created a series of running figures by combining two of them. (If you look closely, you can see that there are two stems in every photograph.) In the example reprinted here (see plate 84), the corkscrew pods have assumed the general appearance of a running winged Nike figure (the Greek goddess of victory), epitomizing forward motion in classical and Hellenistic Greek art.

While the similarity to Greek sculpture is probably subliminal rather than intentional, Beane purposely instills these plants with a sense of movement—and human movement at that. As a student at the Rhode Island School of Design, he had photographed live models, including one draped in vines (see plate 5), so that "he was kind of incorporated into the plant." This experience with the human form, although limited compared with a Weston or a Mapplethorpe, was of fundamental importance in shaping Beane's vision of flower photography. As we shall see repeatedly, not only do flowers often take on very human traits but they become metaphors of existence in highly philosophical terms.

The problem with taking photographs of flowers is that they most often look like *still* lifes. How, then, is it possible to make them appear to come alive in a picture that never changes? Earlier, I discussed how the leading flower painters of the eighteenth century achieved this through artistic illusion. Photographers face technical limitations in copying these painterly techniques because they must of necessity work in a flat plane. Seen in these terms, Beane's efforts to impart animistic motion to plant life is one of the bolder—and more unusual—innovations in recent photography. It involved a deep understanding of each plant to be photographed, and a focus on arrangement in terms of light and contrast. It was part of a youthful experimental phase and, like others of its kind, it did not last long. Nor did it need to, once Beane had accomplished his purpose.

When Beane returns a few years later to make a color photograph of a red ruffled cyclamen (plate 34), the stamen has been removed, the blossom folds back on itself naturally, and it seems to be rushing forward while looking back at some unknown pursuer. More amazing still is the image of a cattleya orchid (plate 22), every vein exposed through artificial lighting and a red filter. The swirling motion is not that of a pinwheel but like that of fabric responding to a dancer. The effect is remarkably close to photographs from the 1890s of the American dancer Loie Fuller doing her famous Serpentine Dance, which caused a sensation at the time, especially in Europe.

OPPOSITE: *In 1999 my aunt Anne took me to Bilbao, Spain, to visit the newly completed Guggenheim by Frank Gehry. We approached the museum from a very different direction every day—from the bridge above, the river below, and so on. From every angle, this organic structure was amazing. Inside, exhibited in the main belly of the structure, were Richard Serra's steel swirls. You could maze in and out of them physically. Returning to New York, I came across these air plants at the market, and they immediately reminded me of my trip to Spain.—cb*

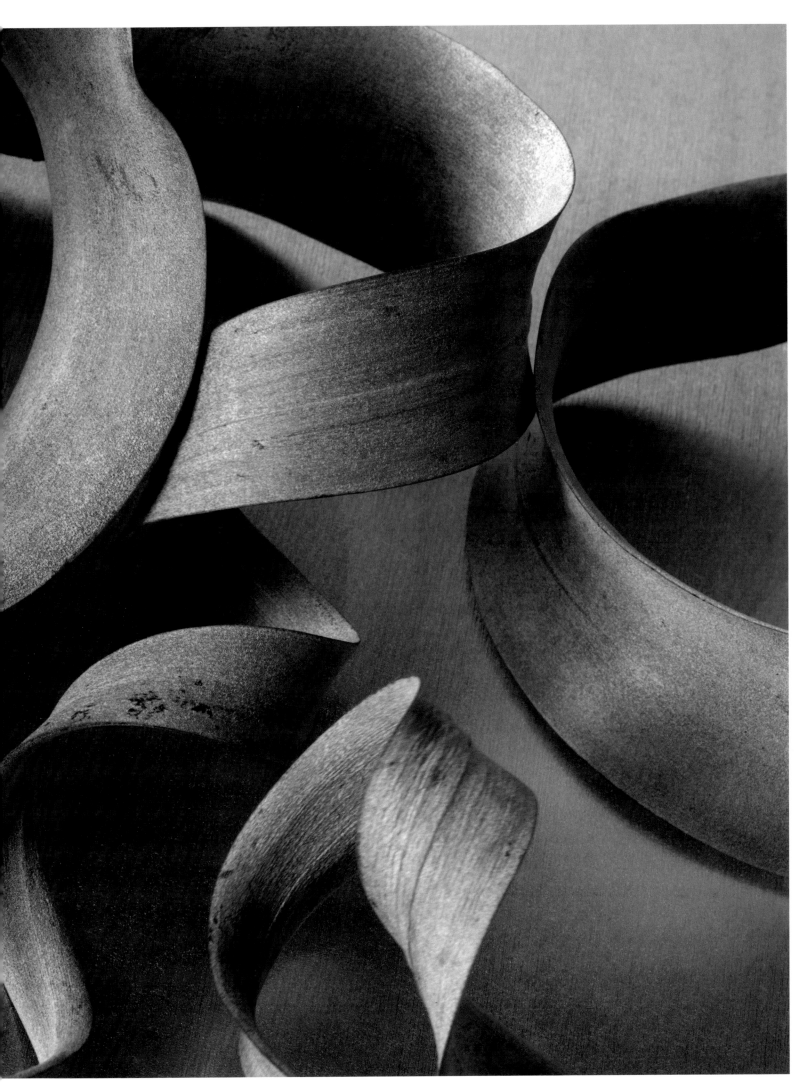

PLATE 14 *Black-and-White Bromeliad*, 1999

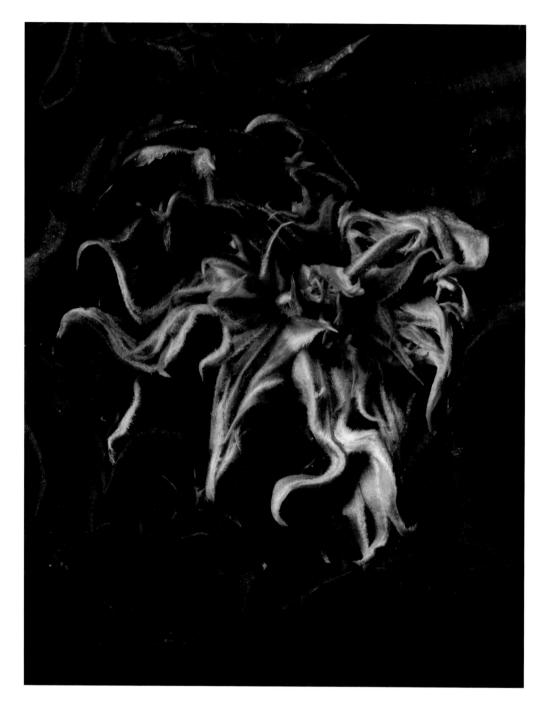

PLATE 15
Fisherman's Friend Garden Rose, 1998

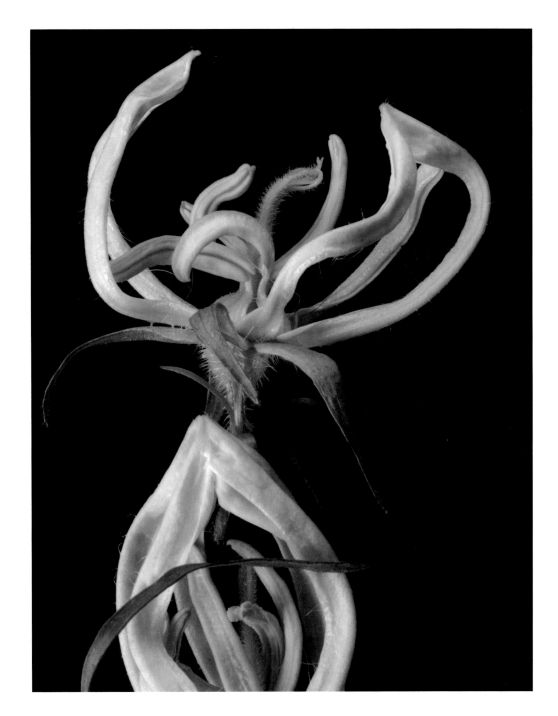

PLATE 16
Campanula, 1997

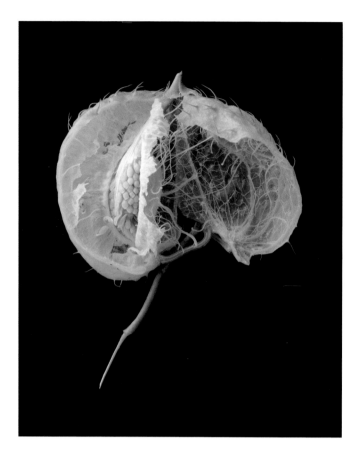

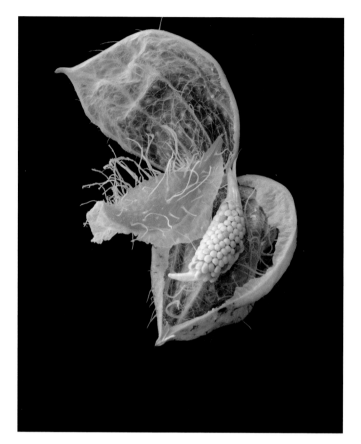

In the flower market, we called milkweeds "Pope's Balls." They arrived from France in rectangular boxes, with thick stems and hairy chartreuse balls attached to them.—cb

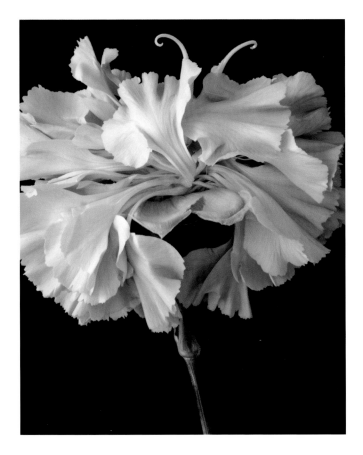

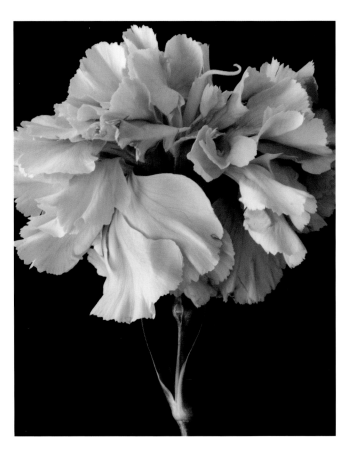

PLATE 19
Study of Carnation #1, 1997

PLATE 20
Study of Carnation #2, 1997

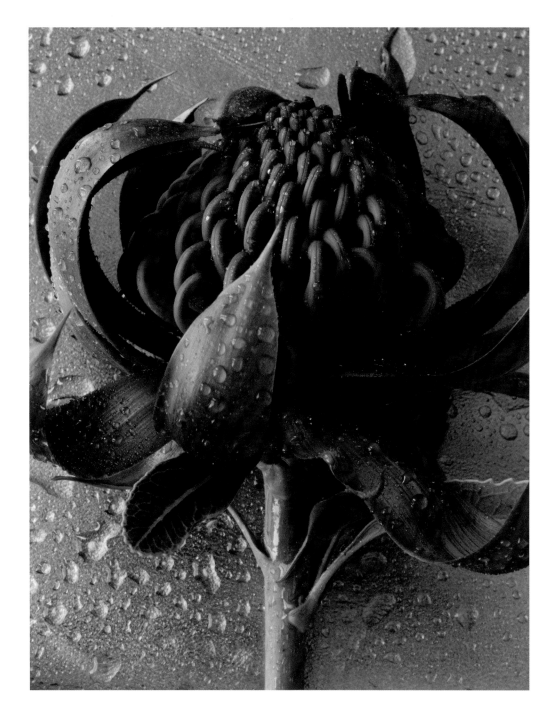

PLATE 21
Wanatah Protea, 1996

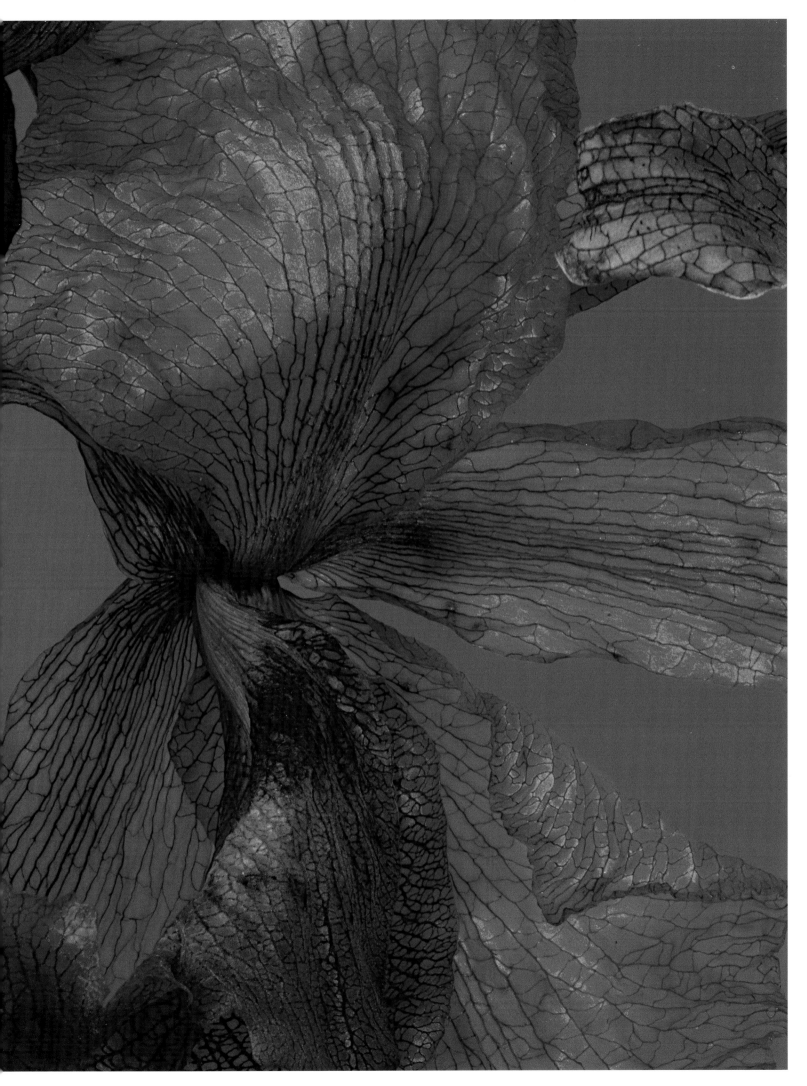

PLATE 22 *Cattleya Veins*, 2000

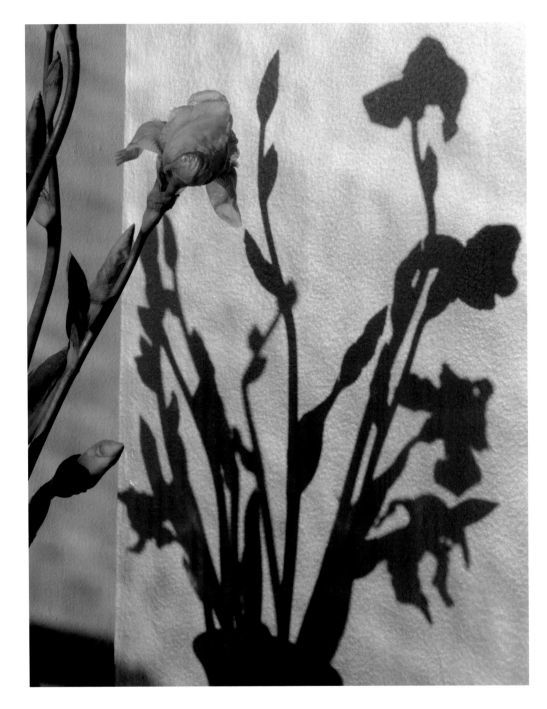

PLATE 23
Bearded Iris in Late Afternoon, 1999

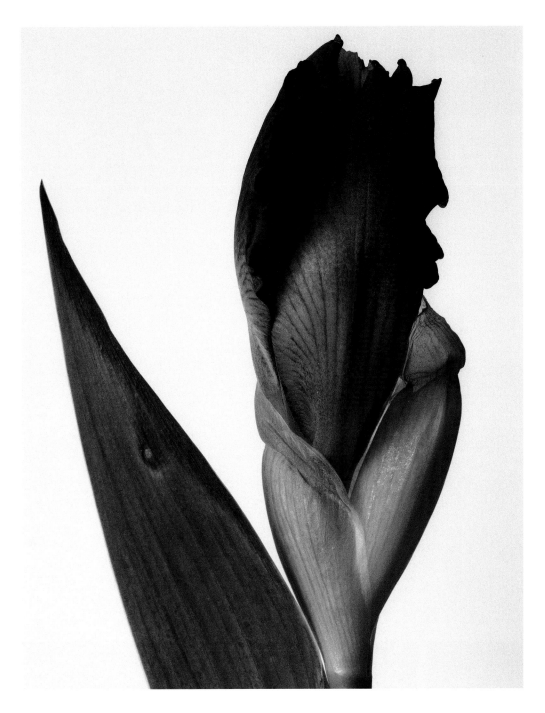

PLATE 24
Iris Bud, 1995–96

My friend Anne from Paris married in 2003 just outside Toulouse, in the south of France. The home we stayed in had a very old iron art nouveau arboretum in the back. A deep fuchsia bougainvillea vine covered its glass walls. But it was the calla lily border that lined the outside perimeter that caught my eye. I had seen the calla only as a cut flower, never as a plant. The lush green leaves illuminated the white flowers, and they all seemed to dance around the glass house.—cb

PLATE 25 *Calla Border at Château Laroque, 2003*

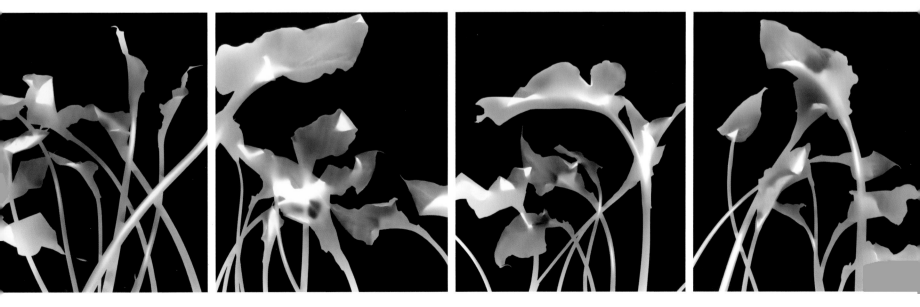

THE FIRST COLOR PHOTOGRAPHS

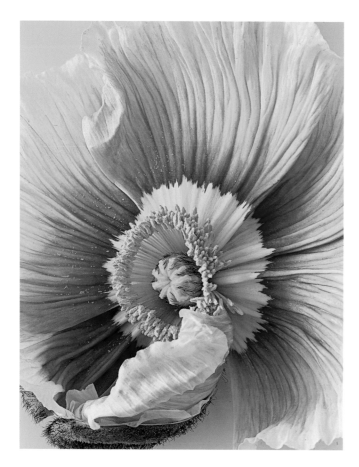

PLATE 26
Icelandic Poppy, 1999

The late 1990s were years of ceaseless experimentation for Beane. Deconstruction provided the basis for *Tulip Orgy Black and White* (plate 41), his first Orgy image, from 1997. Here tulip petals (hardly recognizable as such in black and white) that seem to have been torn from their flowers are heaped together, like bodies piled on top of each other in mass sexual congress; hence the title. The one element clearly missing from Beane's photograph is something that it virtually calls out for: color.

Fortunately, in 1997 Beane began to experiment with color photography. Soon he was photographing each image in both color and black and white. He clung to black and white, unsure which direction to pursue, until around the year 2000, when he settled, for the most part, on color. The first successful color series from 1997 was devoted to poppies, a number of which were published the following year in *House & Garden* magazine. Two are reproduced here. The most successful one of the entire group, called *Helen Elizabeth* (plate 29), is shown close-up as a mature blossom juxtaposed with a hairy green pod, like the one from which it popped open. Because of how it is lighted, some of the petals look as diaphanous as gauze, while others seem more akin to crumpled crepe paper, despite their intense color.

The public reception of the initial Poppy series gained Beane some of his first recognition outside the small group of admirers and collectors who came to his studio. It also provided the point of departure for what became one of his trademarks: flowers seen "up close and personal." Finally, this success helped to determine a preference for similar-looking floral types, above all the peony.

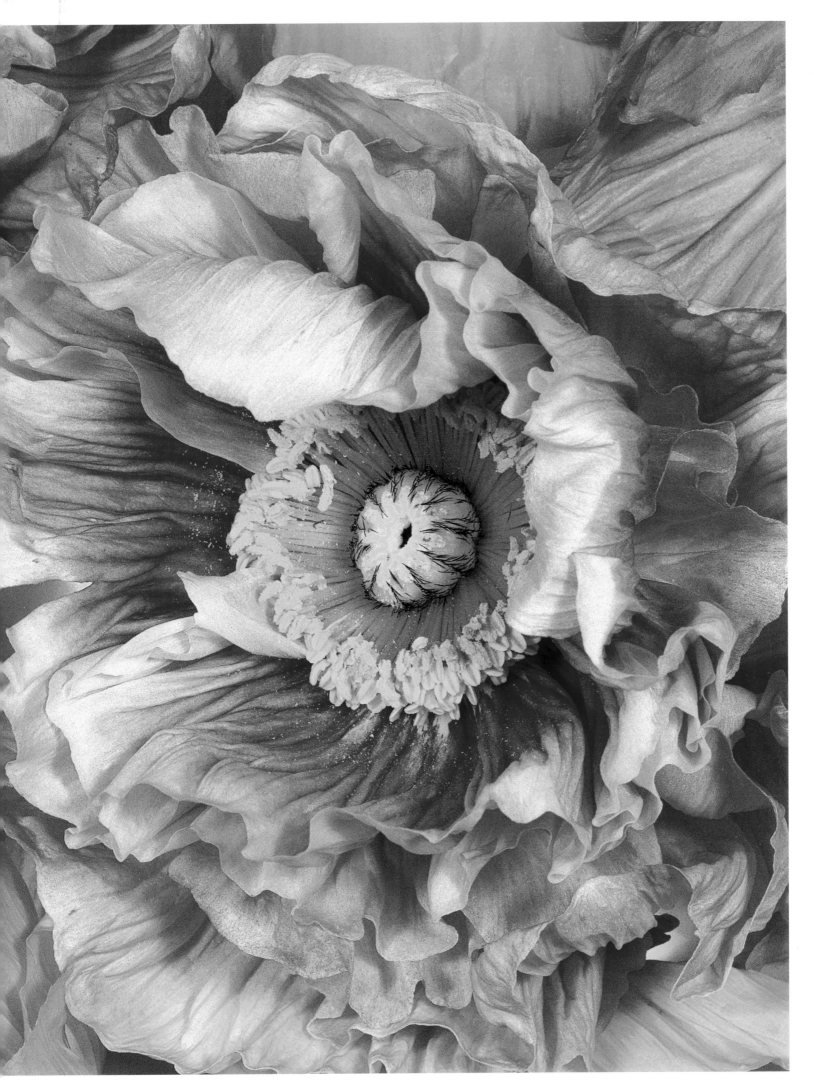

PLATE 27 *Poppy Flamenco,* 2002

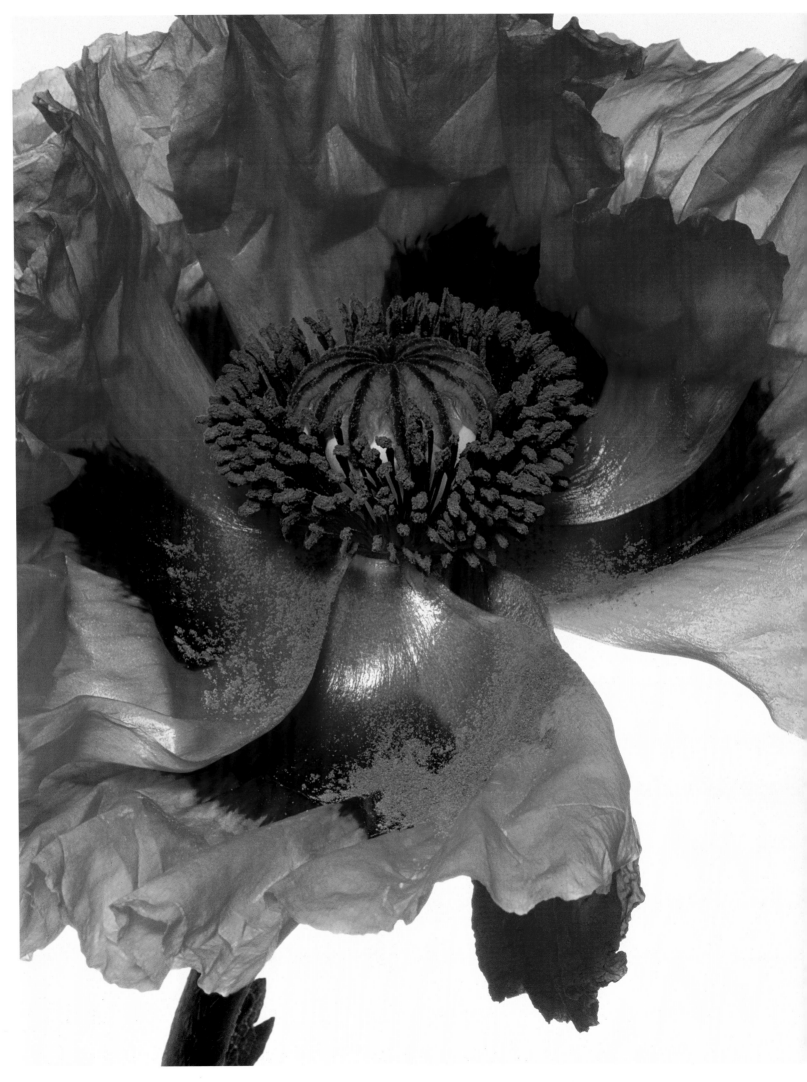

PLATE 28 *Oriental Poppy with Gray Dust*, 1997

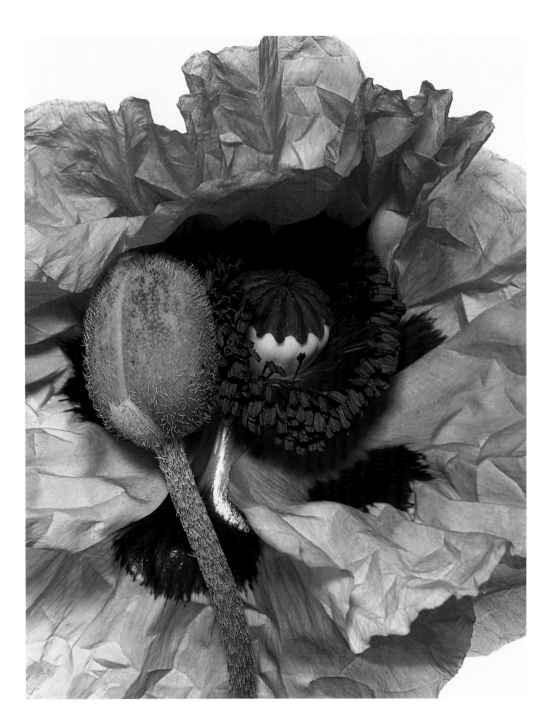

PLATE 29
Oriental Poppy Helen Elizabeth, 1997

My mother used to have a slate-lined flower bed in the back garden. Every year at the end of May, the Oriental poppies would reappear. Their fuzzy hard shells would give way to this explosion of color. Unfortunately, between spring showers and morning dew, the brilliance of these top-heavy flowers was short-lived. I remember gray dust spread all over crimson, pink, and black petals shattered on the grass below.—cb

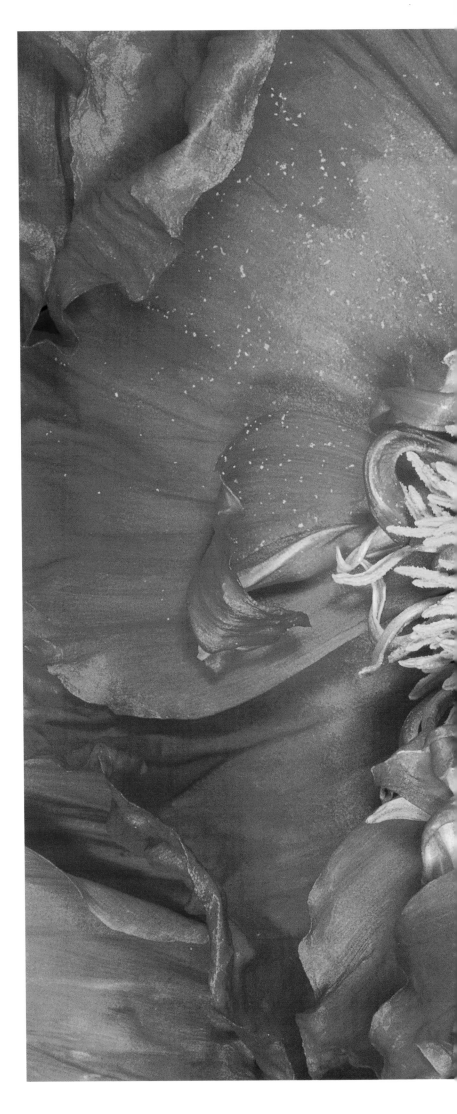

Photographing poppies became an annual ritual for me. Each year they would arrive from Italy, fifty hairy stems packed together.—cb

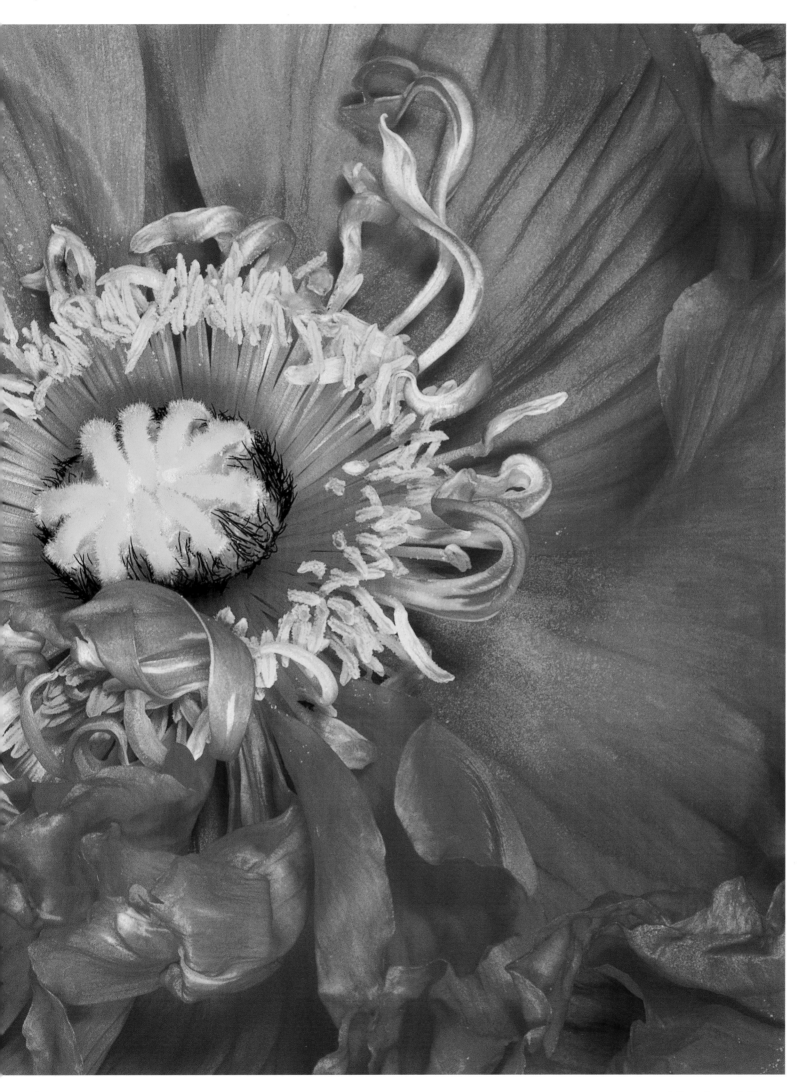

PLATE 30 *Poppy Orange Frill,* 2001

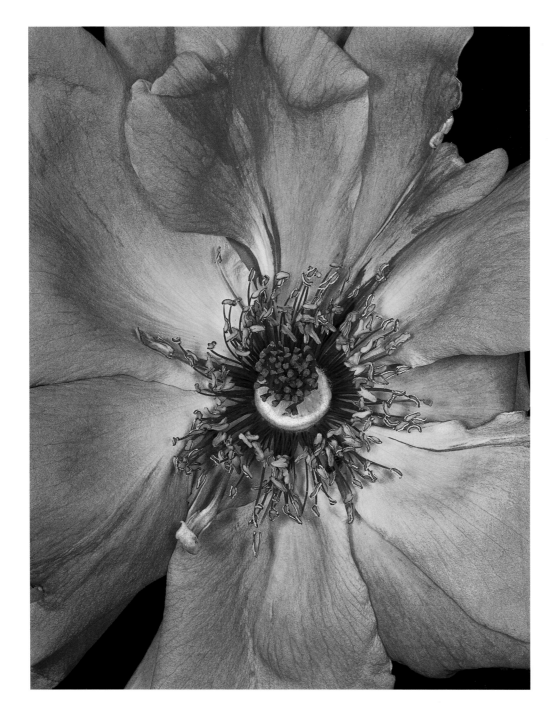

PLATE 31
Garden Rose Playboy, 2000

OPPOSITE: *Mysterious varieties of midnight and noir flowers appeared at the market. Chocolate cosmos and Black Magic roses were sold off the shelves as quickly as they were put on.—cb*

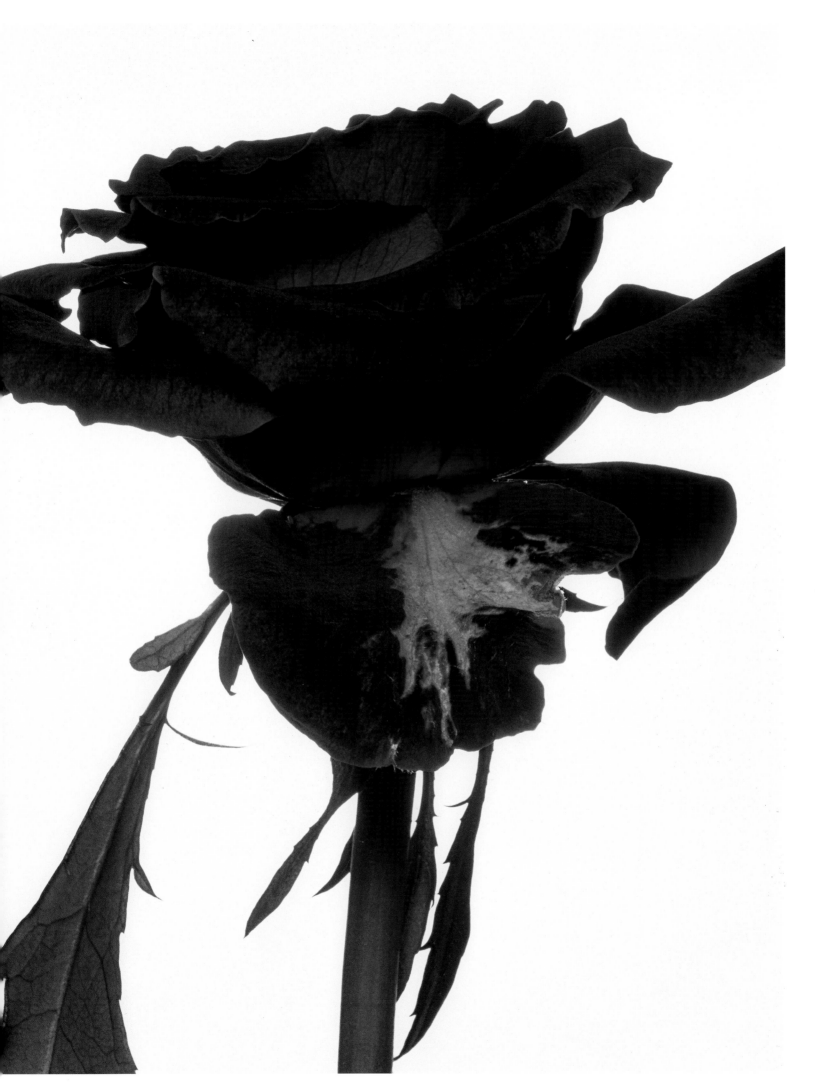

PLATE 32 *Black Magic*, 1997

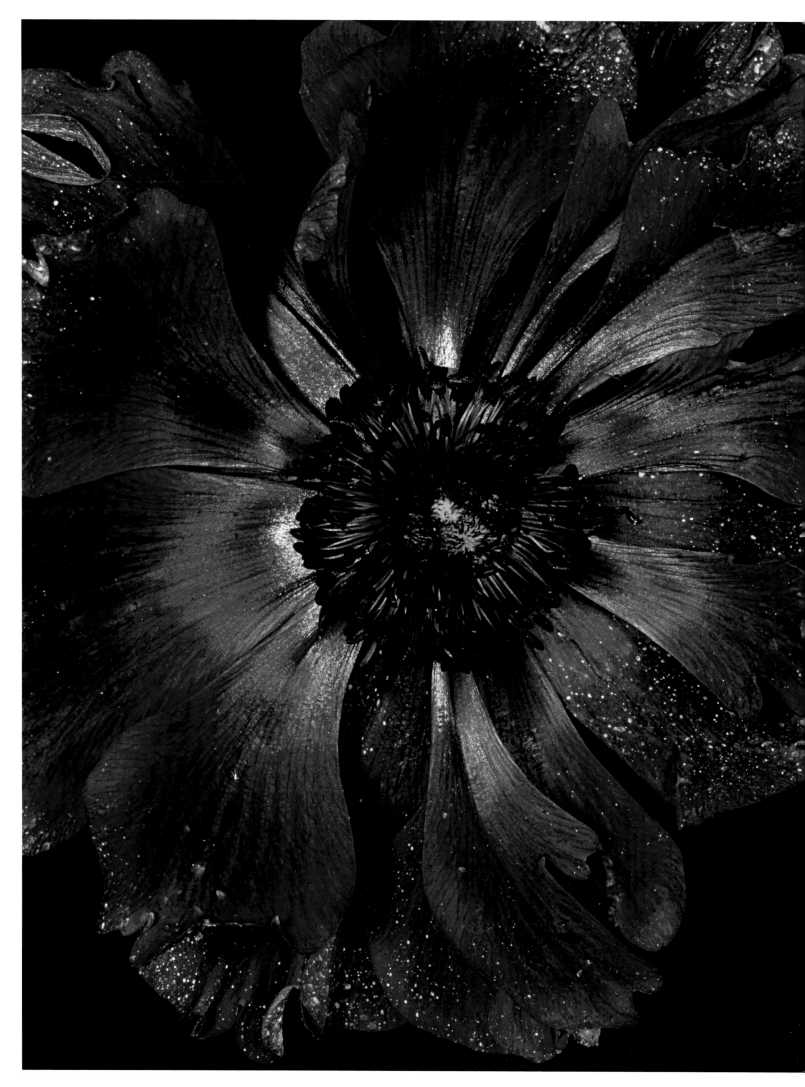

PLATE 33 *Sprayed Anemone,* 2001

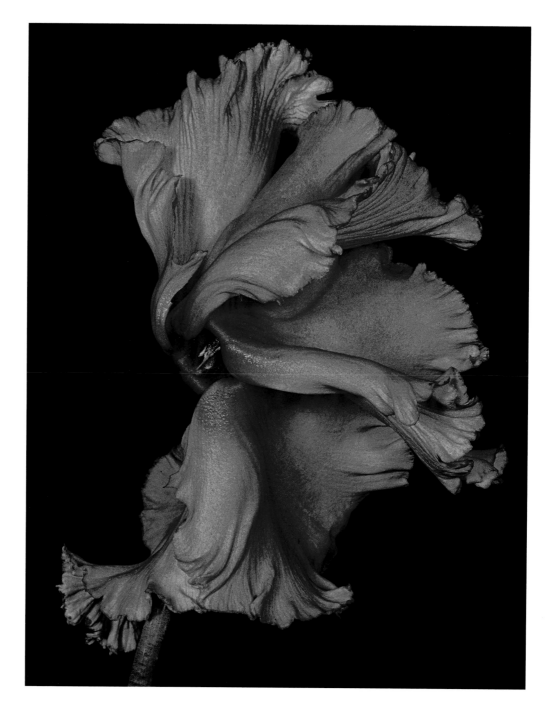

PLATE 34
Double Cyclamen, 2002

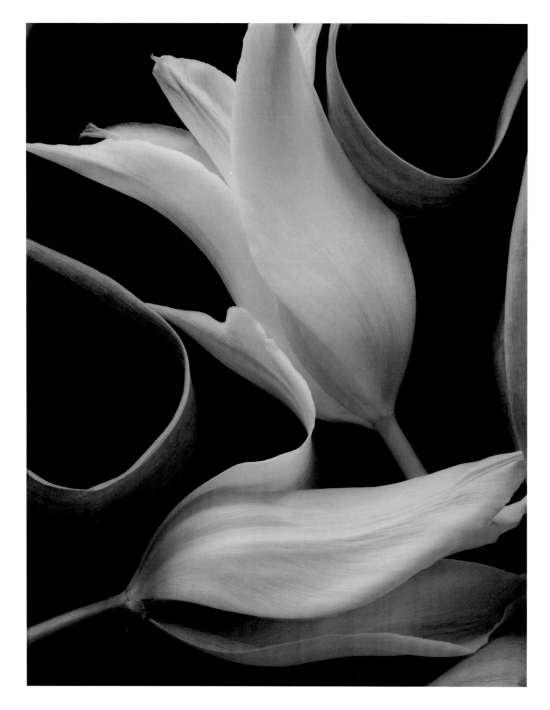

PLATE 35
Black-and-White Study of Pencil Tulips, 1997

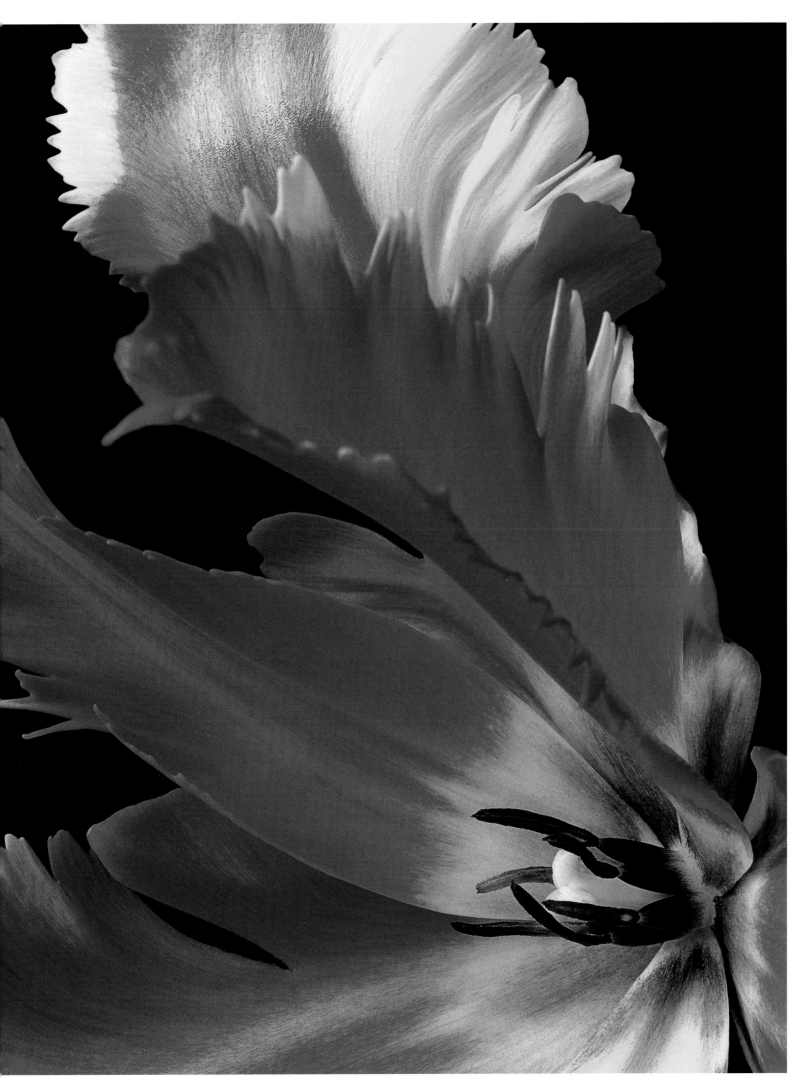

PLATE 36 *Parrot Tulip Flame,* 2000

OPPOSITE: *Robert Isabell, the king of event planners in New York City, generously lent me a vast studio loft space up above his warehouse in the meat market district. Every afternoon after work I would go photograph in this space using available photo equipment. Surrounded by Irving Penn's ads from Robert's perfume campaign, my confidence with color photography was inspired—cb.*

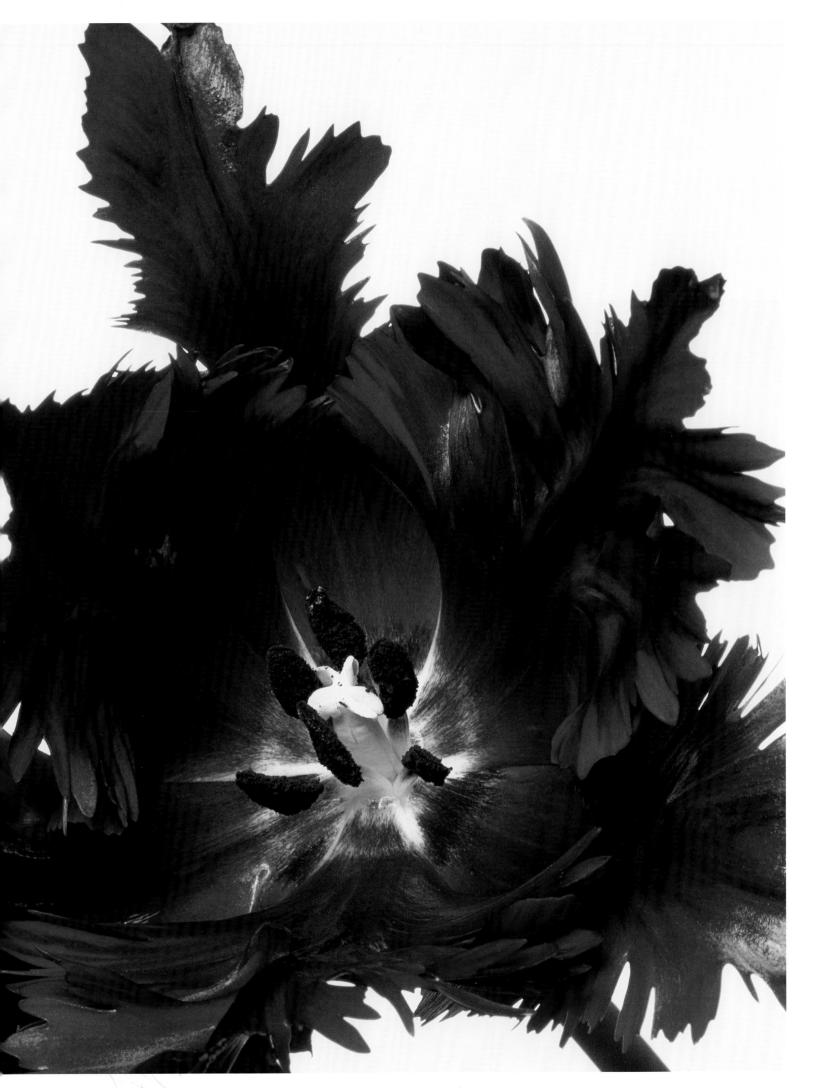

PLATE 37 *Black Parrot Tulip with Cobalt Center,* 1997

THE ORGY SERIES

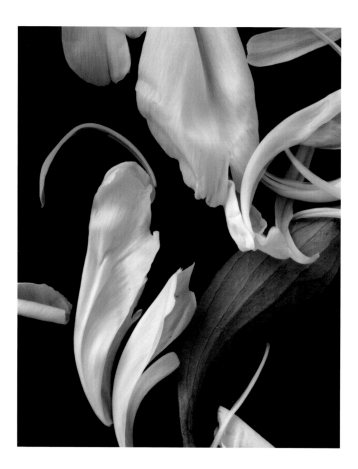

PLATE 38
Peony Petals Black-and-White Study #1, 1997

The successful foray into color prompted Beane to take his first color Orgy photograph (see plate 40). Here the composition has become more open. The forms seem to reach out to each other almost longingly, as if expressing a need for intimacy, instead of being piled in a jumble as in the black-and-white Orgy, or jostling confrontationally as in the black-and-white photo of the bromeliad leaves. Through the addition of color, a fundamental change in meaning has also taken place. The sensual gratification of sexual pleasure implicit in the term *orgy* has been replaced by something more subtle: the sensuous gratification of the senses for the sake of aesthetic pleasure, through delight in the color, form, and texture of the floral forms.

This new sensuousness holds true throughout the Orgy series, which refers as much to an orgy of color and texture as to any more sexual interpretation. The Orgy photos are profuse in their number and diversity of composition, color, and floral selection, which usually consists of petals from one or more flowers. Although the series started with tulip petals (as in plate 39), it soon encompassed nearly every flower that Beane regularly photographs.

The reason for this range is that each variety is obtainable during certain seasons only. While he has access to a wide array of interesting flowers throughout the year, he has to take advantage of what is available. The Orgy series is ongoing. It is based on an organizing principle and changes over time rather than adhering to a static formula. Taken together, however, the theory of deconstruction and the Orgy series provided the foundation for Beane's mature work, which is inconceivable without these experiments.

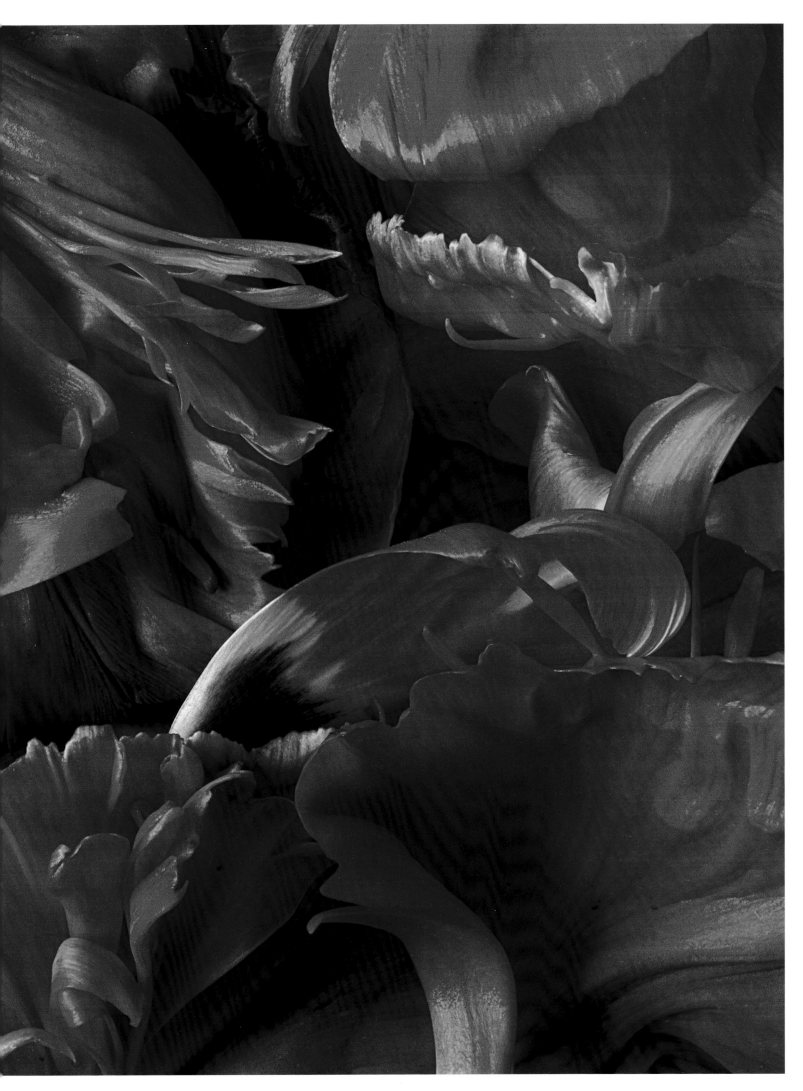

PLATE 39 *Tulip Orgy*, 2003

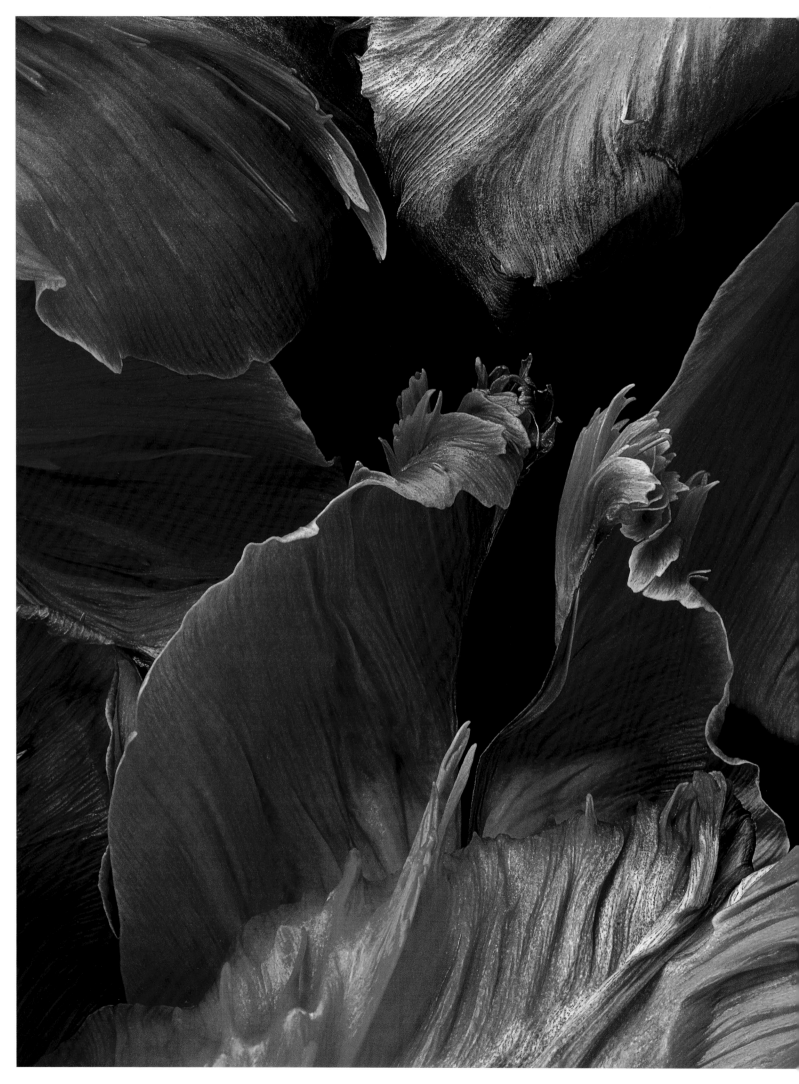

PLATE 40 *First Color Tulip Orgy,* 1998

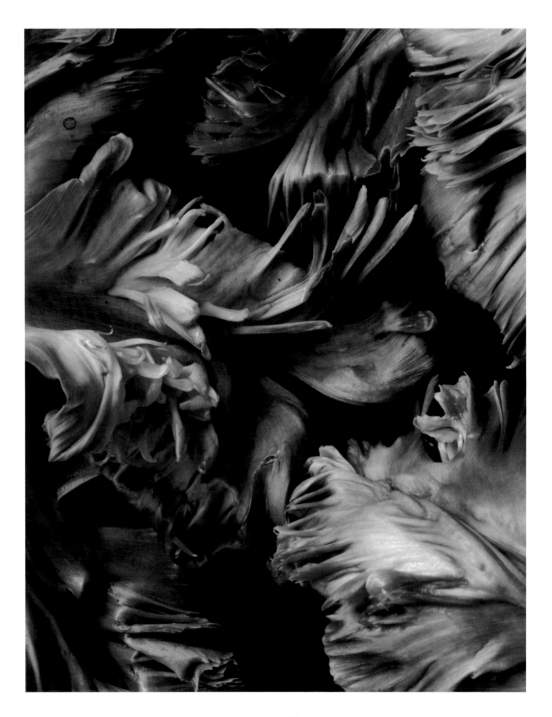

PLATE 41
Tulip Orgy Black and White, 1997

OPPOSITE: *The intricate ruffles of certain flowers began to demand my attention. Every spring I would look forward to the different hues and varieties of the bearded iris, whose petals transformed into abstract and undulating earthscapes.*—cb

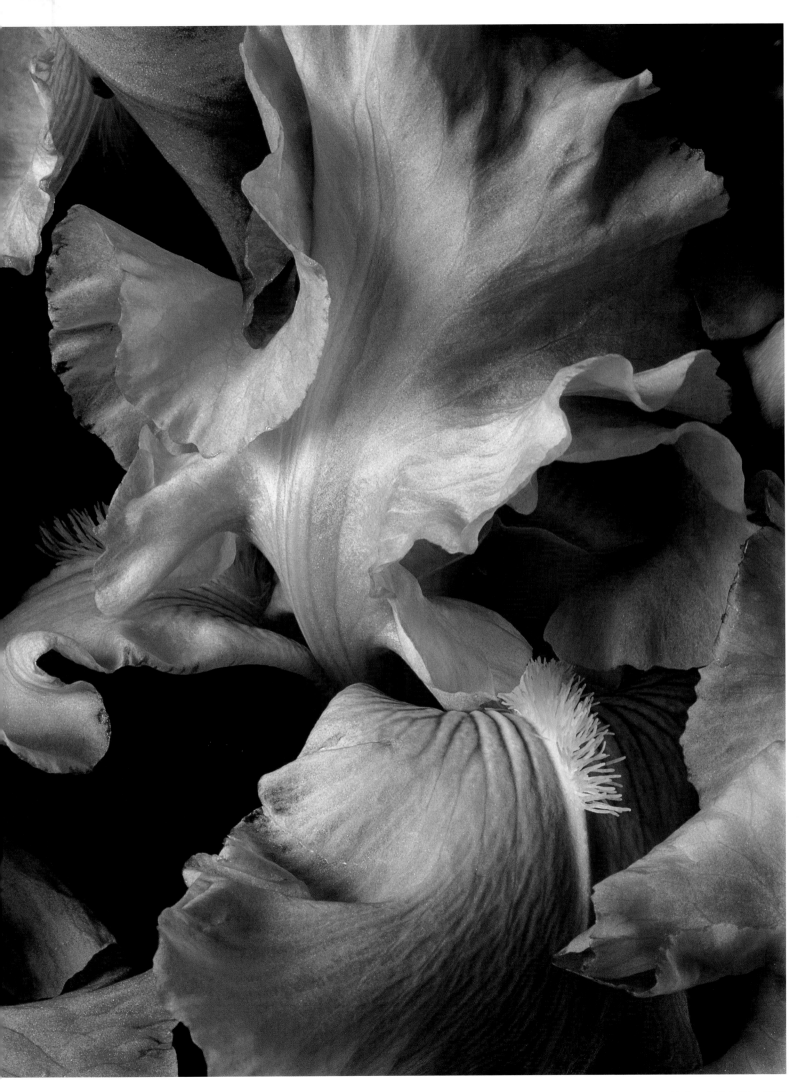

PLATE 42 *Bearded Iris Blue*, 2002

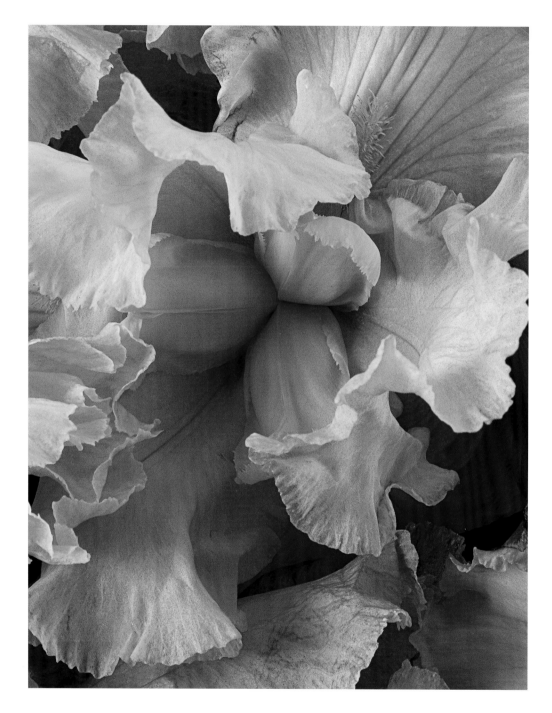

PLATE 43
Orange Iris, 2003

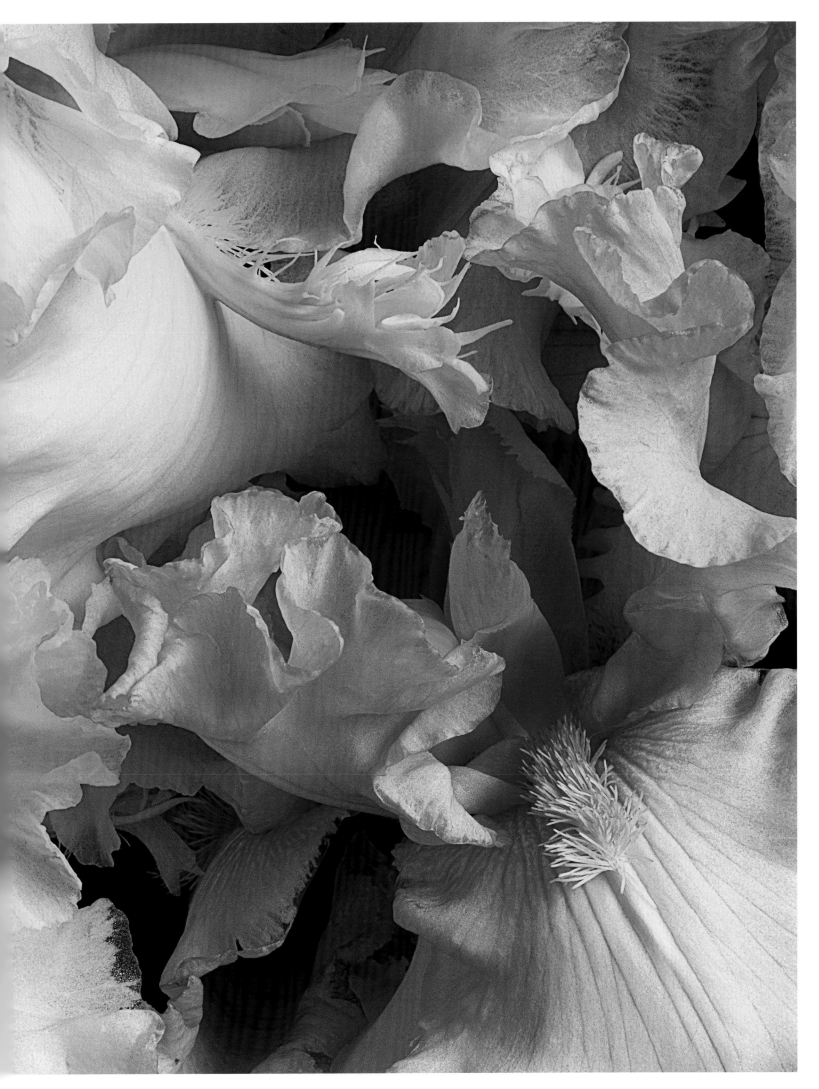

PLATE 44 *Iris Orgy,* 2003

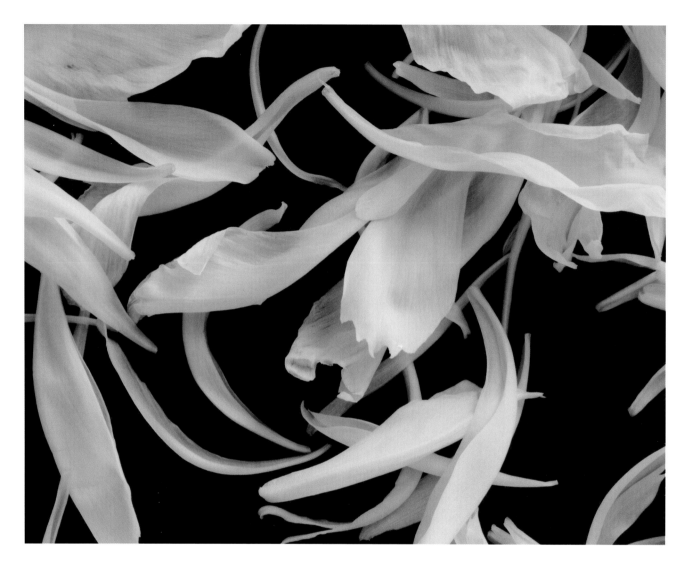

PLATE 45
Peony Petals Black-and-White Study #2, 1997

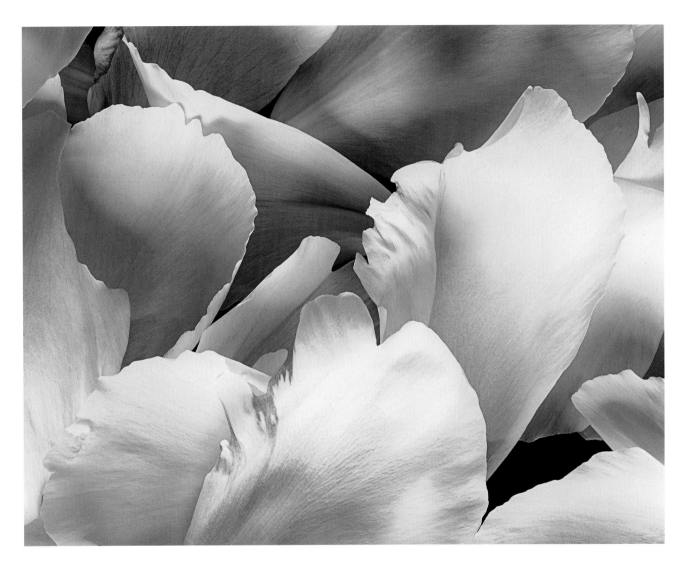

PLATE 46
Peony Petals Orgy, 2003

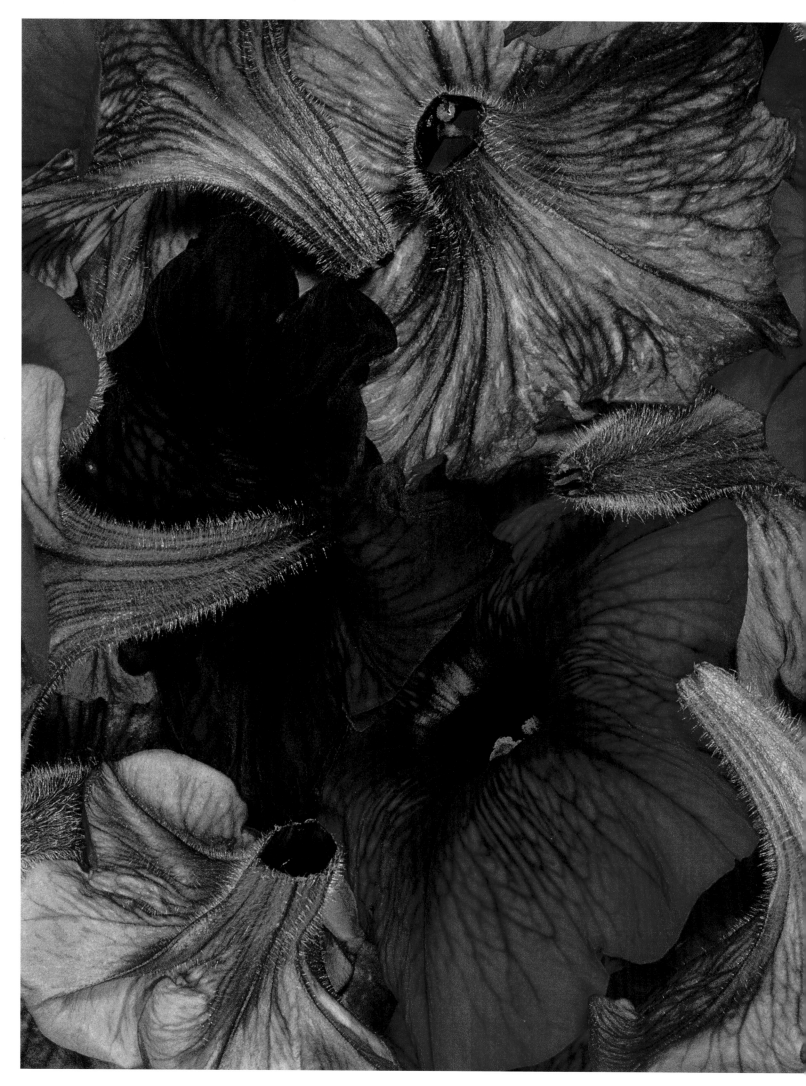

PLATE 47 *Petunia Orgy*, 1999

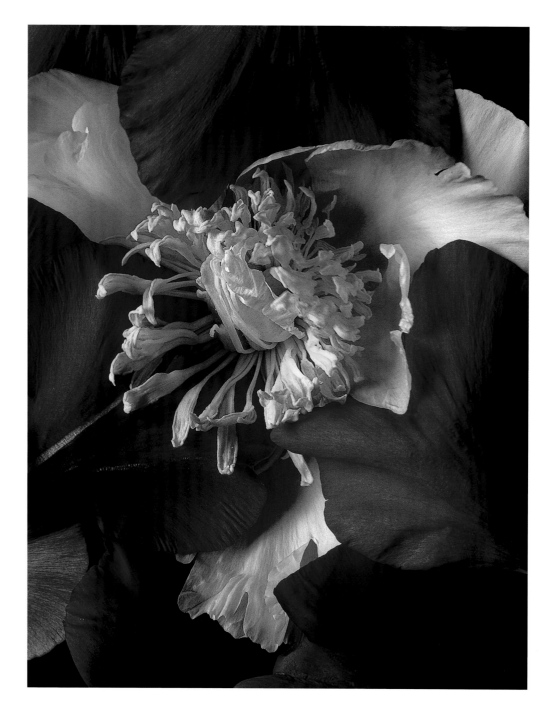

PLATE 48
Painting with Petals Peony Study #2, 2004

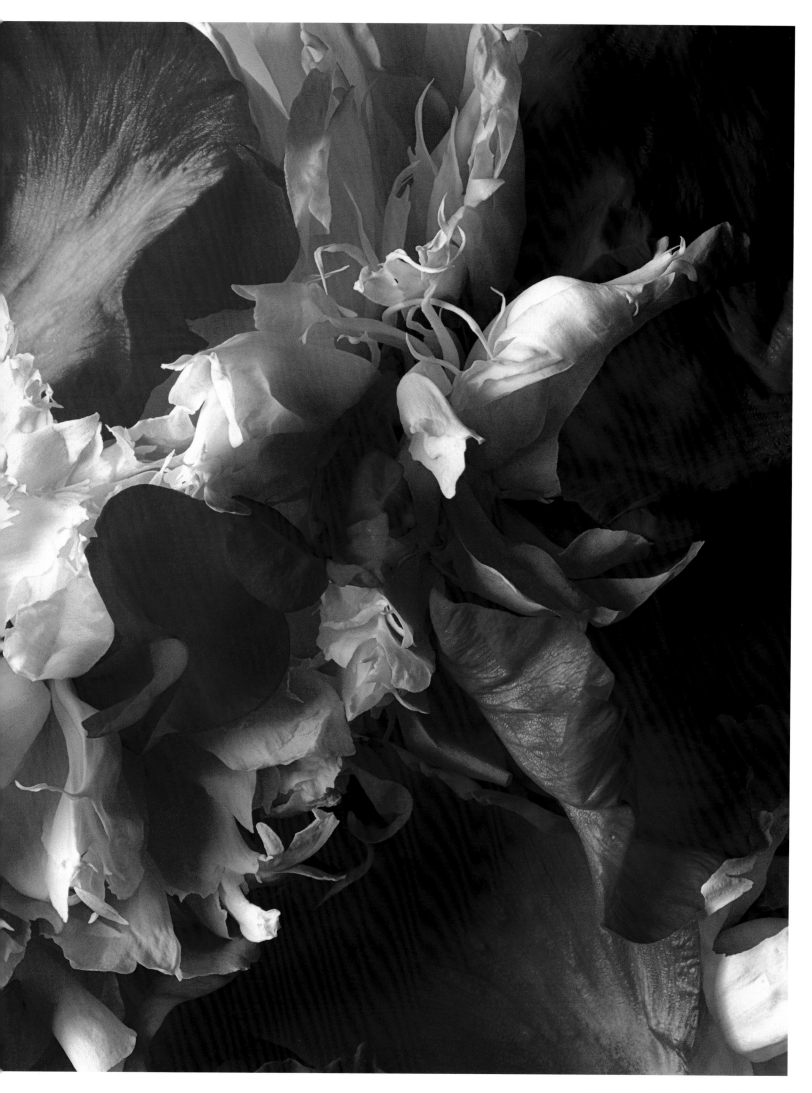

PLATE 49 *Painting with Petals Peony Study #1, 2004*

breakthrough

THE PEONY SERIES, 1999–2003

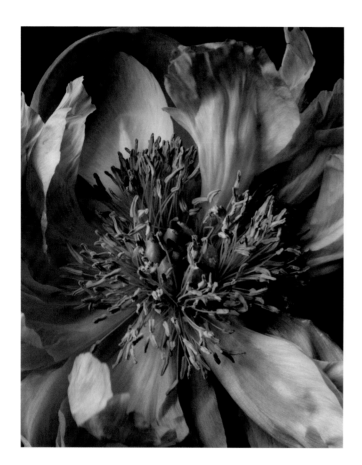

PLATE 50
Early Peony Study, 1996

A breakthrough came in 1999 with *Coral Charm Peony* (opposite), Beane's first close-up color photo of a peony. Previously, he photographed peonies only in black and white and had never risked coming this close to his subject. The reasons are technical as well as aesthetic. Because of its long focal length, the lens on a large-format camera, with bellows fully extended for close-up photography, has a very shallow frontal plane where everything remains in clear focus, especially when the aperture is closed down all the way for maximum depth of field. At such close distances, lighting a flower becomes challenging even in a frontal view, whether natural daylight, flash, or floodlights are being used. The demands become even greater if the flower is turned at an angle, because of the limited depth of field.

In *Coral Charm Peony,* despite being so close that you can practically feel the lens touching the petals, everything is in clear focus, every form is perfectly lighted, and an illusion of three-dimensional fullness and depth is retained through contrast and overlapping. Only a few stamens are hidden among the double petals, so that the focus is on the orange ovaries awaiting fertilization, which miraculously stand out rather than appearing submerged.

Technique alone cannot account for the quality of Beane's peonies, since there are other photographers who are equally experienced and capable. Beane's images display an innate affinity for peonies that is quite special. Beane has probed peonies from deep within the blossom, at virtually every angle and under nearly every kind of lighting condition. If you take the time to look at them carefully, it becomes obvious that there is something about this particular type of flower that inspires him as no other kind does.

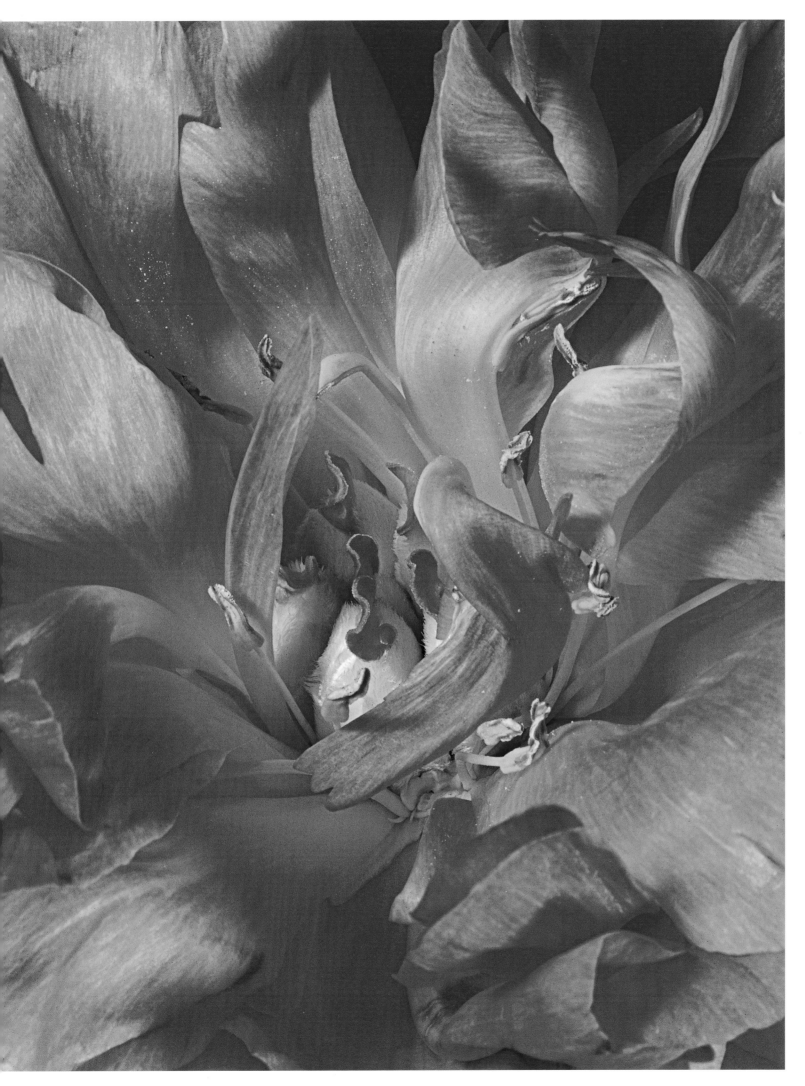

PLATE 51 *Coral Charm Peony*, 1999

The unfolding of the Peony series reveals a great deal about the workings of Beane's imagination. Beane at first worked with the lens placed parallel and very close to the center of the peony (compare plates 52 and 53). He then began to turn the flower on its axis to show a partial-side view without losing sharpness or clarity (see plate 56).

Beane was hardly the first person to stick a lens far into a flower blossom to reveal its most intimate details. This "in-your-bloom" approach has been around since at least 1925, when Imogen Cunningham used it in a few of her flower photographs. It became especially popular in the 1930s. Beane, however, has managed to get closer and deeper into flowers than even Cunningham, without losing detail or clarity. He did this by maintaining tight control of what falls within the limited focal range of the frontal plane. Indeed, he pushed the technically feasible to its absolute limits. Few others have pulled off the macrophotography of flowers with such consistent success or on such a grand scale. Even the bravest members of Group f/64—who were, after all, the greatest photographers of their generation in this country—hesitated to go beyond what they felt certain in their own minds was possible.

Beane would sometimes arrange peony petals in the manner of the Orgy images, of which *Painting with Petals* (plate 49) is the finest example. And, given the possibilities inherent in deconstruction, it was inevitable that Beane would decide to combine peony blossoms. The effect can be very subtle—for example, in *Peony Falcon Red Ruffles* (plate 59) and *God of Fire* (plate 60). You have to look hard before you realize that each photograph really consists of two flowers, not one. Although it is relatively easy to see that a peony study from 2001 (see plate 55) is composed of petals from several varieties of peonies, it takes close inspection to be certain that a later peony study (see plate 48) also consists of two flowers.

Flower photography, like any art form, is a result of cumulative practice and the understanding that comes with it. The Peony series incorporates ultra-close-up photography and the experience with deconstruction in the Orgy series, allowing Beane to extend the newly combined approach in every direction. The peony experience altered (or, in the parlance of deconstruction, "infected") Beane's way of photographing other flowers. Its impact can be seen in some of his photographs of poppies, which may be frontal close-ups (*Poppy Orange Frill,* plate 30), viewed even nearer from an angle (*Icelandic Poppy,* plate 26), or, as in *Poppy Flamenco* (plate 27), consisting of stacks of blossoms.

At first glance, one is hard-pressed to find any underlying sense of direction amid the seemingly endless sea of images in the Peony series. If there is one, it can be seen in a group called Ruffles (see plates 42, 57, and 58). Many of the photos we have discussed, as well as a number of irises, were incorporated into this group. As the title suggests, they share a preference for the decorative, showy aspect of flowers, which he treats in much the same way a good designer would use fabric and decorative edging in creating a costume.

OPPOSITE: *Some varieties of tree peonies in the market are very similar to Oriental poppies. The deep black spot that marked each petal caught my eye. This variety, "Fashion Pink," with its striking ruffles, resembles a couture gown.—cb*

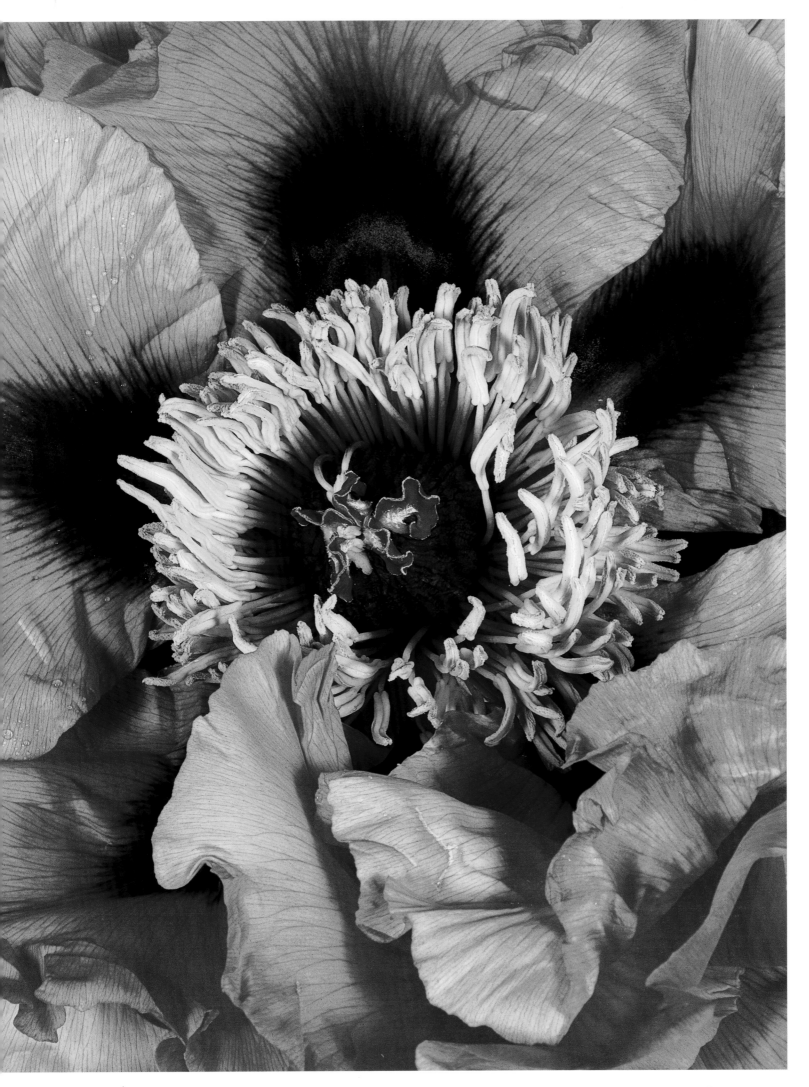

PLATE 52 *Fashion Pink Tree Peony,* 2003

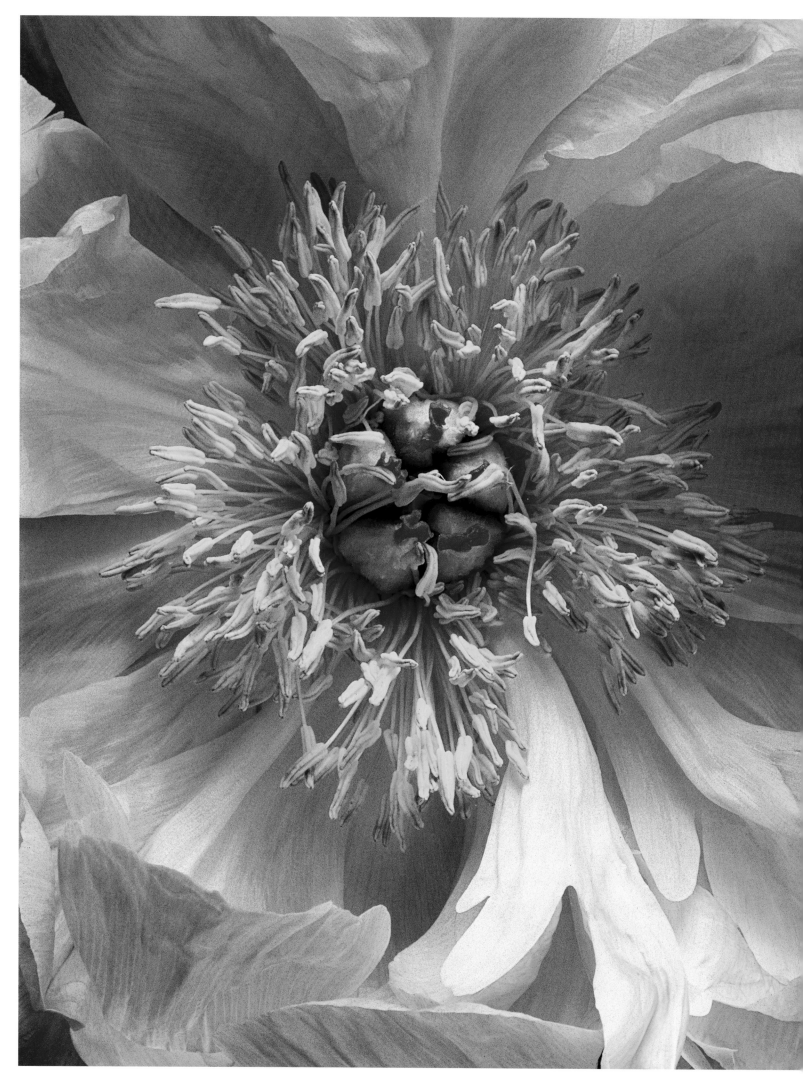

PLATE 53 *Coral Magic,* 2004

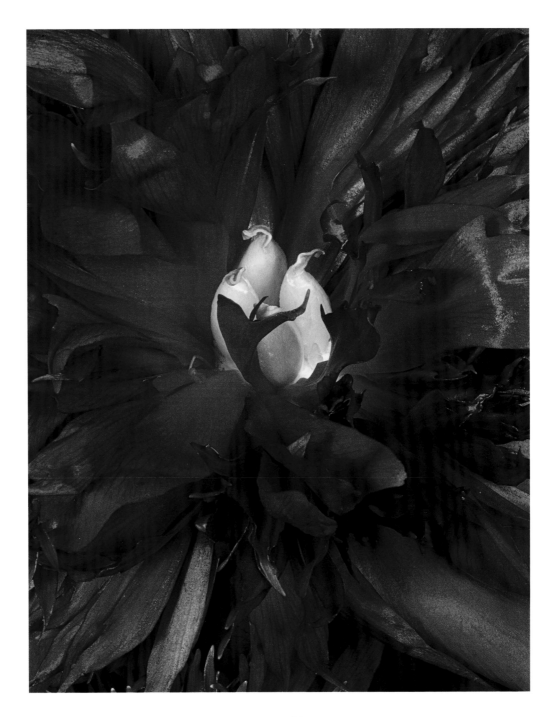

PLATE 54
Burgandy Peony Gold Center, 2001

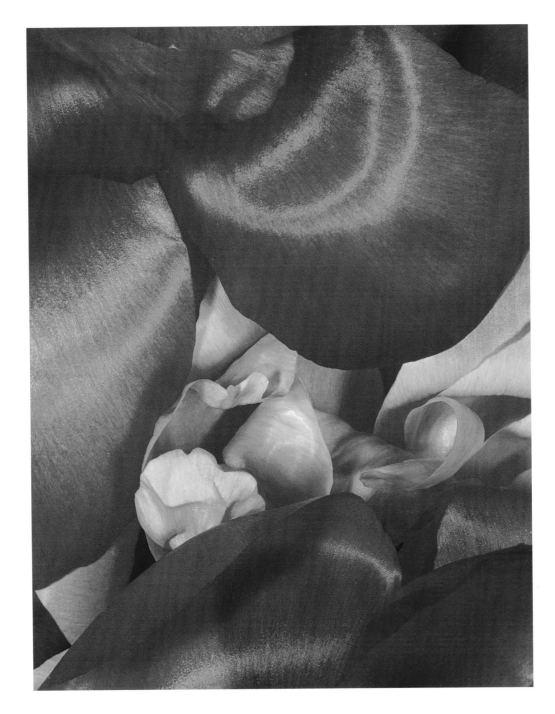

PLATE 55
Peony Study with Petals of Flame #4, 2001

OPPOSITE: *I was confined to a wheelchair and hadn't photographed for well over a year. My friend Zezé, who had sent flowers throughout my recovery from spinal surgery, gave me a very simple arrangement of the most beautiful yellow tree peonies. Knowing their fragility and ephemeral nature, I sat at the corner of my bed with my tripod, and managed to take this photo. It was the hardest and most painful shot I ever took.—cb*

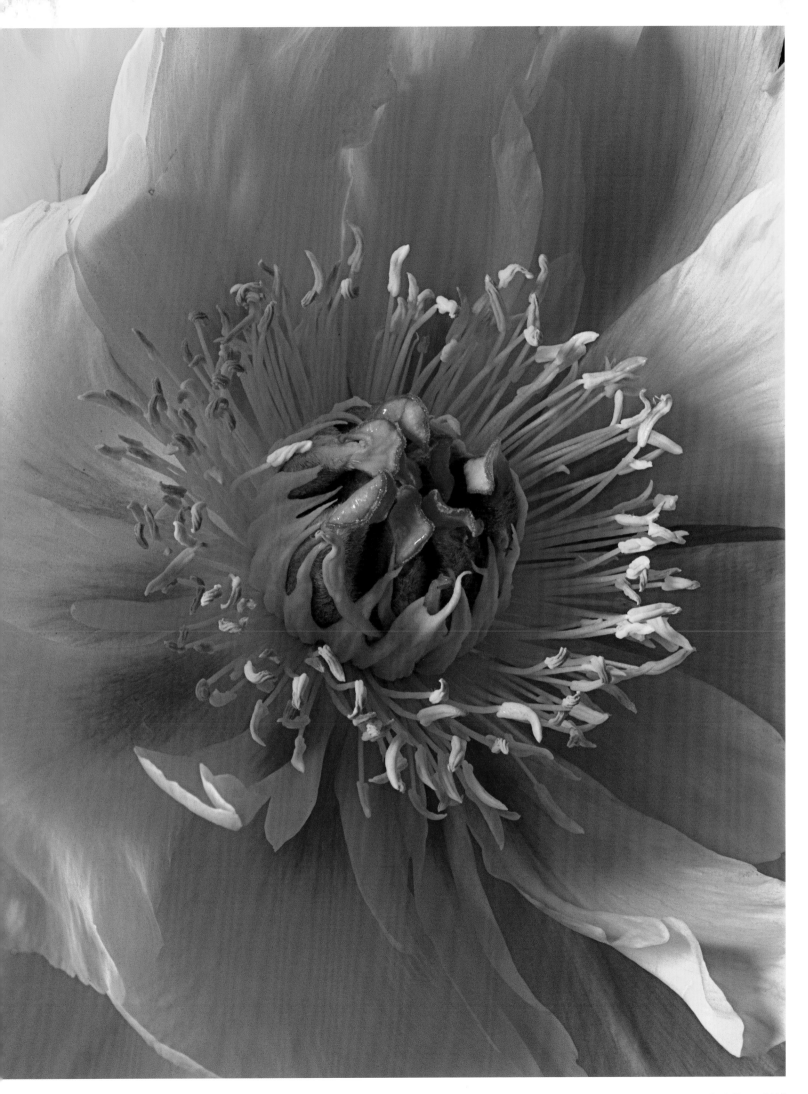

PLATE 56 *Zezé's Peony, 2006*

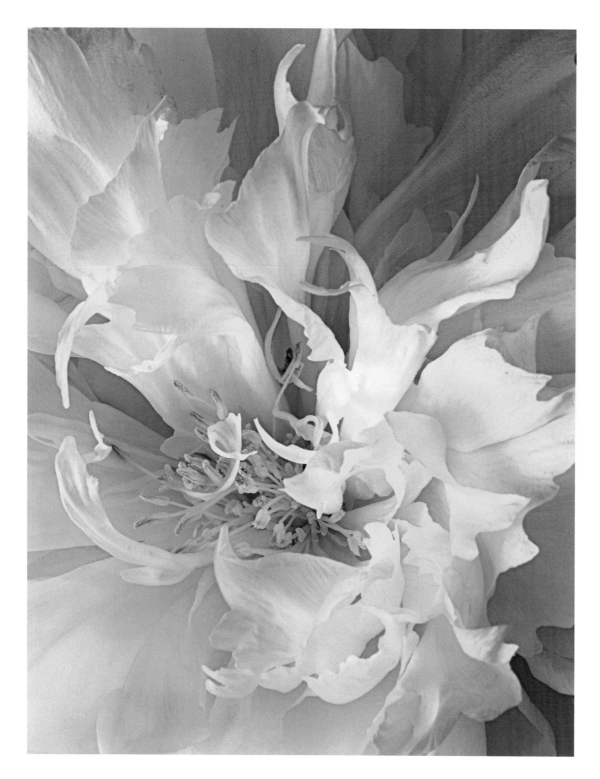

PLATE 57
Bowl of Cream, 2004

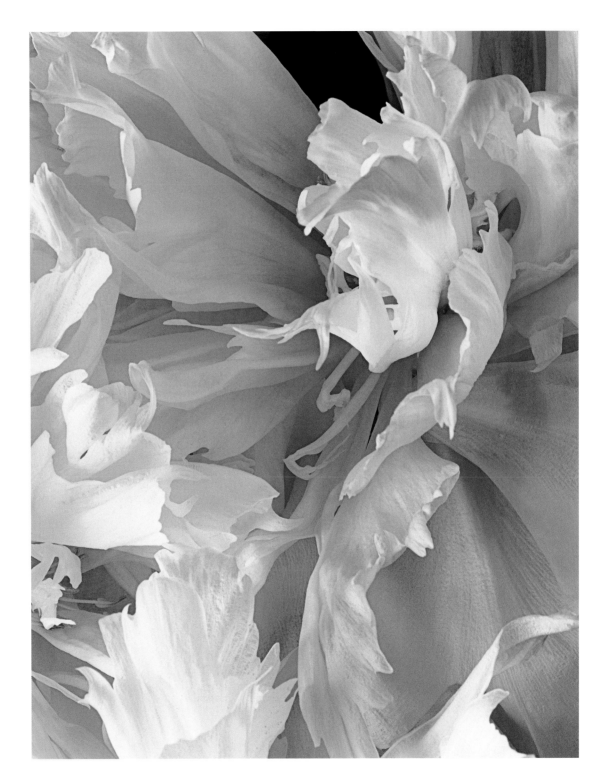

PLATE 58
Fringed Ivory, 2004

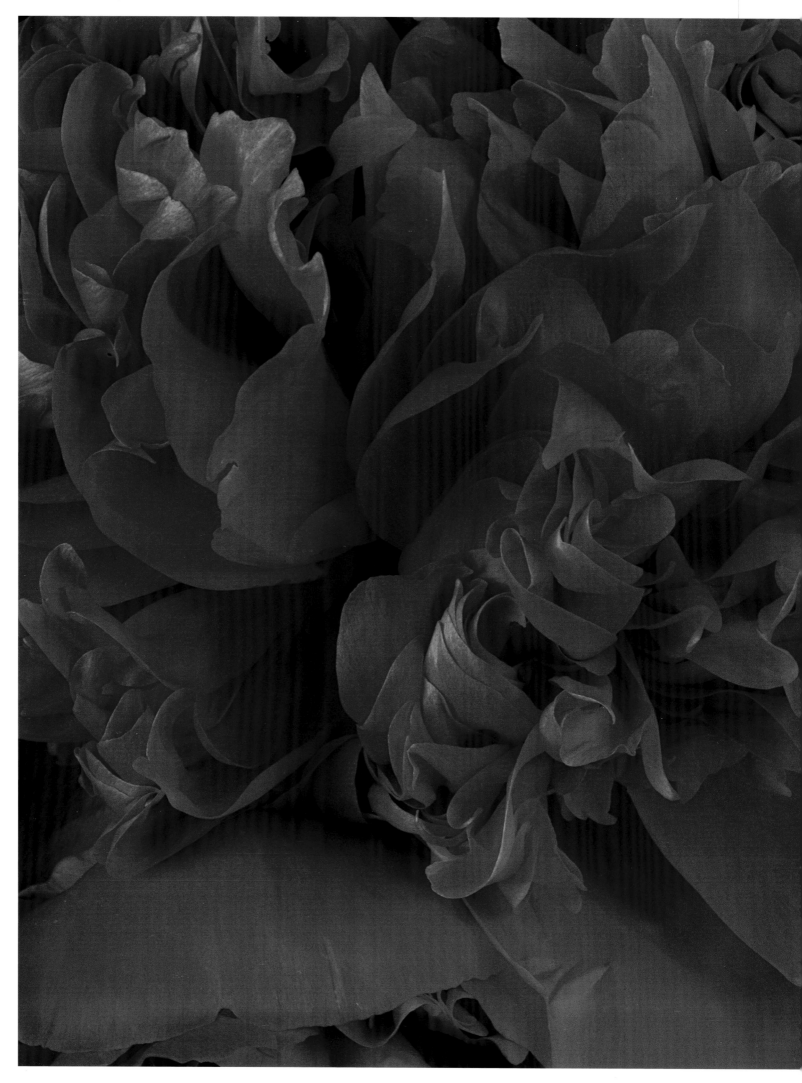

PLATE 59 *Peony Falcon Red Ruffles,* 2001

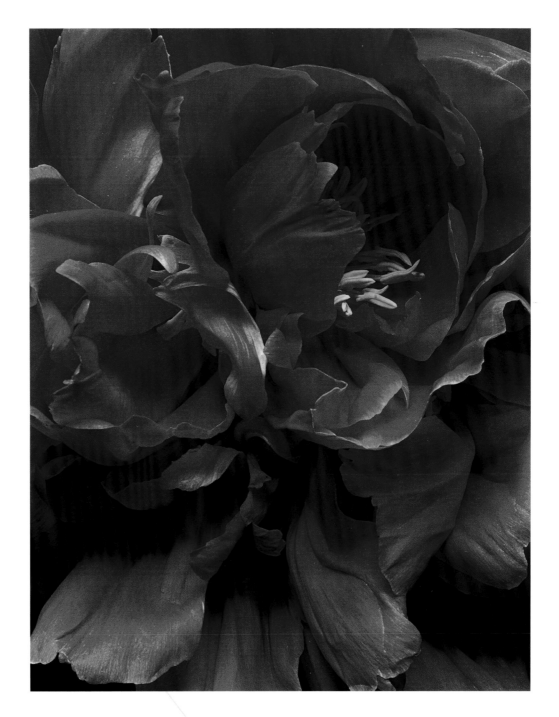

PLATE 60
God of Fire, 2007

THE PHOTOGRAPHER AS PAINTER

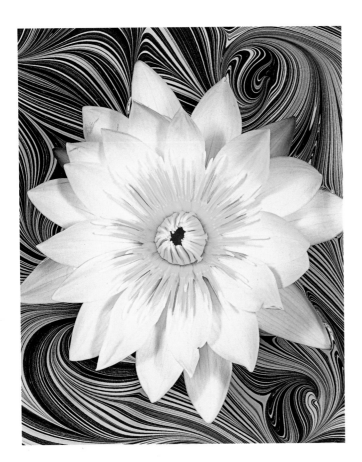

As usual with Beane, just when you think you have begun to figure him out he changes on you. And this next transformation is so unexpected that it leaves you stunned. It's called the Camouflage series, and it is unlike anything I've ever seen in flower photography. It elevates Beane to the rank of the pioneers who defined photography more than a century and a half ago.

In hindsight, the series seems like a natural extension of his previous work. Yet it began casually, almost by accident, and took some time to evolve. The starting point was a photograph of hops leaves covered with mold and mildew, taken in early 2000 (see plate 93). Beane had already made other images of dead vegetation, which has been a major preoccupation of his, and he had previously altered the appearance of plants and flowers often beyond recognition. But here was a microcosm in which nearly every element was disguised so as to be unreadable. In a word, it was camouflaged.

The idea for the Camouflage imagery lay dormant until the summer of 2000, when Beane found some water lilies at the flower market. This discovery was made toward the end of what he sometimes refers to as his "Black Flower Phase," when he would take at least one photograph of a black flower each week. The Black Flower phase began in 1997 with a black iris and includes the rose in *Black Magic* (plate 32) from the same year, which nearly echoes a black-and-white photograph by Denis Brihat; the dark-purple and cobalt-blue parrot tulip (see plate 37) from 1997; and the purple anemone (see plate 33) from 2001.

Returning to the water lilies and their role in the Camouflage series, Beane knew that the lilies had to be kept in water. He placed them on a tray lined with black plastic

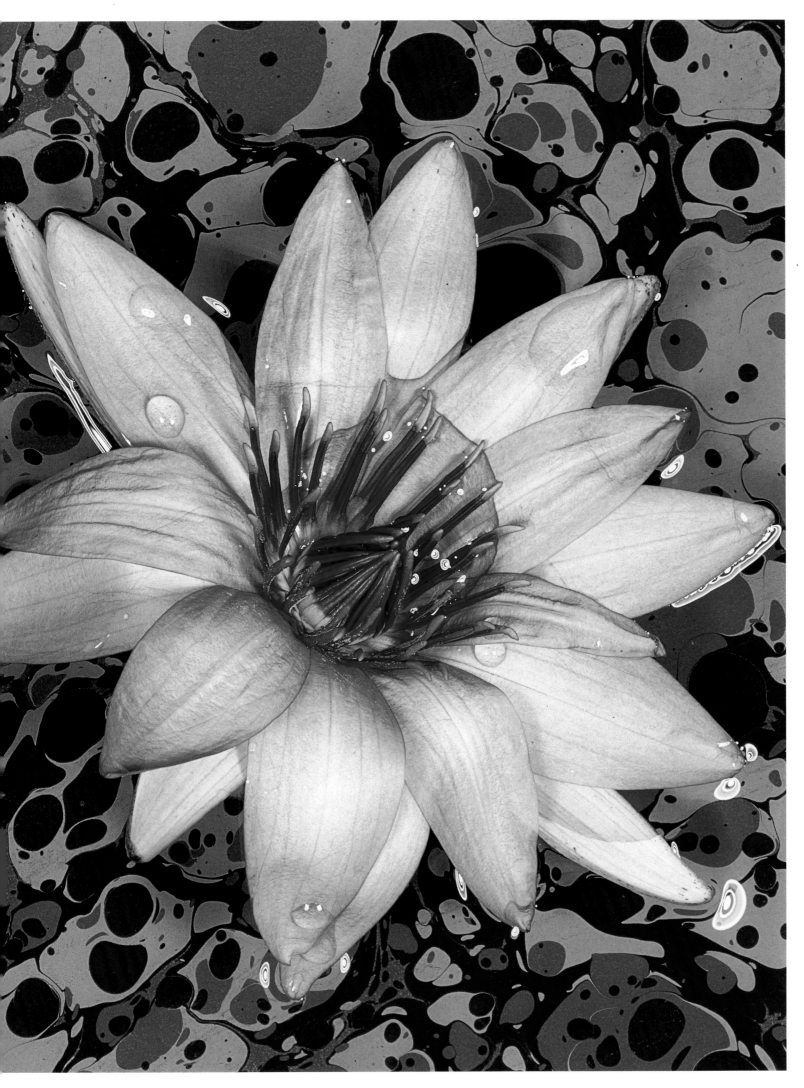

PLATE 62 *Lavender Water Lily,* 2000

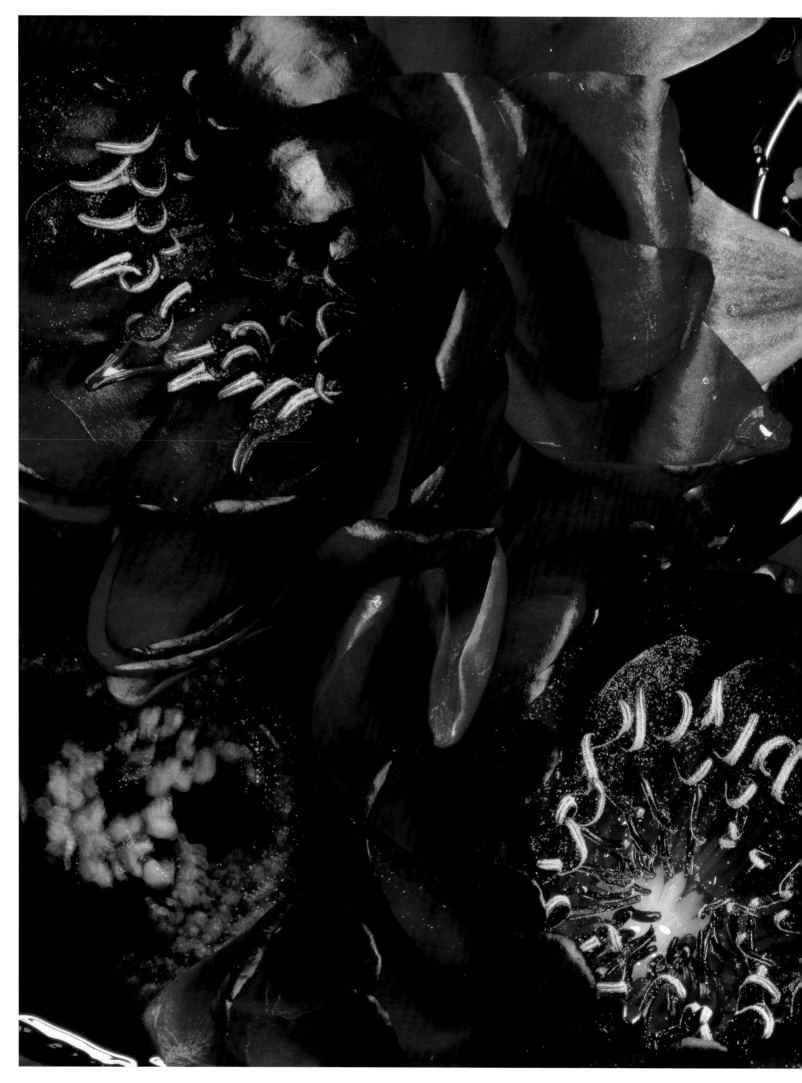

PLATE 63 *Aubergine Water Lilies with Swirling Algae, 2000*

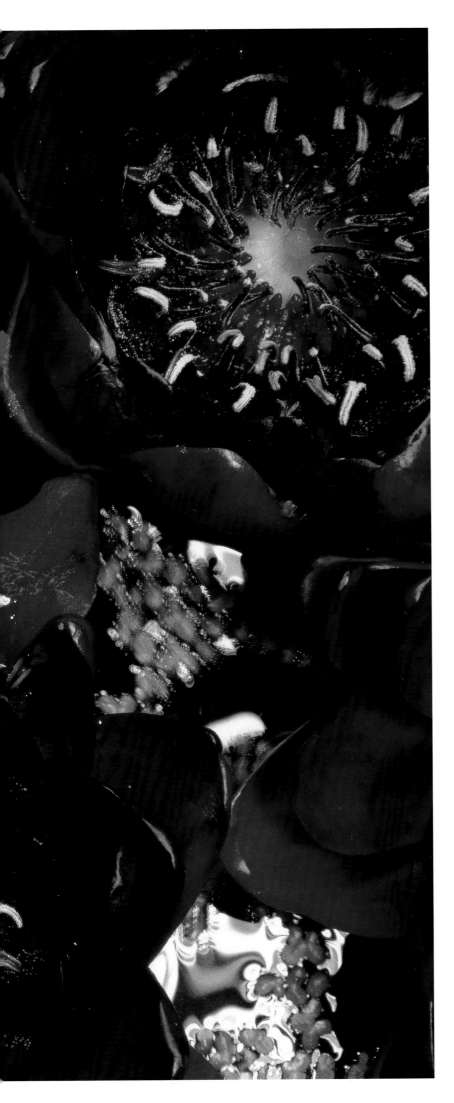

and used artificial light to create an eerie, almost nocturnal world, with shadowy forms and occasional highlights, the brightest of which is created by algae that live in the root system of the plants (see plate 63). The result is a form of camouflage. Certainly most people would find it hard to name the flowers without the benefit of the title.

The photograph lays the technical foundation for what became the Camouflage series. It required a leap of the imagination of the kind that distinguishes art from craft. Craft, which sticks to a template with little variation, requires ability but not necessarily something called talent. Talent is an innate gift and cannot be taught, only enhanced through training. In a great artist, talent becomes genius. Professional photographers who adhere to what they learned in school and never question underlying principles are craftsmen. Those who keep seeking out new possibilities without knowing in advance where they will lead are artists.

What finally ignited Beane's imagination was the tragedy of September 11, 2001. "After 9/11, artists were doing dark and depressing works," he notes. "I just wanted to do a 180." In doing so, he made an affirmative statement about life—one that would be a precursor to a later, and equally powerful, artistic statement made after compelling life circumstances. These photographs reflect the deeply felt human need not merely to survive but to make something worthwhile out of life, under even the bleakest circumstances.

Beane's Camouflage series reflects the conceptual inspiration of Andy Warhol's camouflage self-portraits and pop art painting in general, especially by those artists who used photographs to create dense, illusionistic paradoxes. There are several who come close to Beane, but it is the work of the artist Audrey Flack that comes to mind first. Her mature paintings were composed of numerous photographs, which she painstakingly assembled into still lifes that are filled with such a dense array of objects and so meticulously

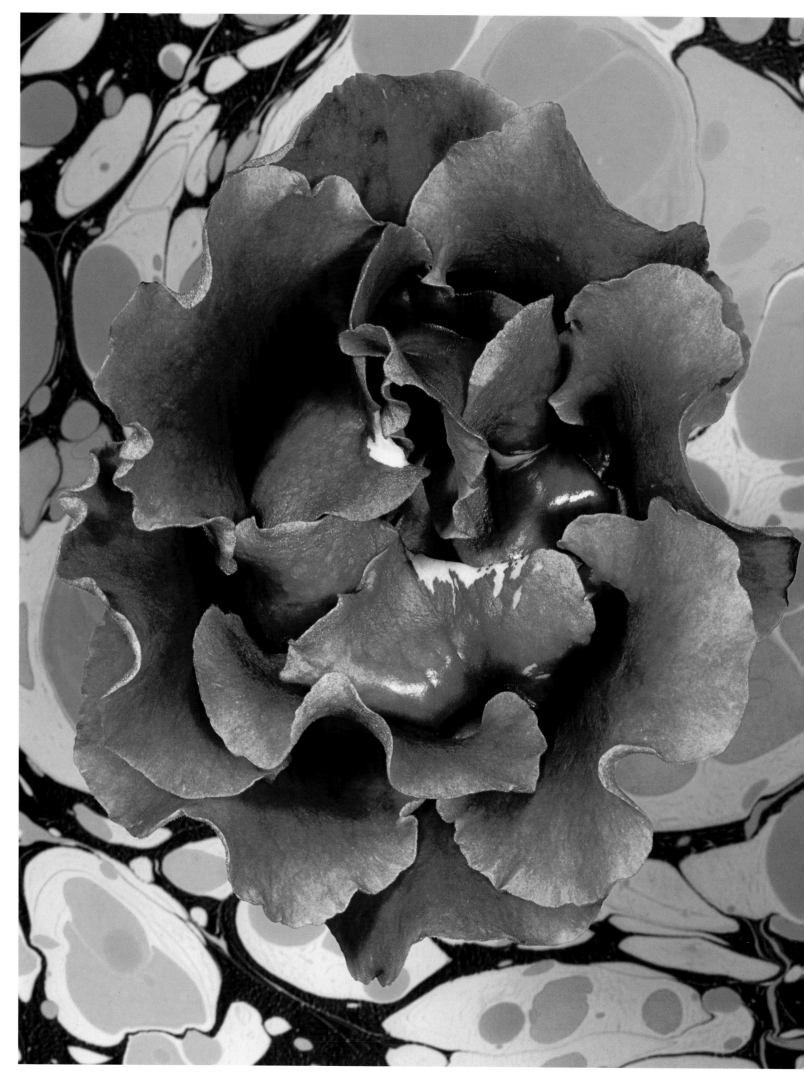

PLATE 64 *Double Gloxinia*, 2004

airbrushed with intense colors that they practically vibrate. They are, in effect, illusions within illusions, so that nothing is quite what it seems, and everything appears in the process of being swallowed up by the picture as a whole.

For the second time in his career, Beane was inspired by the art around him, without directly imitating it. Instead, he discovered how to paint with photography, using a technique of his own devising. Beane's leap of the imagination consisted of submerging marble-colored paper in water to serve as a background for flowers floating on the surface. It was a brilliant idea.

The existing Camouflage photographs were mostly done within a few months and follow no developmental sequence. Rather, there are two coexisting strands. The first makes little pretense at disguising the flowers against their colorful backgrounds. We see this in *Lavender Water Lily* (plate 62). The second strand develops the full potential of camouflage and more. In *Burgundy Passionflower* (plate 66), the flower has begun to merge with its rust-and-yellow background, while in *Double Gloxinia* (plate 64), the flower is almost indistinguishable from its marbled background.

Camouflage becomes outright transformation in the most advanced images. The mottled petals of orchids lend themselves perfectly to camouflage when placed against a background of appropriate colors and shapes. In *Oncidium Red, White, and Blue* (plate 69), we have real difficulty making out what manner of creature this is. It might be a creature

from the sea or a spider instead of an orchid. Confusion gives way to utter bewilderment in *Odontoglossum Milkyway* (plate 67) and *Odontoglossum Pink Spot* (plate 68). These two orchids grow at high elevations (7,000–10,000 feet) in Central and South America. They are among the largest of all orchids, as well as some of the most striking, because of their fleshy, speckled petals. They certainly appealed to Beane's imagination, which has shown a growing inclination for the unusual and the exotic to stimulate new ideas.

In this liquid environment, the large, spotted orchids look more like menacing sea urchins than like any kind of flower. Likewise, the prickly orange critter crawling along the bottom of what appears to be a stream turns out to be nothing more than a cactus flower (see plate 65). Equally harmless is the bizarre-looking "octopus," waving seemingly ominous tentacles, that floats nonchalantly by in *Bromeliad Sci-Fi* (plate 70). It is nothing more than a rather peculiar bromeliad, with its shallow root system visible at the bottom.

Other photographers have tried various forms of floral camouflage, either by packing flowers in such a dense arrangement that they lose their identity (for instance, in *Iceland Poppies* by Steve Lovi, 1988) or by placing a profusion of them against flowered wallpaper in a game of hide-and-seek, of which Don Worth's *Orchids and Caladiums, Mill Valley, California* (1984) is the classic example. But Beane's Camouflage series—from concept to photographic approach—is without precedent and remains unique.

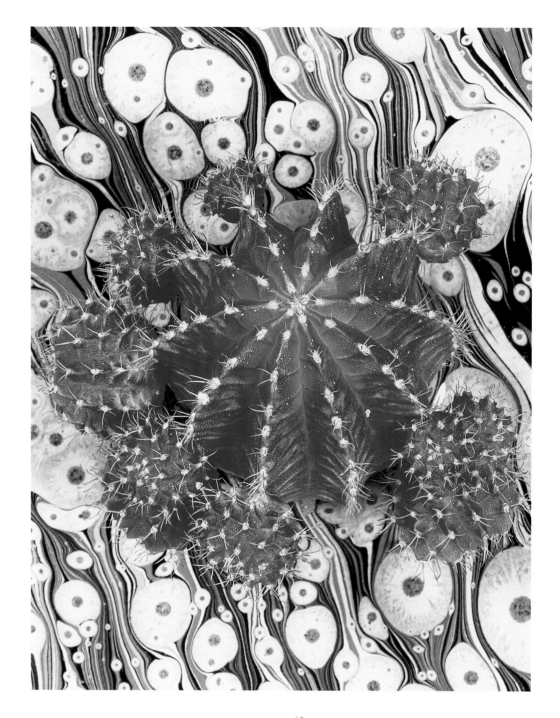

PLATE 65
Fluorescent Orange Cactus, 2003

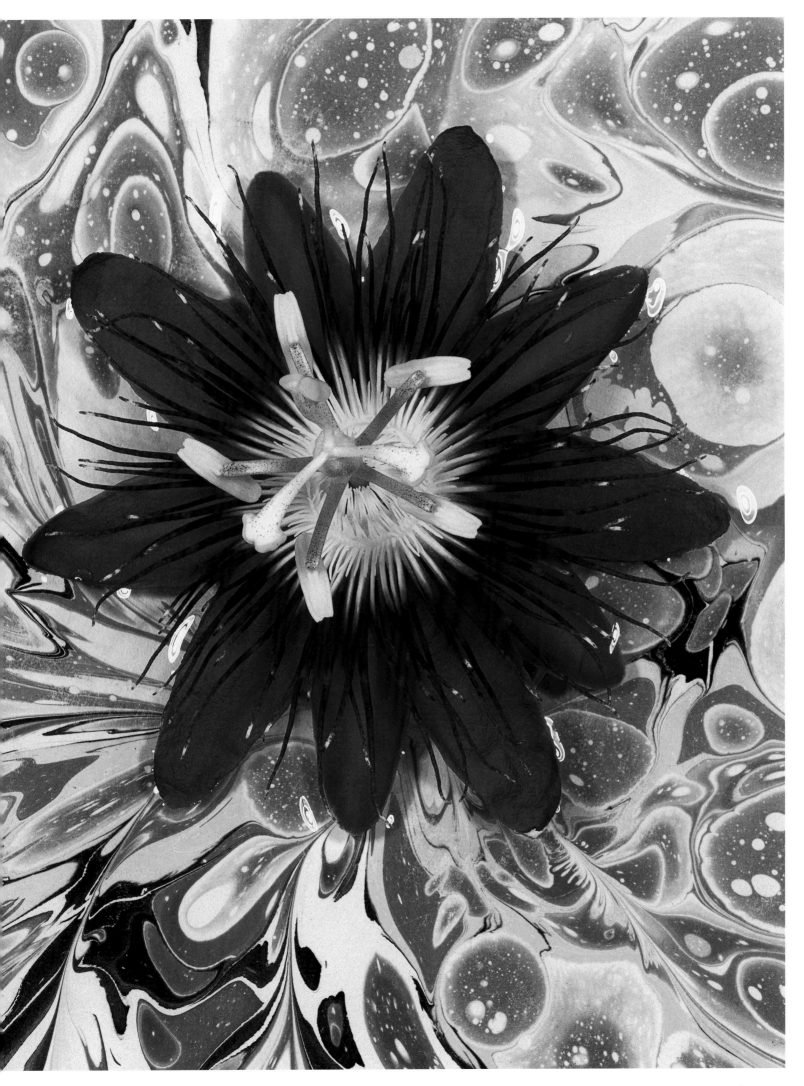

PLATE 66 *Burgundy Passionflower,* 2003

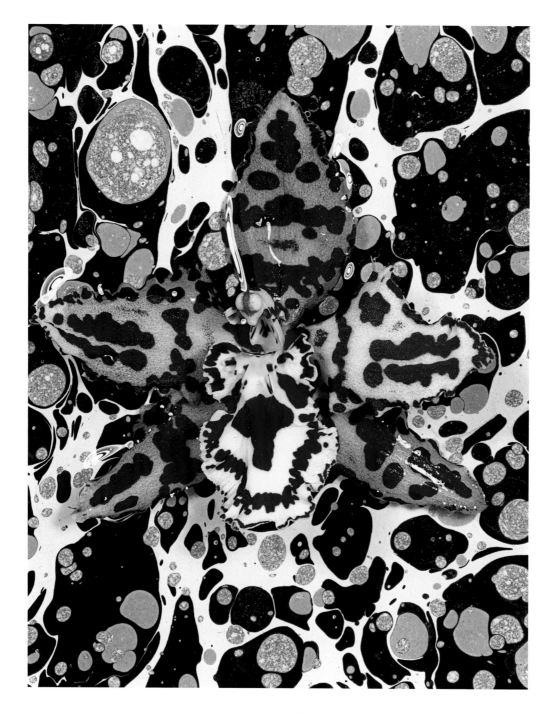

PLATE 67
Odontoglossum Milkyway, 2001

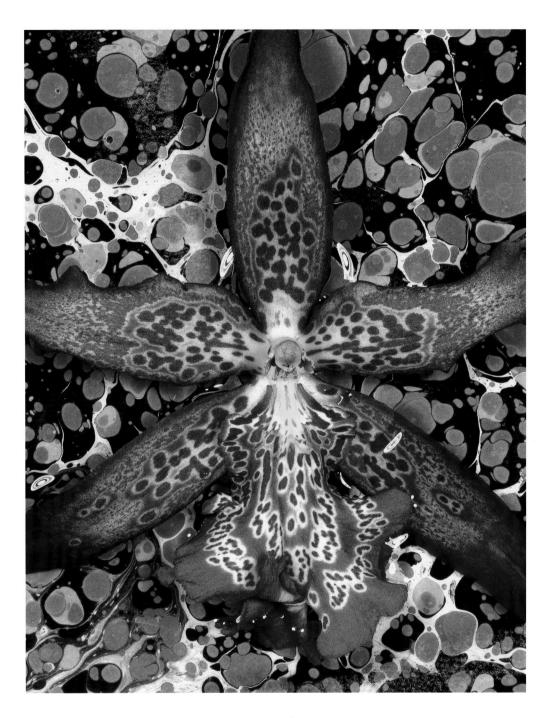

PLATE 68
Odontoglossum Pink Spot, 2001

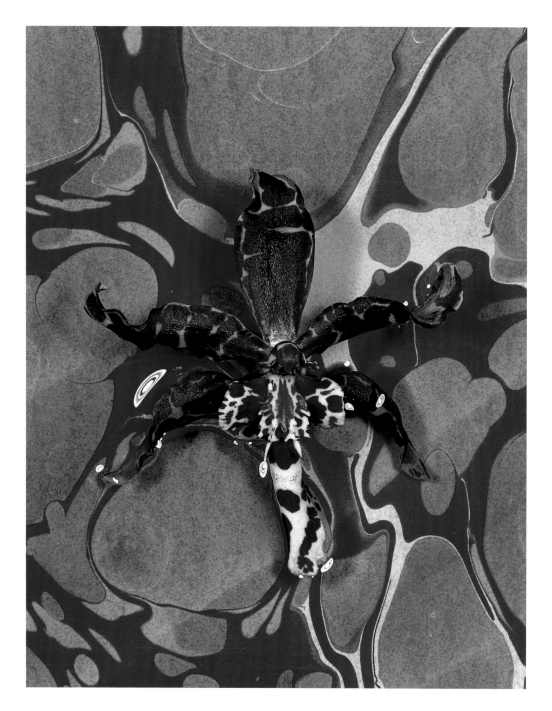

PLATE 69
Oncidium Red, White, and Blue, 2001

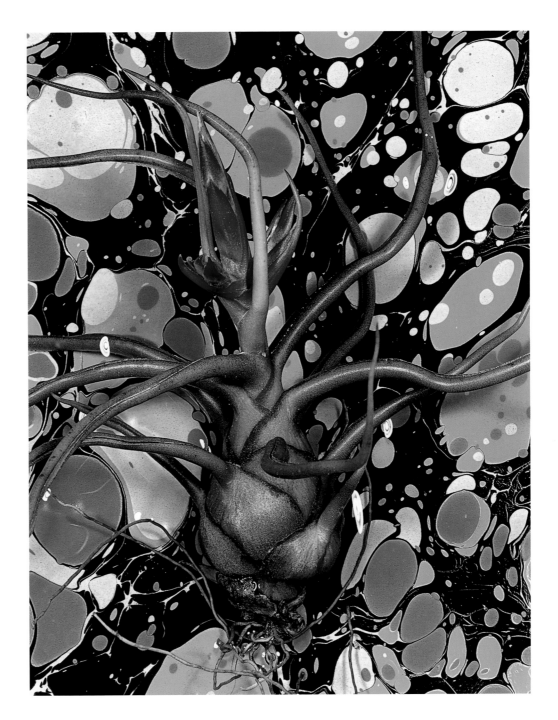

PLATE 70
Bromeliad Sci-Fi, 2001

THE RANUNCULUS

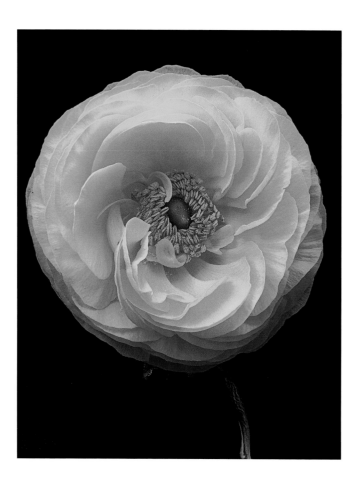

PLATE 71
Yellow Ranunculus with Stem, 1998

The old Alexander's department store in Manhattan was a favorite building of mine because its upper frieze was adorned with "Enamel Titties," one-of-a-kind sculptures made by English enamelist Stefan Knapp. Years ago, I managed to acquire four of these enamel globes at the flea market on Sixth Avenue. They'd been salvaged when Alexander's was torn down, and became my inspiration for Ranunculus Grid *(plate 75).—cb*

Surprisingly, Beane nearly abandoned the Camouflage photographs in early 2001, just when he had perfected them. At face value, this turn of events appears most unfortunate, for the Camouflages represent a defining moment in his career. Still, they were not appreciated at first and did not sell well, and it is not difficult to see why. They must have baffled most people. Despite their often colorful, decorative quality, they are the very antithesis of conventional flower photography. Consequently, Beane turned his main attention to photos of ranunculus.

Describing ranunculus in an interview, Beane said, "I was obsessed with them for months. They all have their own personalities. I must have photographed hundreds." He had photographed them as early as 1998 (such as *Yellow Ranunculus with Stem*), but the group from 2003 is by far his largest sample (see especially plates 73 and 74). Like that early example, they are among the most conservative photographs Beane has ever taken that I know of. He used the same lighting techniques and overhead view against a black background for each shot. Such black backgrounds have been traditional in European flower painting since the seventeenth century and especially during the eighteenth. In America, they became the norm around the middle of the nineteenth century, thanks largely to George Cochran Lambdin, whose work was widely reproduced by the chromolithographer Louis Prang. Interestingly, Beane's approach here is indebted to the photographic tradition Group f/64 spawned, against which he had otherwise so consistently rebelled. The formula ensures visual success, for it is ideally suited to capturing the formal beauty, elegant forms, luscious colors, and velvety textures of ranunculus.

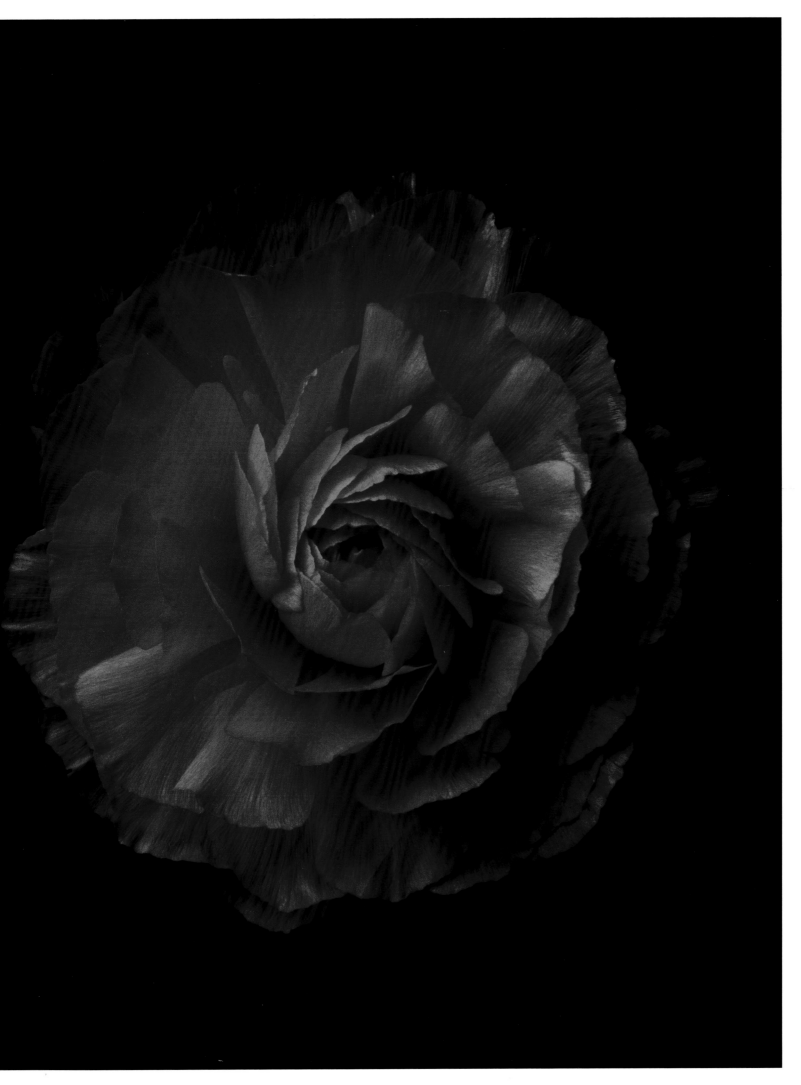

PLATE 72 *Ranunculus Fuchsia,* 2003

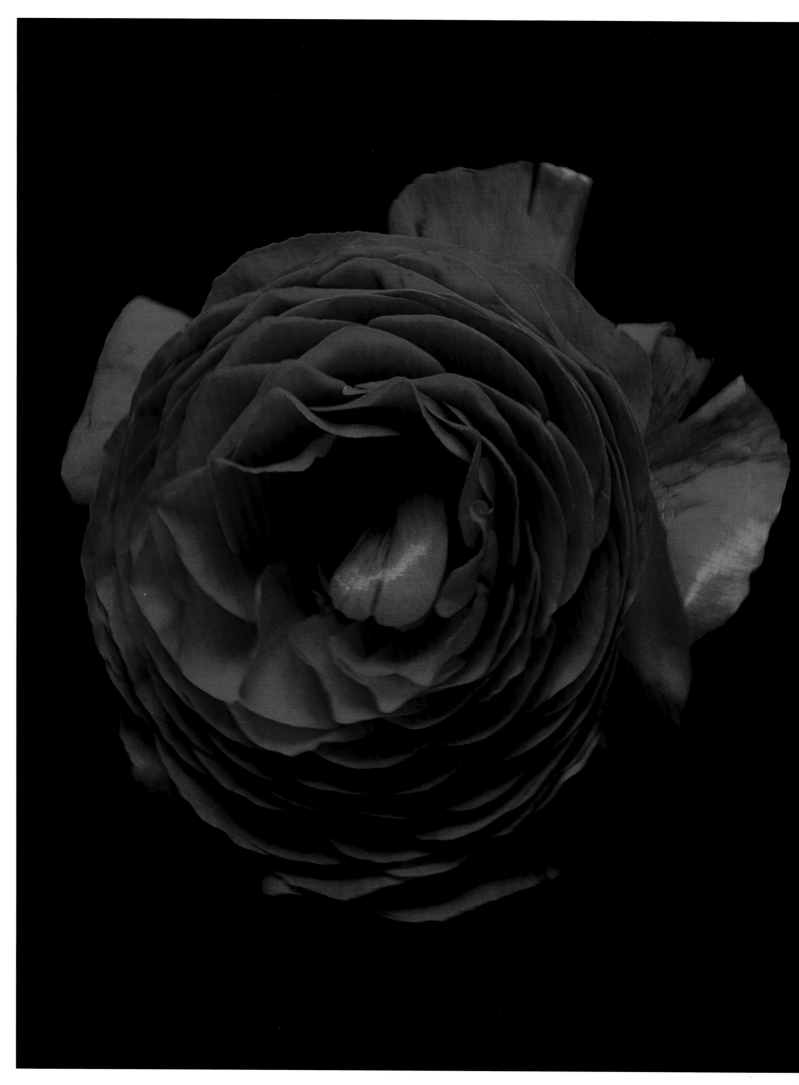

PLATE 73 *The Tongue,* 2003

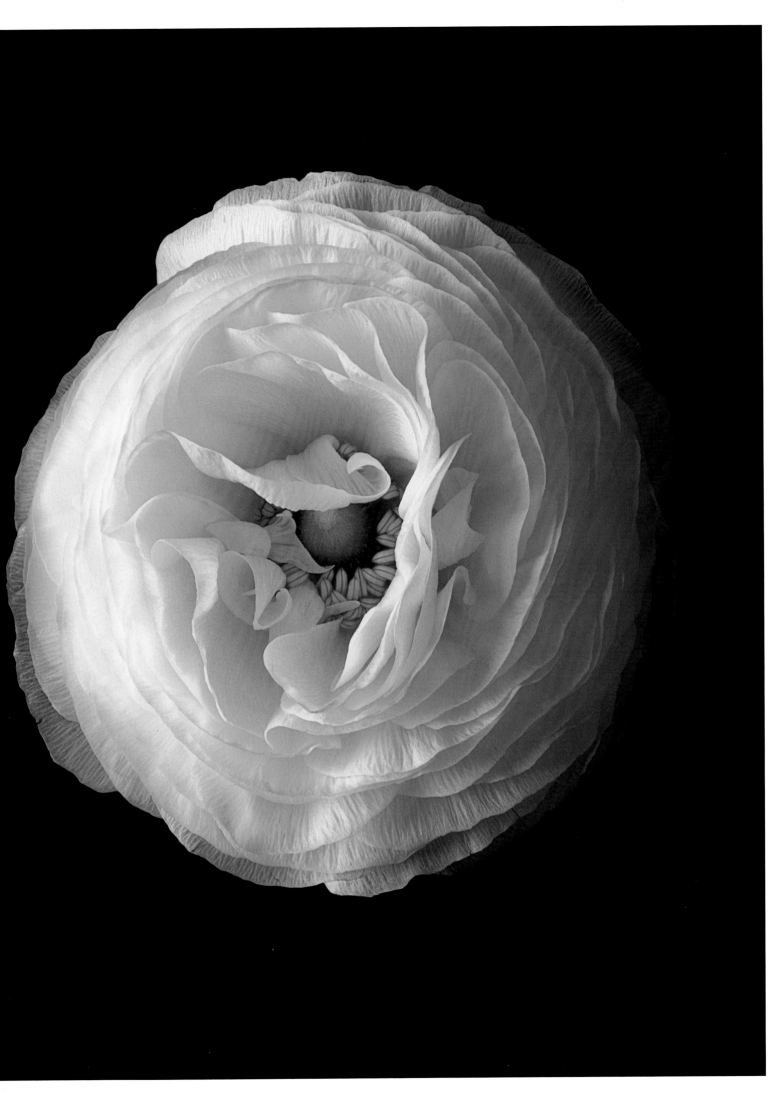

PLATE 74 *Ranunculus White*, 2003; Overleaf: PLATE 75 *Ranunculus Grid*, 1998–2003

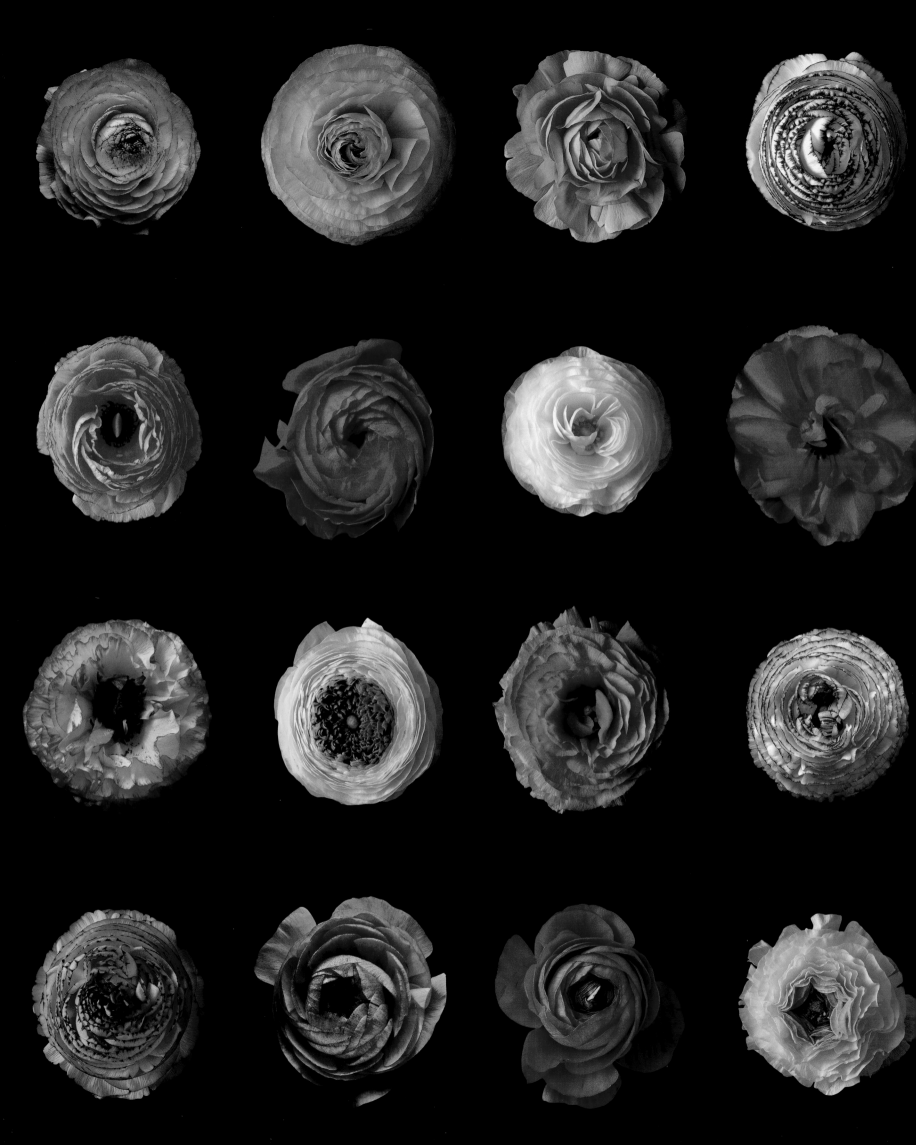

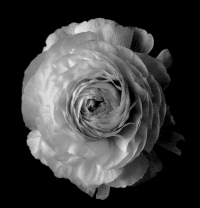
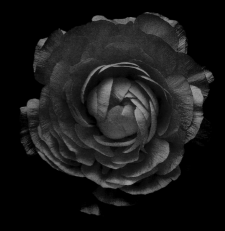
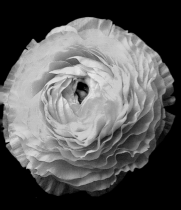
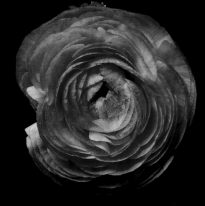
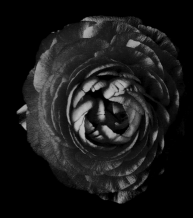
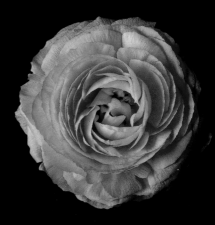
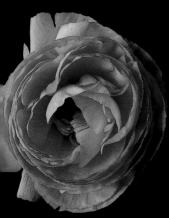
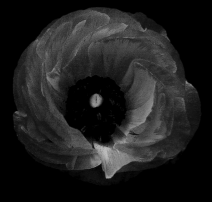
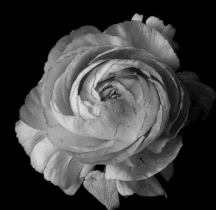
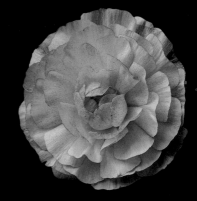
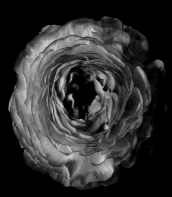
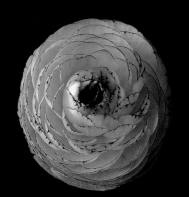
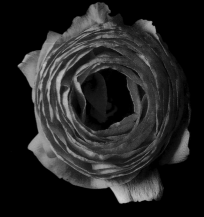
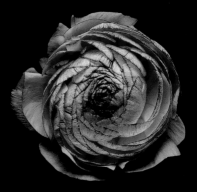

TUTTI FRUTTI

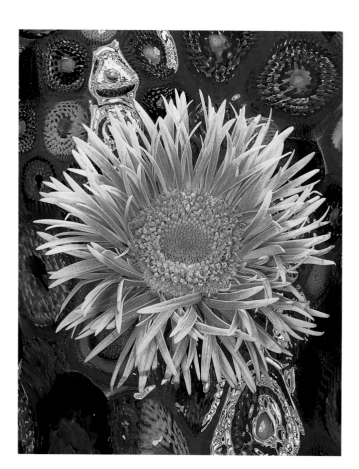

The Camouflages were eventually received more favorably, and as sales picked up Beane felt confident enough to make new ones. He also decided in late 2003 to undertake an entirely new series along the same lines but with a different kind of background: glass. Not just any kind of glass—specifically, Murano glass. Beane bought the glass at online auctions, 1960s and '70s ashtrays that no one wanted anymore. Though often regarded as rather cheap, even sleazy, this kind of glass, from an island off Venice, met Beane's needs perfectly. It is shiny, so it looks wet, and usually has melted colored globules floating like islands amid striated bands that recall miniature stained-glass windows.

Murano glass thus serves the same purpose as marbleized paper. Supposedly, it simplified the process of setting up and lighting his scenes. Beane had already experimented with it at least once, in a photo taken in 2002 of a gerber daisy on a Murano glass vase lighted from within. The result was very successful, and Beane had every reason to expect that the new series, called Tutti Frutti (after the Italian ice cream that is studded with pieces of dried fruit), would be as well. However, the process turned out to be far from easy.

Cineraria (opposite) is Beane's first attempt at defining the imagery in the Tutti Frutti series. It essentially takes the gloxinia from the Camouflages (see plate 64) as its point of departure, but the result is surprisingly flat. Clearly, the two series presented him with very different challenges. It was no simple matter to translate the effects from the submerged world of the Camouflages into the tabletop "glass stage" of the Tutti Fruttis. From *Cineraria,* it is readily apparent that Beane had many issues to settle about lighting and which flowers look best against which backgrounds.

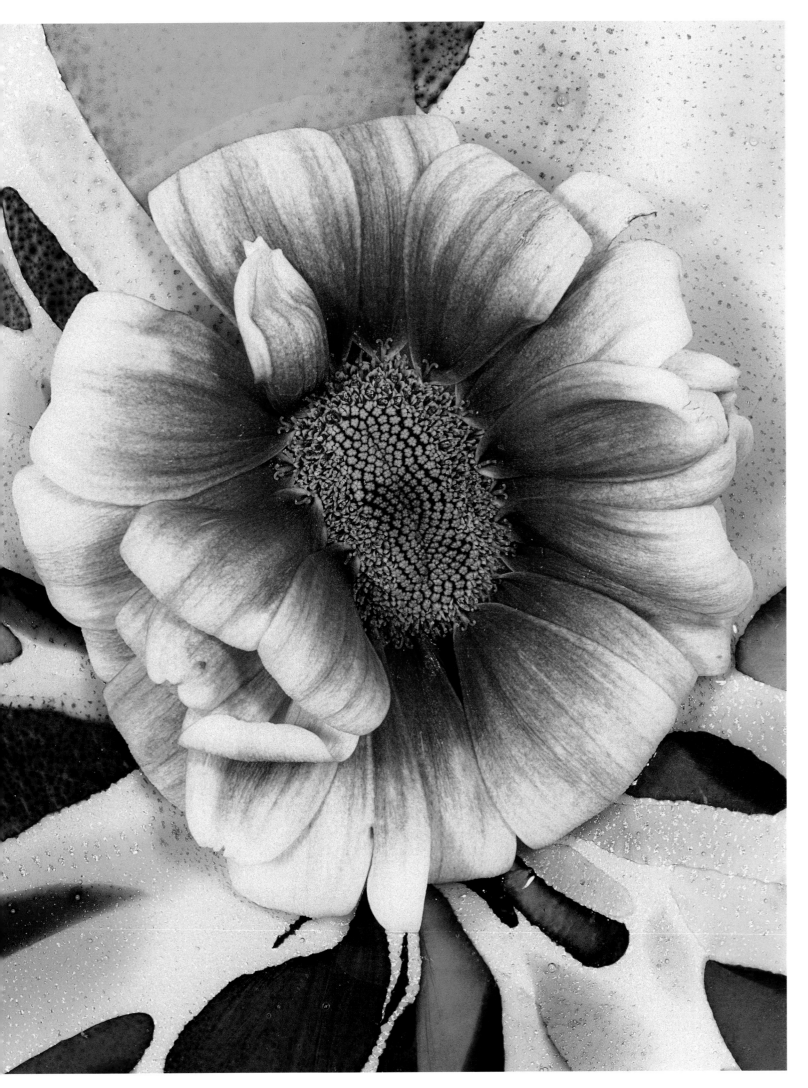

PLATE 77 *Cineraria,* 2003

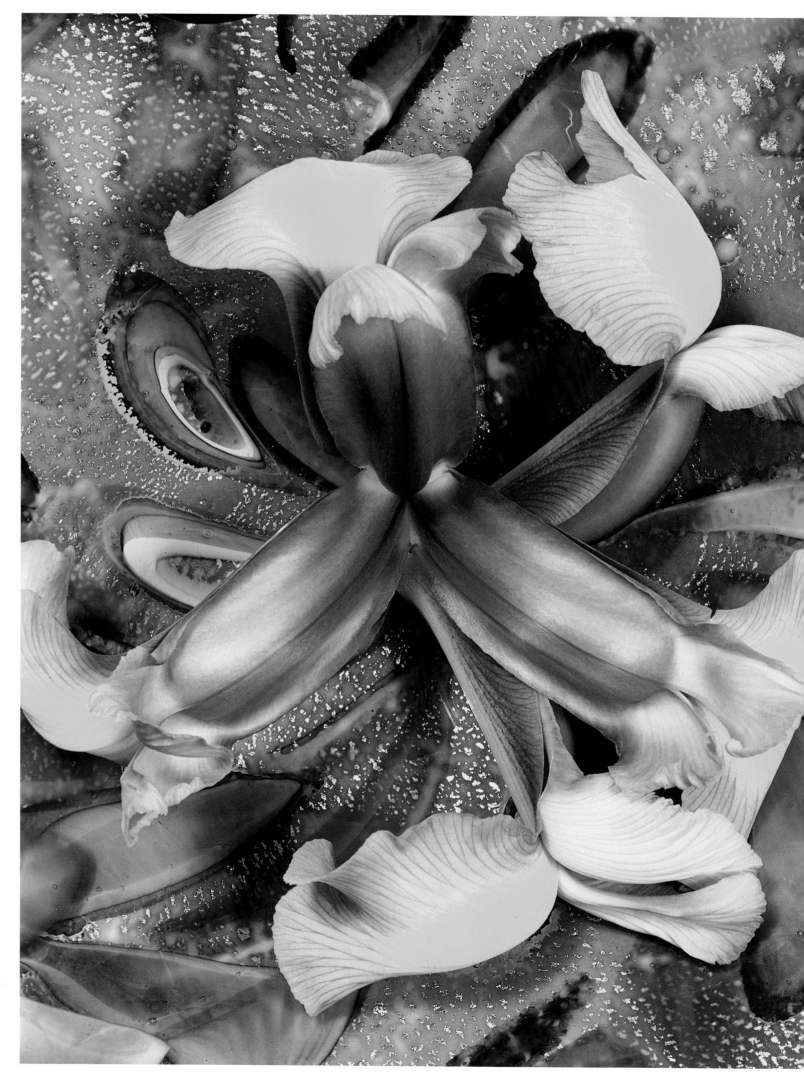

PLATE 78 *Siberian Iris,* 2004

The next two examples show Beane further exploring the possibilities of his Murano-made environment. Both show varieties of the phalaenopsis orchid, which is typically two to three inches wide. In *Chagall's Phalaenopsis* (plate 79), photographed directly from above, Beane makes a halfhearted attempt to camouflage the flower, which nevertheless stands out illusionistically from its background, for now the lighting is under better control (note the shadows). In *Phalaenopsis on Lace* (plate 80), the shot is taken at nearly ground level against a "lace glass" backdrop, so that the bloom appears to be growing in a fantasy landscape.

As in the Camouflage series, Beane turned to large orchids and similar flowers, not so much to disguise as to transform their true nature. In these works, background is carefully selected and becomes as variegated as possible. Beane also modified his approach to lighting. He supplemented his preference for natural daylight with artificial light, sometimes to light the glass from behind, at others to create highlights on the flowers. The effect ranges from the subtle to the dramatic. The net result of these changes is photographs that surpass even the finest of the Camouflages.

The difference between Beane's previous Tutti Frutti efforts and a pair of photographs of cattleya orchids (see plates 82 and 83) from 2004 is so vast that it is hard to believe they are by the same person. We have entered a new world. What was the magic ingredient that made such a metamorphosis possible? I believe it was the flowers themselves. As a photographer, Beane has been consistently inspired by plants, which have virtually dictated to his imagination the innovations necessary for their pictorial realization. For example, the two odontoglossums (see plates 67 and 68) brought the Camouflage series (and Beane's photography as a whole) to a new level of creativity.

When I was preparing the sections on modern photography for Janson's *History of Art,* I read every original document written by all the great photographers. The one thing they all shared was this kind of receptiveness, which allowed their subjects—human, animal, vegetal, or landscape—to shape, and often determine, the visual result. Each image was filtered through the artist's imagination, personality, and outlook, and bears the stamp of his individuality and unique style. That, after all, is what art is all about. But the photographers wrote eloquently about the inspiration received from favorite motifs as the lifeblood of their creativity.

I have in mind, as an example, Edward Weston's *Daybooks* from the summer of 1930, with its rapturous passages about photographing dozens of bell peppers, even after creating the perfect image on August 8th, which he saw as the culmination of a lifetime of experience that began twenty years before during his youth on a Michigan farm. No less ecstatic is his account of taking a spontaneous portrait of the Mexican painter José Orozco, on August 27th, under less than ideal conditions; yet the result, he noted, is "one of my finest portraits," because of, as he wrote earlier that year, the "coincidence of the sitter's revealment, the photographer's realization, [and] the camera's readiness."

Like most artists, Beane isn't much of a writer or spokesman for his work. His photographs speak for themselves. The two cattleya orchids are as powerful a testimony to the creative process that gave birth to them as Weston's photographs of bell peppers. Even without the *Daybooks,* we would recognize the inspiration the peppers gave rise to and the restless search for a "completely satisfying [image that] takes one beyond the world we know in the conscious mind . . . into an inner reality—the absolute—with a clear understanding, a mystic revelation . . . through one's intuitive self." We hardly need to question why certain orchids or the peony inspire Beane, any more than we would ask Weston why a pepper or a cabbage leaf inspired him.

Interestingly enough, about 1995, near the beginning of his career, Beane had taken a black-and-white photograph

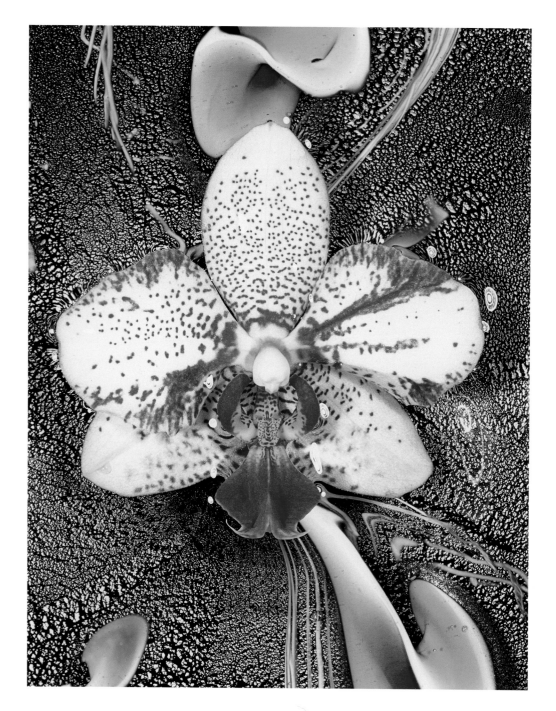

PLATE 79
Chagall's Phalaenopsis, 2004

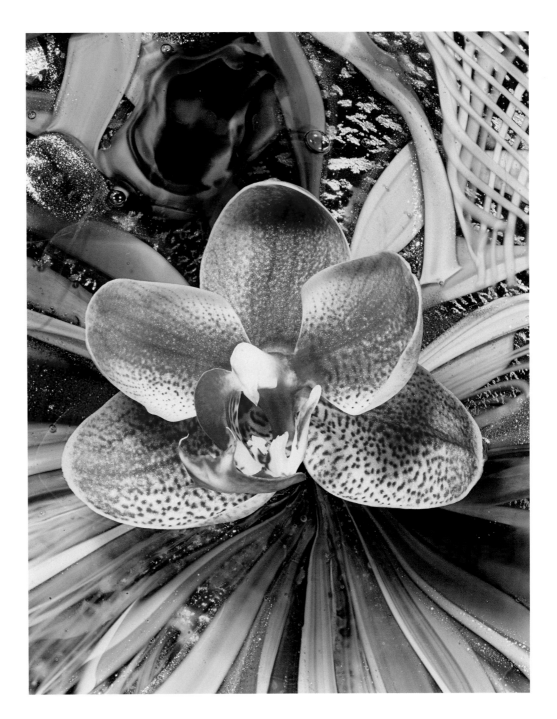

PLATE 80
Phalaenopsis on Lace, 2004

of an odontoglossum orchid against a paper background. By accident, a drop of water fell onto the paper and went unnoticed by him when he took the picture. But when he printed the image, the orchid looked like a huge spider that had managed to spit its venom onto the paper.

We have that same sense of menace, and more, in *Cattleya in Midnight Sky* (plate 83). The mysterious form, half submerged in the dark, almost subterranean background, suddenly becomes alarming because of the bright-yellow opening at its three-lobed lips. It seems to be lying in wait, ready to devour prey in an instant or inflict harm on an enemy that comes too near. Its companion in *Orange Cattleya* (plate 82) is just as fearsome. Supported by giant, powerful arms, it looks up at us with its Cyclopean "eye" through its huge, gaping mouth consisting of a single lip, as if assessing whether we are fit to be its next meal. The two are impressive enough on a page. Now imagine them forty or more inches high. Talk about a jolt!

Later that same year, Beane took his two finest single images (as distinguished from his multipartite panels, which are discussed at the end of this volume). The orchid in *Lady's Slipper* (plate 81) looks at first like a giant bumblebee that has just alighted near some flowers to gather pollen. With its turbanlike "head" and dotted yellow petals, this is certainly the most exotic of any lady's slipper I've ever seen. Here it seems huge. In reality, it is no more than a few inches across. Beane makes it appear larger than it is, not only by having it fill most of the image but also by surrounding it

with islands of floating glass embedded within the swirling sea of speckled glass.

Equally perfect is the photo of a Siberian iris (see plate 78), a hothouse cultivar from Holland. We would readily be forgiven for mistaking it for an orchid, for at first glance it looks very similar to the spiderlike *Oncidium Red, White, and Blue* (plate 69) from the Camouflages. Only the yellow fringes at the tips of the petals give it away. Whereas the orchid seems a little lost as it slowly creeps across the confusing background, the iris seems to have come fully to life. Beane has placed it against a piece of Murano glass that looks as if it were teeming with microorganisms caught in a headlong rush of swirling tidewater. With its arms and legs akimbo, the iris has become a willing partner in this dance of life, skimming as carefree as a water bug on the surface of a pond.

In both *Lady's Slipper* and *Siberian Iris*, the flowers are perfectly integrated into their settings, rather than being submerged in, camouflaged by, or standing out from them. In a sense, it is an ideal form of camouflage, in which the object becomes almost one with its environment. What renders them perfectly convincing in both visual and aesthetic terms is the lighting. These are masterly examples of the carefully controlled use of light to make forms on such a small scale seem fully three-dimensional, so that they appear to swell with life. Their surroundings receive just the right amount of light to reinforce this impression by creating an illusion of depth that looks much greater than it actually is, or ever could be.

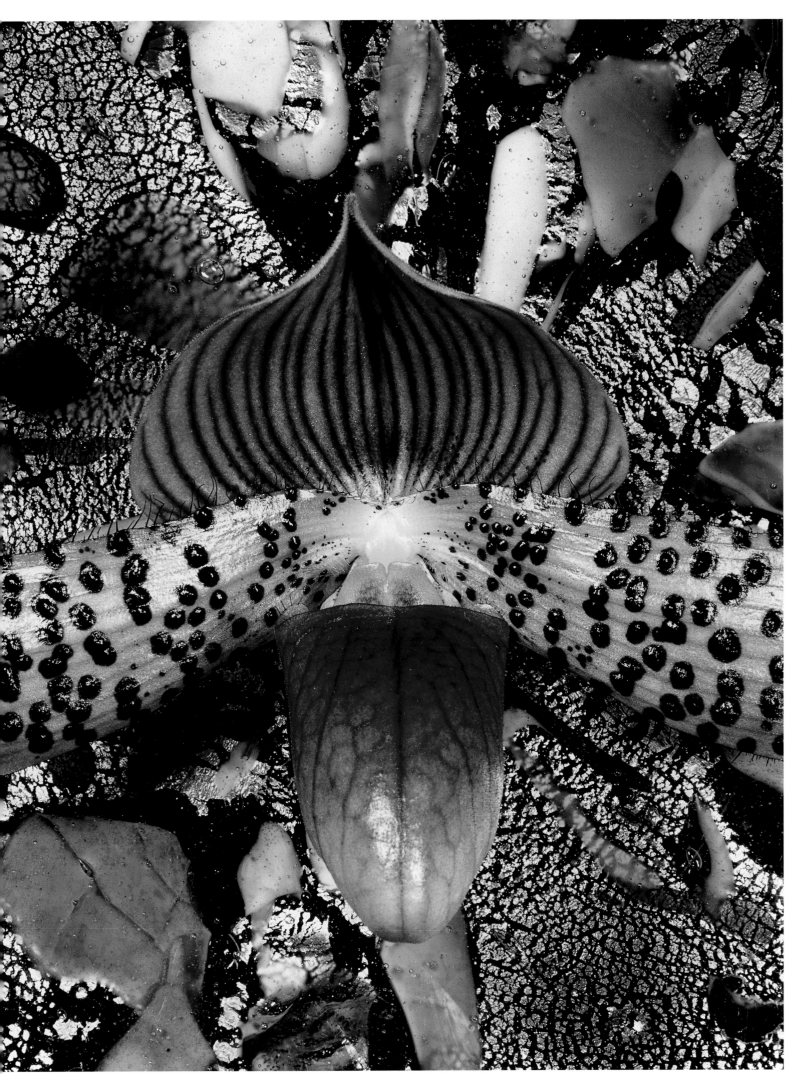

PLATE 81 *Lady's Slipper, 2004*

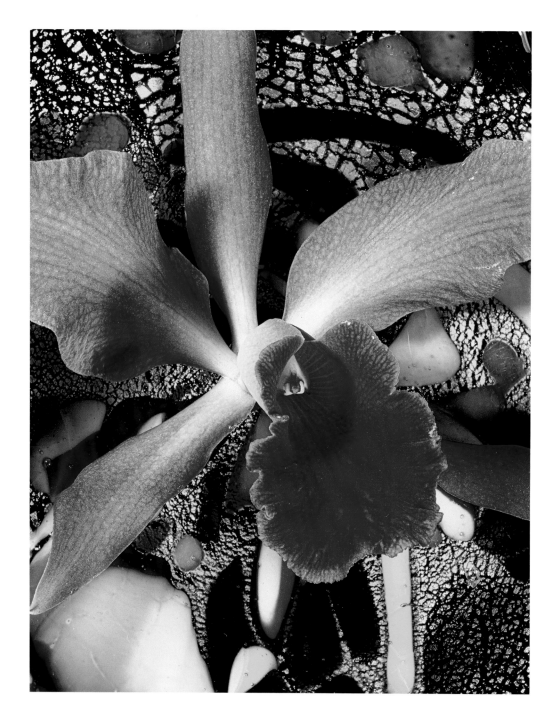

PLATE 82
Orange Cattleya, 2004

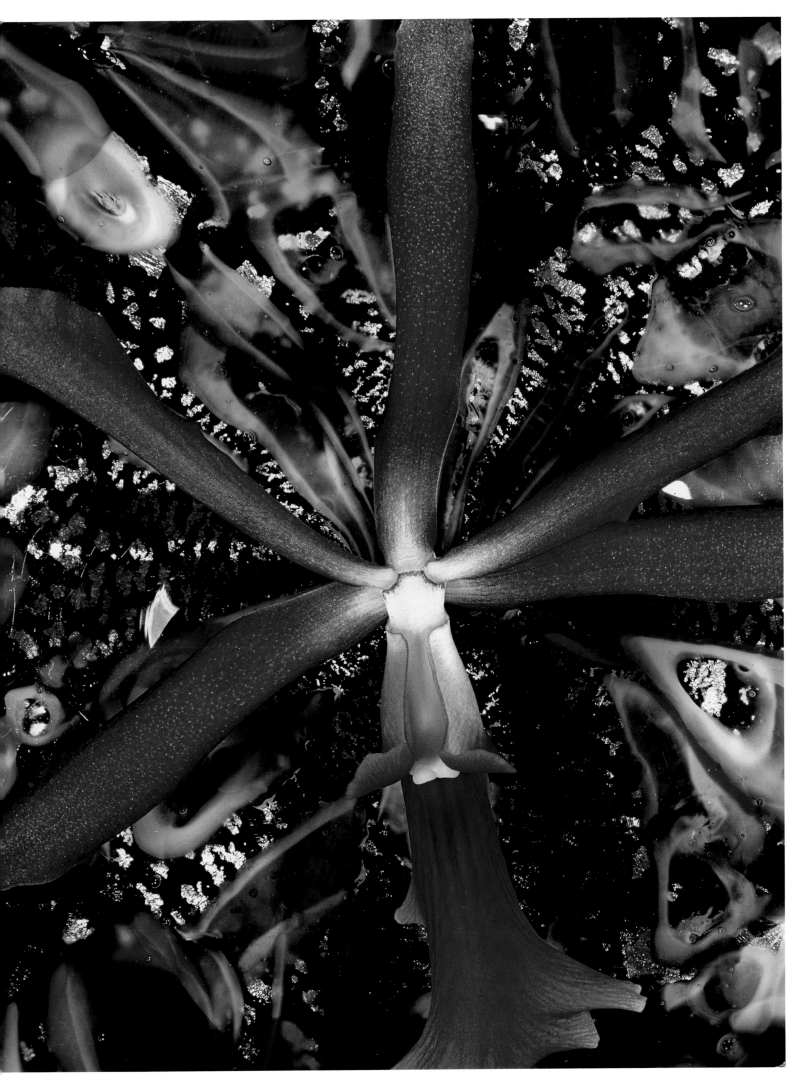

PLATE 83 *Cattleya in Midnight Sky,* 2004

WHY MUST THE BEAUTIFUL DIE?

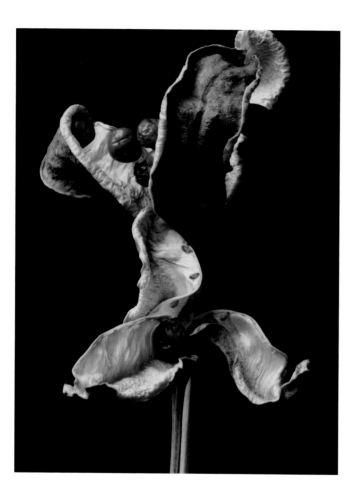

The title, taken from a famous lament, serves to remind us that plants, from the most humble to the most beautiful, are, like us, short-lived. Although this *vanitas* theme has been part of floral imagery from the beginning of flower painting in about 1600, it has acquired an especially widespread currency since the early twentieth century. In 2000, just as Beane reached maturity as a flower photographer, he developed an on-and-off fascination for dead plant forms.

The theme is found in several sections throughout this book. In *Air Swirls* (plate 86) Beane revisits in color his original black-and-white deconstruction (see plate 14). The color version is photographed through a blue filter and tied in knots far more complex than the "half-tied shoelaces" in his early Polaroid of two tree ferns in a vase (see plate 13). These plants hardly resemble leaves anymore. Instead, they recall intricate medieval metalwork that has rusted and been painted over. No less removed from our understanding of reality is the image of lacy bromeliads (see plate 109), seen in the cool light of morning, with meandering lines that recall the spontaneous drawings of Cy Twombly from the late 1950s and '60s.

The world of dead plants that Beane uncovers can be as hauntingly beautiful as it is repellent. The decaying brown tulip petals (see plate 90) and the dried sweet pea leaves (see plate 99), both from 2000, which have been injected with blue dye to show every vein, remind us of an ancient necropolis, or perhaps of the huddled victims of Mount Vesuvius buried beneath the lava and ash in Pompeii and Herculaneum.

An early example, from the late 1990s, of Beane's fascination with vegetation that has been petrified through freezing is a photograph of two frozen kale, which exists in

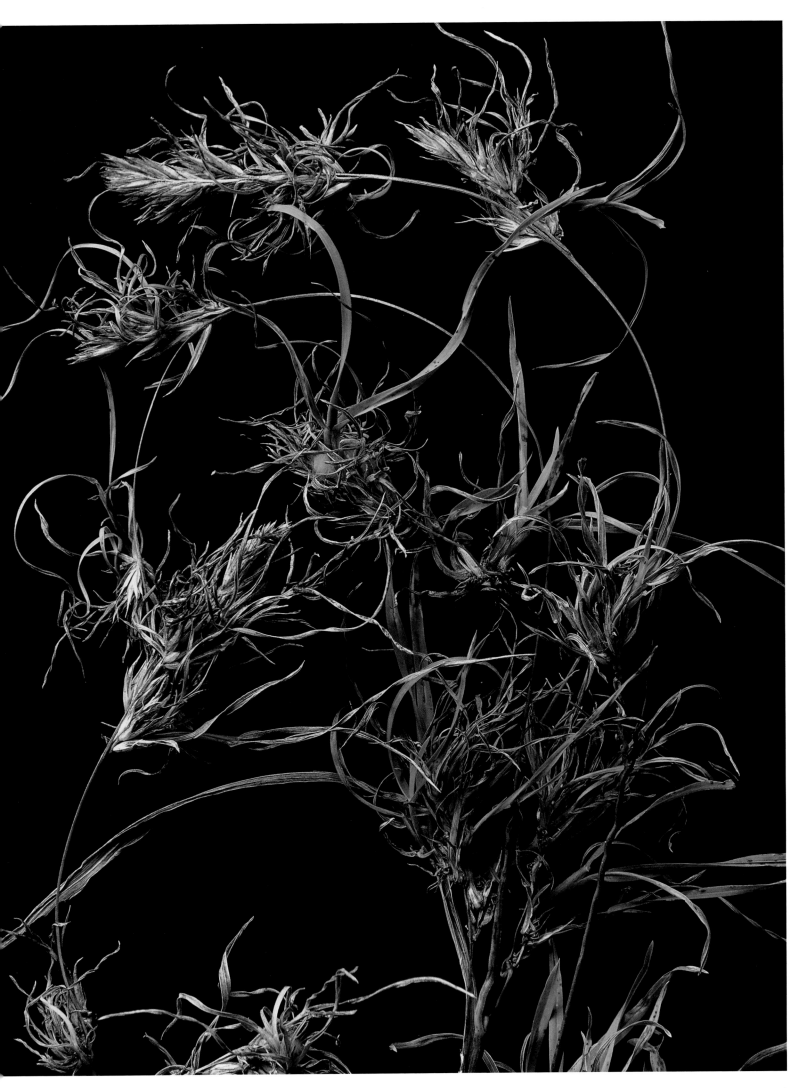

PLATE 85 *Spider Grass*, 2004

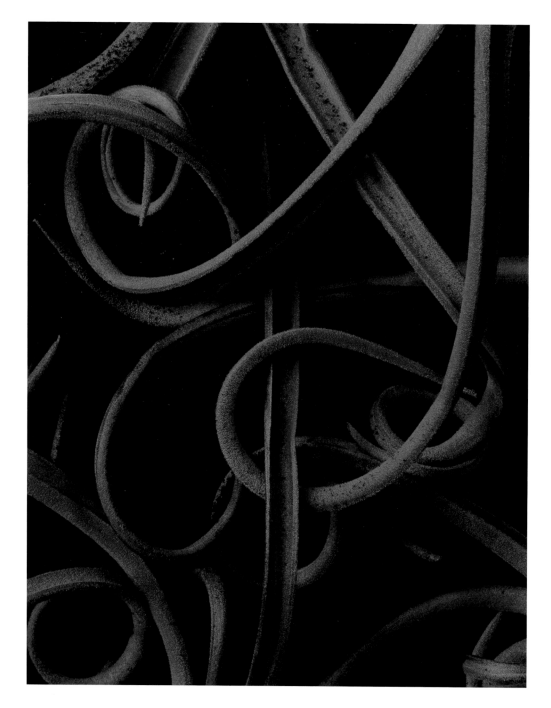

PLATE 86
Air Swirls, 2000

I saw these bromeliads for the first time when I was walking by Novelty Plants (known for just that) on 28th Street. Using very little light and giving the illusion of night with a cooling filter, I dissected the tentacles of the plants and recomposed them in black sand. When I got the film back, the effect was surprisingly magical.—cb

both color and black and white, titled *Kale after Frost* (plate 94). The two plants seem like mummies brought suddenly to life, visions to haunt our dreams in the dark of night. They possess the same supernatural quality as the "running" iris pod figure in *Iris Pod Black-and-White Study* (plate 84), which dates from about the same time. Two petrified cattails (plates 105 and 106) deformed by frost, look, respectively, like a cow's carcass and a plucked chicken being processed at a meatpacking plant. Or perhaps they are so hacked away and deformed that they recall the ghoulish remains in some of Francis Bacon's paintings.

In two photographs of decayed cotton bolls (see plates 97 and 98), Beane carries the theme of death to its ultimate conclusion: he creates gaping jaws to the mouth of hell, from which there can be no escape. These are tormented images of the kind that emerge only from deep within the human psyche. Like all the photographs discussed here, they leave an indelible impression on the viewer.

Within this icy world of death, Beane nevertheless manages to discover objects of great beauty. The windswept form of a dusty miller (see plate 87) is, in its own peculiar way, as graceful as Bernini's figure of Daphne turning into a tree to escape the amorous advances of the god Apollo. Several branches of pussy willow from 2002 (see plate 95) curve to form fingers like those of a violinist preparing to gently cradle the neck of his instrument. And two fantail pussy willows (see plate 96) remind us of the scroll end of violins—or perhaps some strange relic of medieval weaponry. At the same time, there is something oddly human about the bowed heads, gaping mouths, and horrified expressions of these plants caught in the throes of death.

We end with two flowers that have been stripped of their petals and nearly everything else. Their souls are laid bare, as it were, for only the hulls remain. A clematis (see plate 112) reveals the skeletal system common to most of the flowers in this book. Lost to the ravages of summer heat, attached, at one time, were the receptacle (at the top of the stem), the calyx (whorl of leaflike sepals), the corolla (whorl of petals), and the central boss of stamens (a few remnants of which can still be seen). To see what the flower might have looked like, compare it with *Zezé's Clematis* (plate 125), one of Beane's first color photographs from 1998. Unlike the recent radiographs and MRIs of flowers, which claim to reveal their inner structure but end up reducing them to wretched-looking pathology specimens, this bloomed clematis, though left naked to the elements, still stands defiantly (note the three remaining leaves), if barely—mute testimony to the indomitable will to survive in all nature.

The Chinese (or Japanese) lantern, found throughout Asia and in southern Europe, and given to Beane by chance in 2001, shows what remains of the rather large seed capsule (see plate 92). The mottled off-white and carmine-red covering has been devoured by insects, which could not penetrate the wiry "cage" enclosing the red seed itself. The effect is so enchanting that the popular name Chinese lantern is well deserved, particularly because of the shape. At the same time, this singularly beautiful object could just as easily pass as a fine example of the jeweler's art.

OPPOSITE: *To bring the night sky into my studio, I placed my favorite black suede shirt behind or beneath the flower (as with this dusty miller). I wore that shirt all the time. Finally it developed so many pollen stains that I could neither wear it nor use it to photograph.*—cb

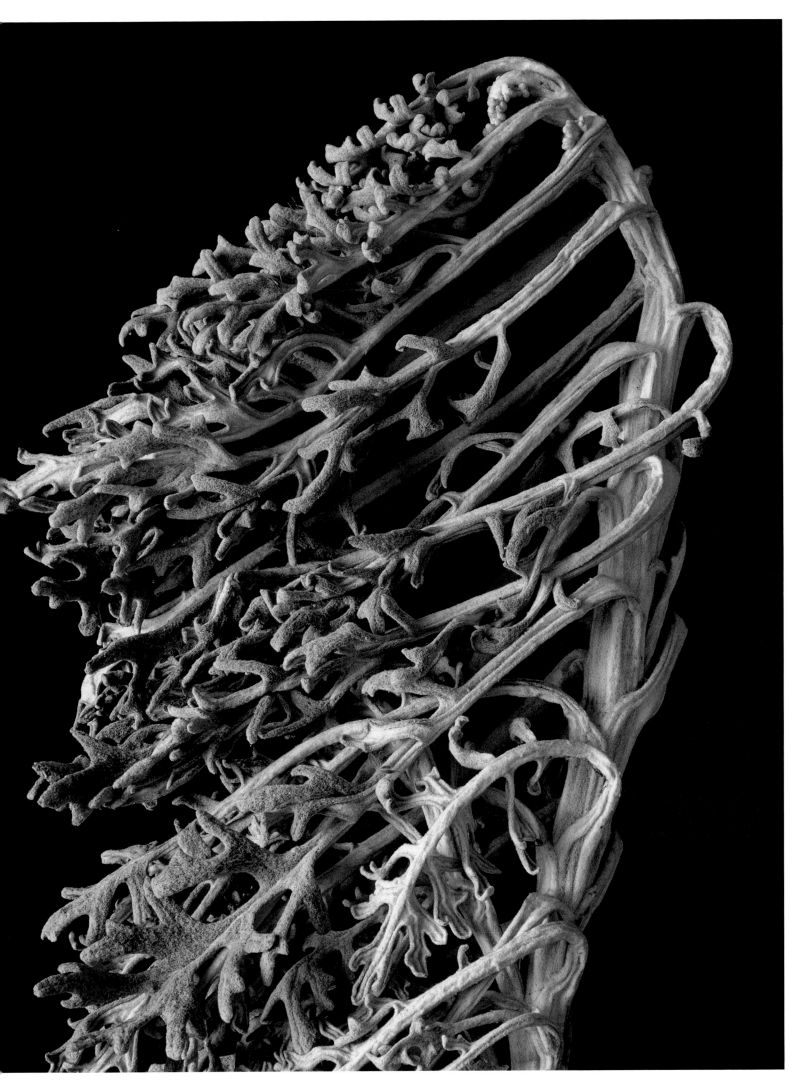

PLATE 87 *Dusty Miller after Winter Thaw*, 2002

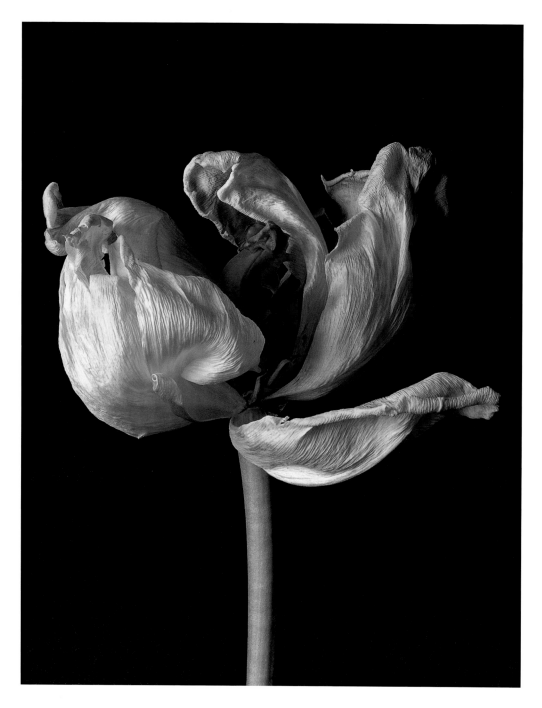

PLATE 88
Study of Dried Tulip #1, 2002

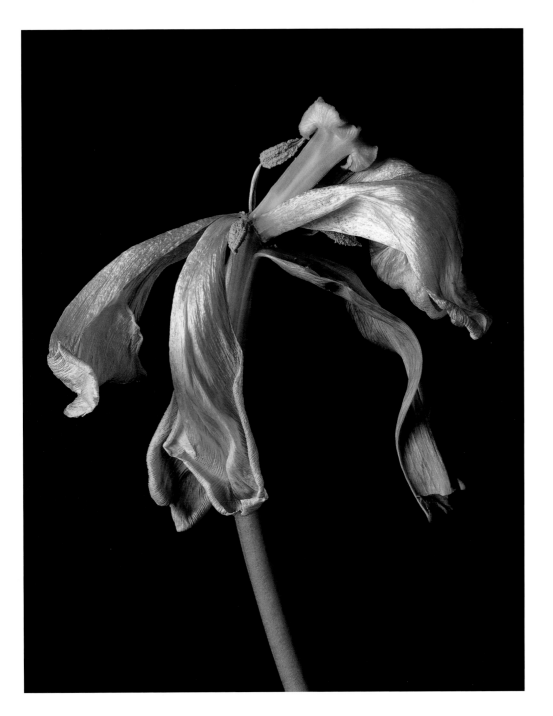

PLATE 89
Study of Dried Tulip #2, 2002

107

PLATE 90 *Orgy of Dried Tulip Petals,* 2000

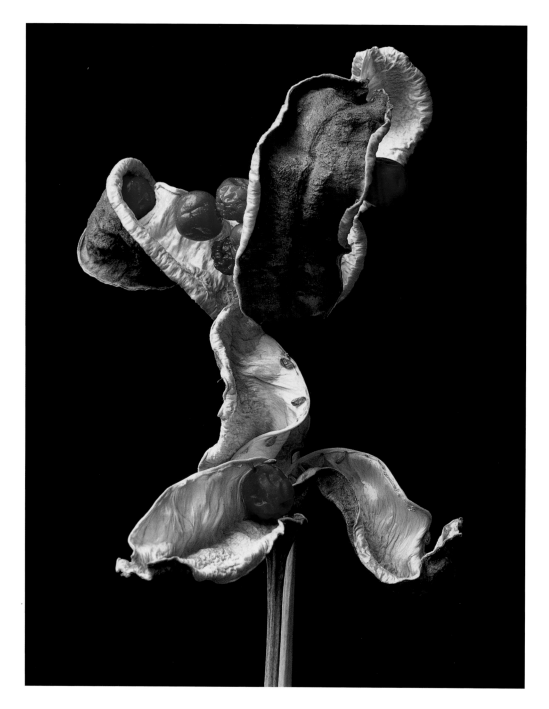

PLATE 91
Iris Pod Color Transition, 1998

My dermatologist turns out to be an avid gardener. He smuggled iris pod cuttings out of Virginia Woolf's garden in England and brought them back to cultivate in his Long Island garden. In turn, he brought me a stash of my own via the Long Island Rail Road.—cb

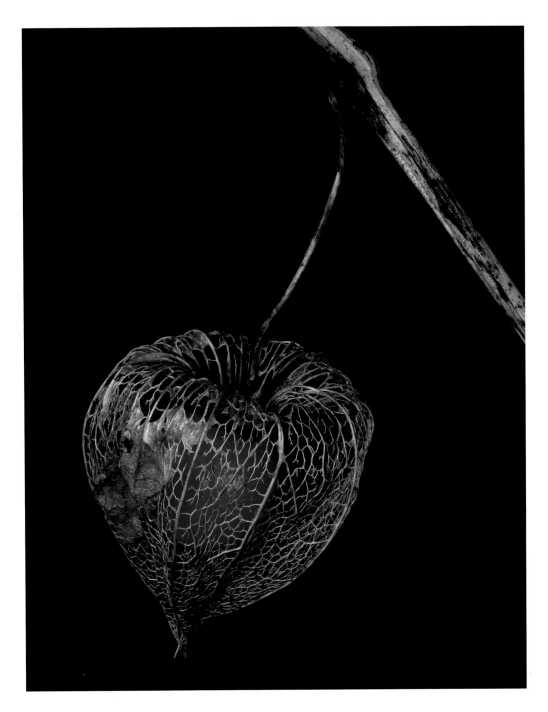

PLATE 92
Fabergé Egg, 2001

Connie Plaissay, a florist here in New York City, brought this object back from his Pennsylvania garden for me to photograph. Somehow an insect, in the process of eating the outer skin of the Chinese lantern, left this golden filigree intact. The stem was cut just before the frost, leaving the fruit unspoiled and protected within before the berry could wither.—cb

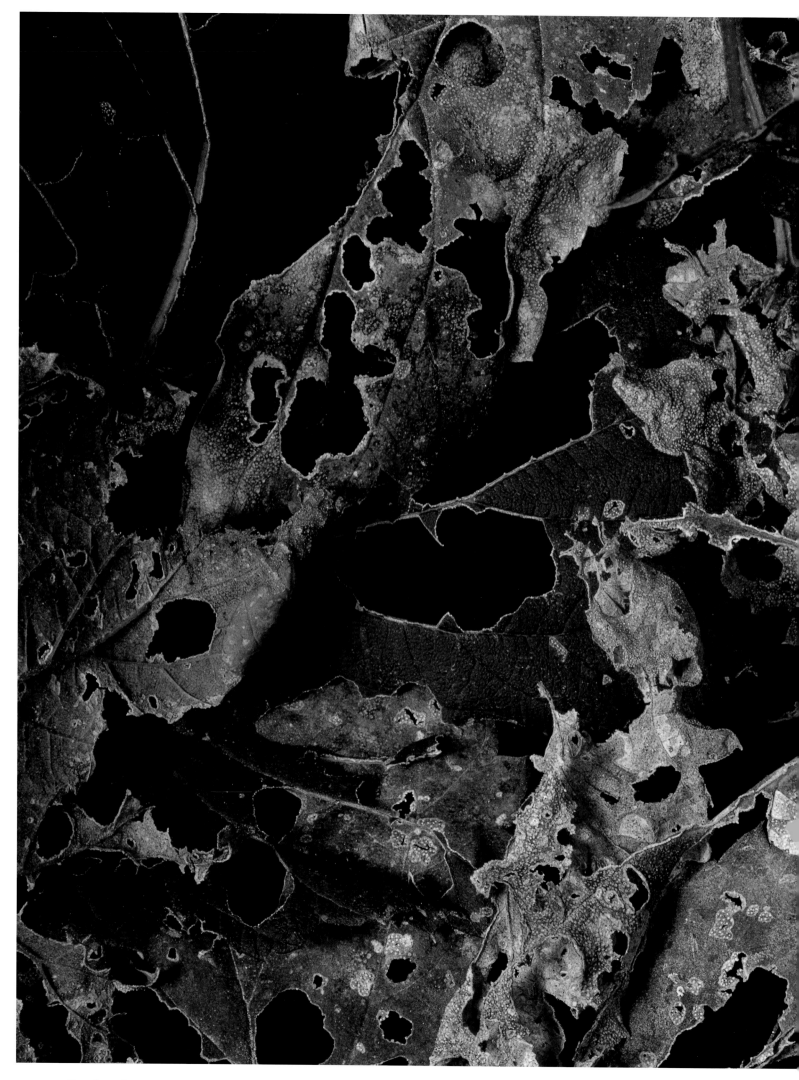

PLATE 93 *Hops Camouflage,* 2000

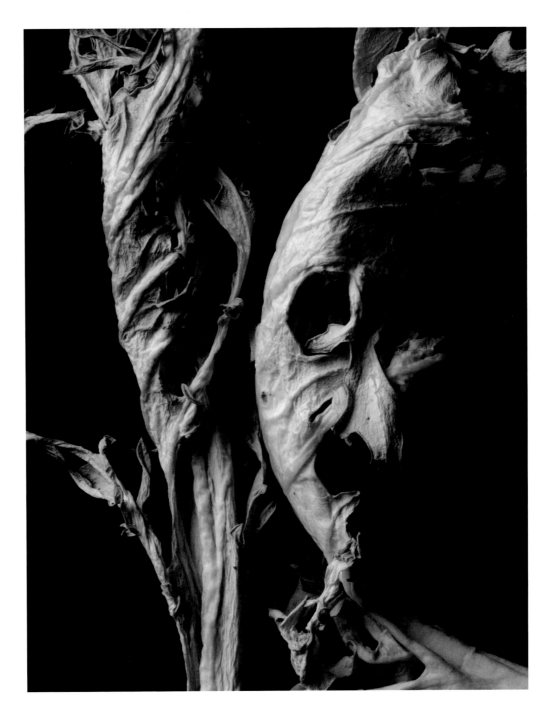

PLATE 94
Kale after Frost, 1998

In the fall, city people like to plant chrysanthemums and decorative kale in the small plots of soil lining the sidewalks. Amid the frost and rains, this kale caught my attention.—cb

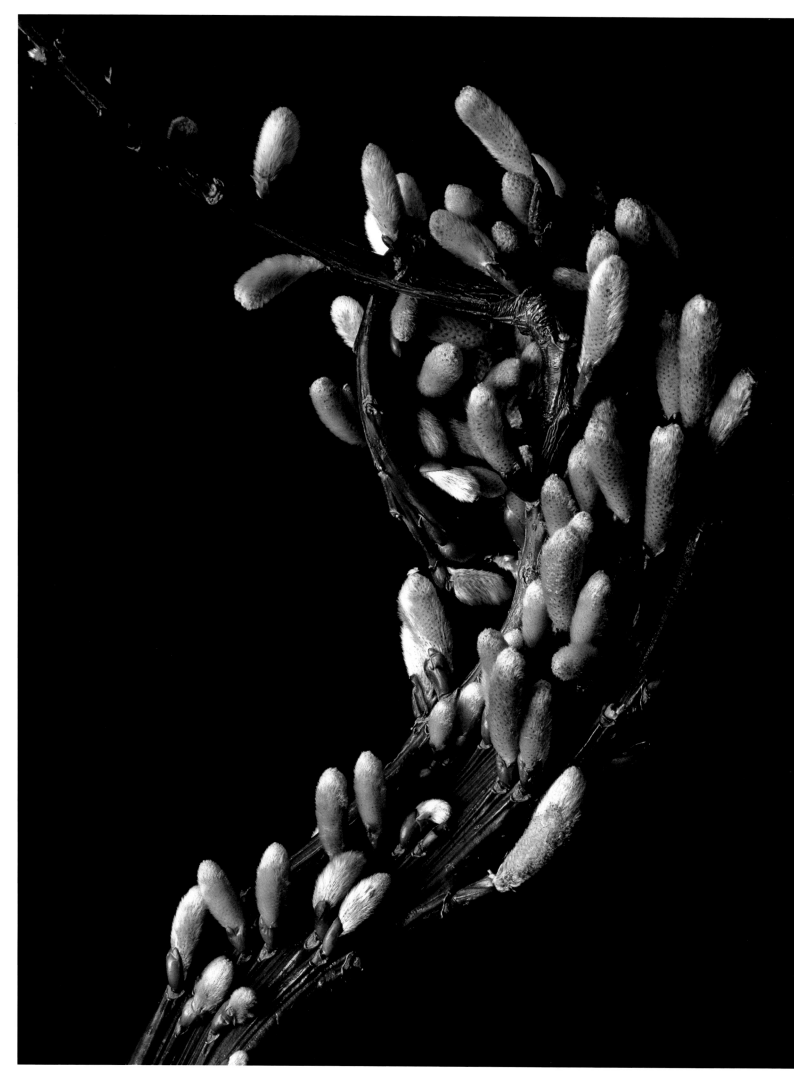

PLATE 95 *Deformed Pussy Willow*, 2002

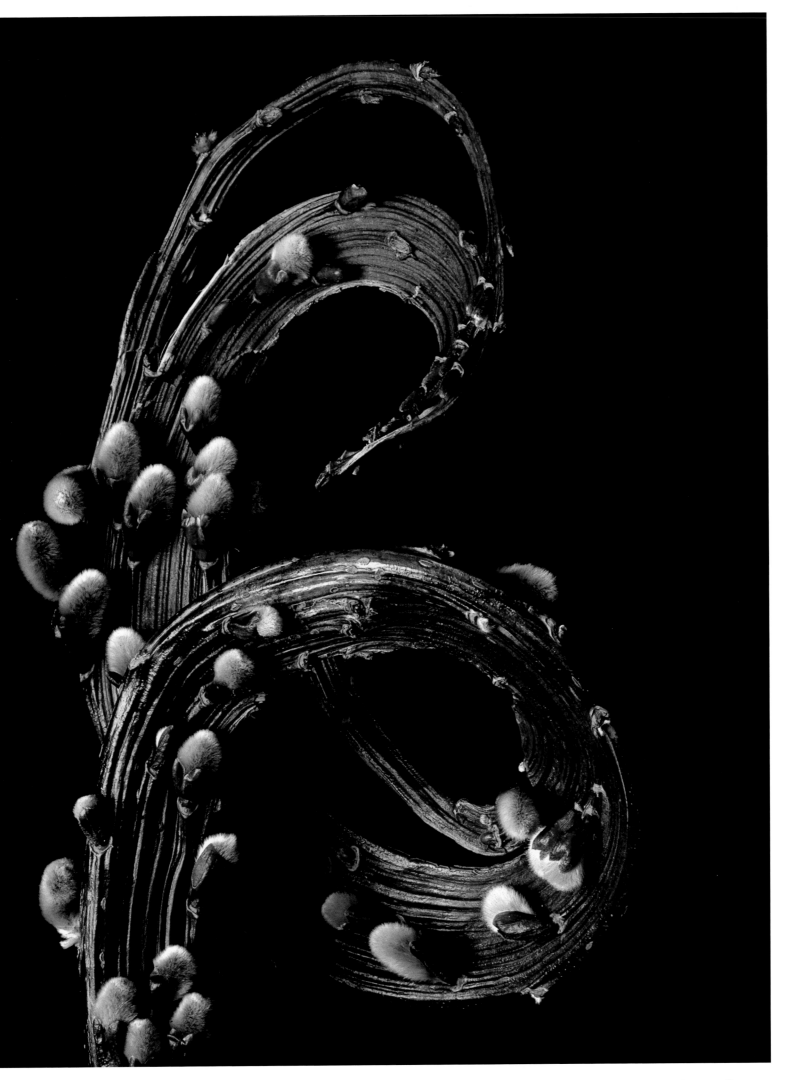

PLATE 96 *Deformed Pussy Willow*, 2002

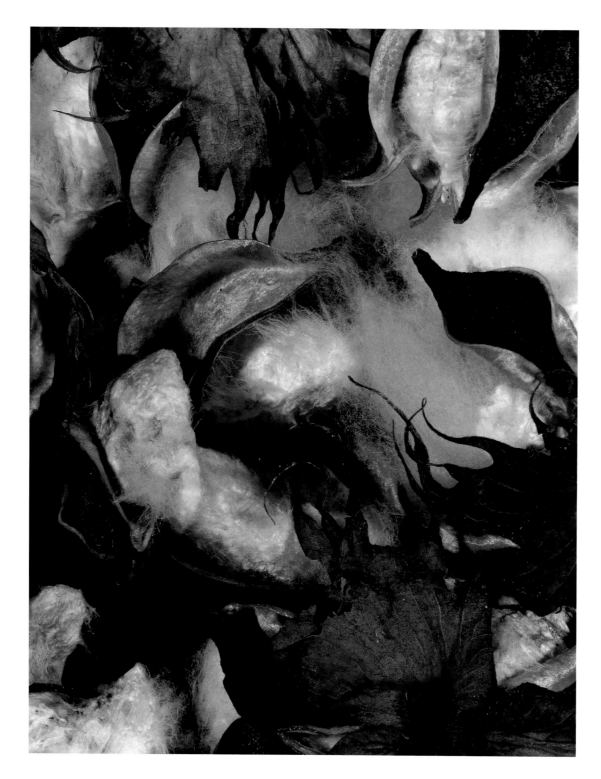

PLATE 97
Baby's Cotton #1, 2000

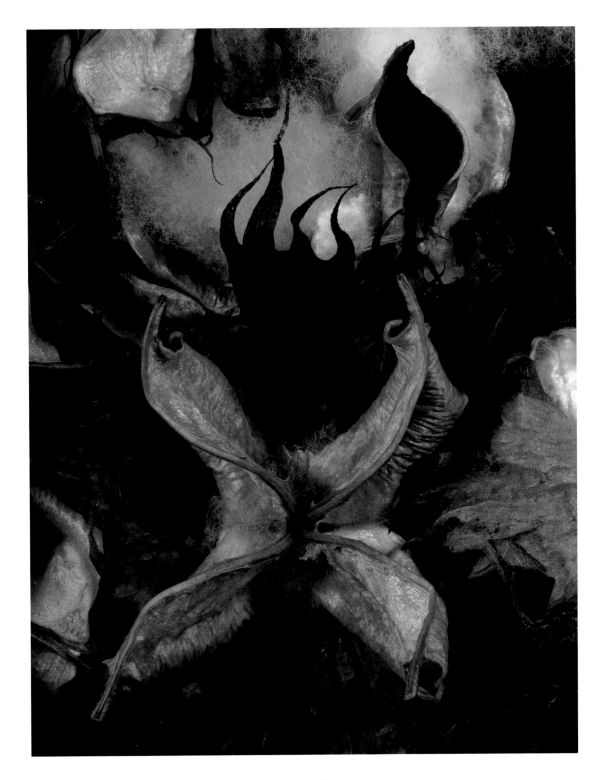

PLATE 98
Baby's Cotton #2, 2000

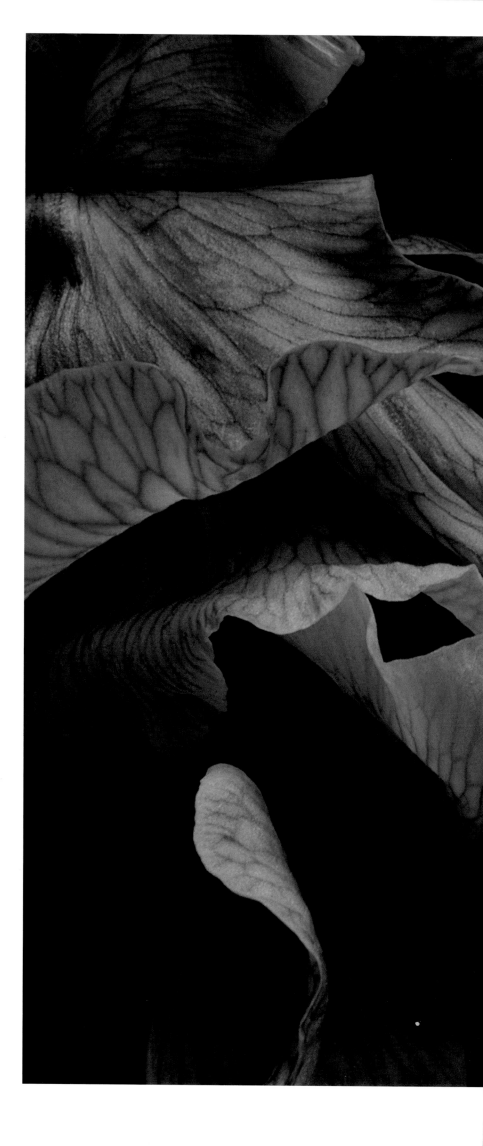

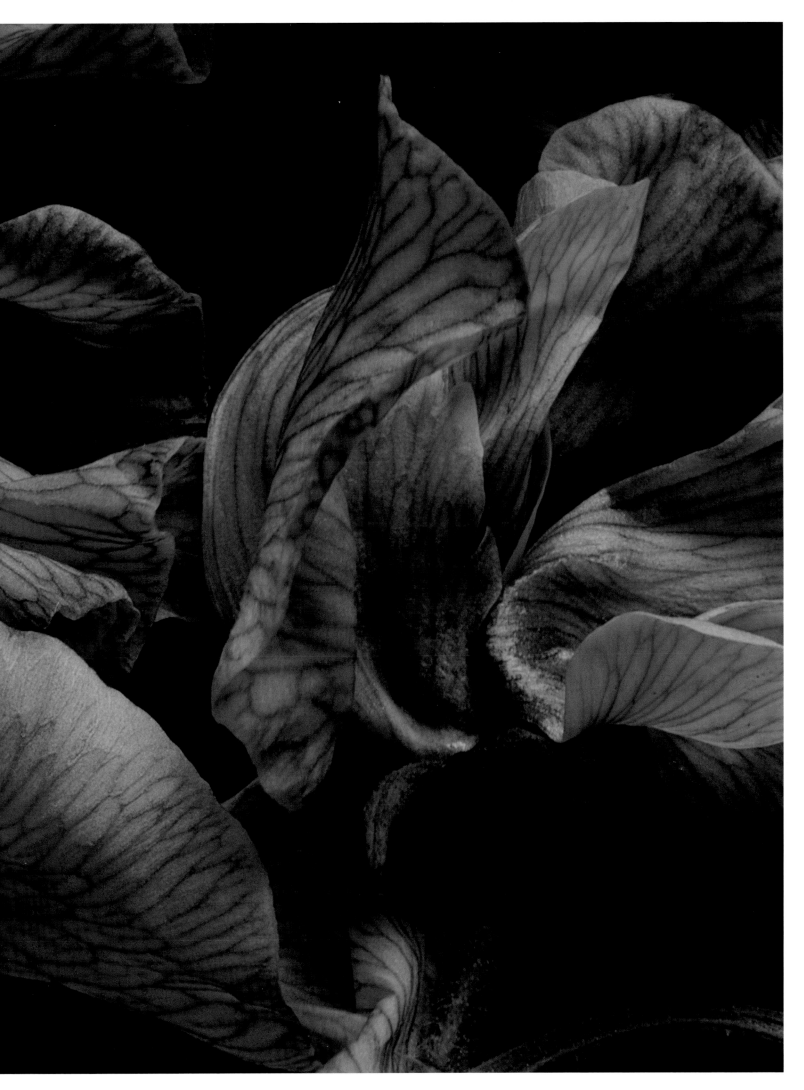

PLATE 99 *Dye-Injected Sweet Peas,* 2000

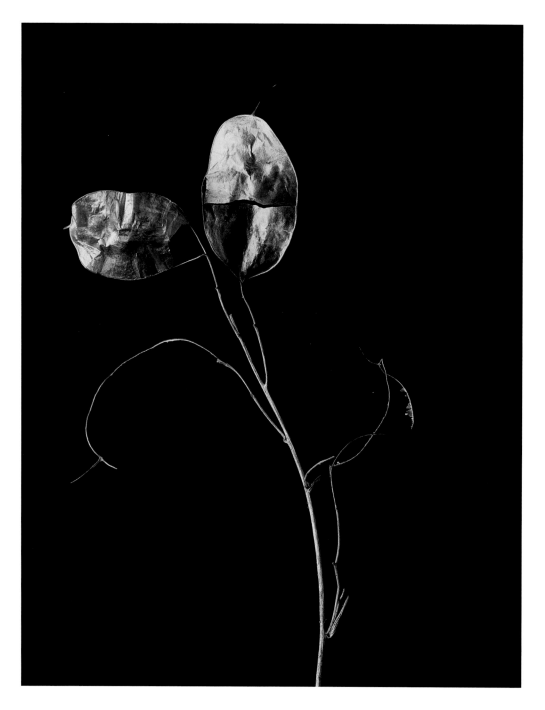

PLATE 100
Luneria #3, 2002

OPPOSITE: *In 2004 I was lucky enough to spend the month of August photographing on a ninety-acre property in Connecticut, which had a modest farmhouse on its grounds. The open farmhouse door was my light source, and the surroundings my subjects. Every morning walk led to a new photographic discovery. At dusk one day, I happened across a typical domed mushroom, white in color. Since light was too low for me to photograph, I took the mushroom, ball root and all, and placed it in a glass of water. The next morning, to my amazement, the mushroom had bloomed wide open, letting me capture it in all its perfection.—cb*

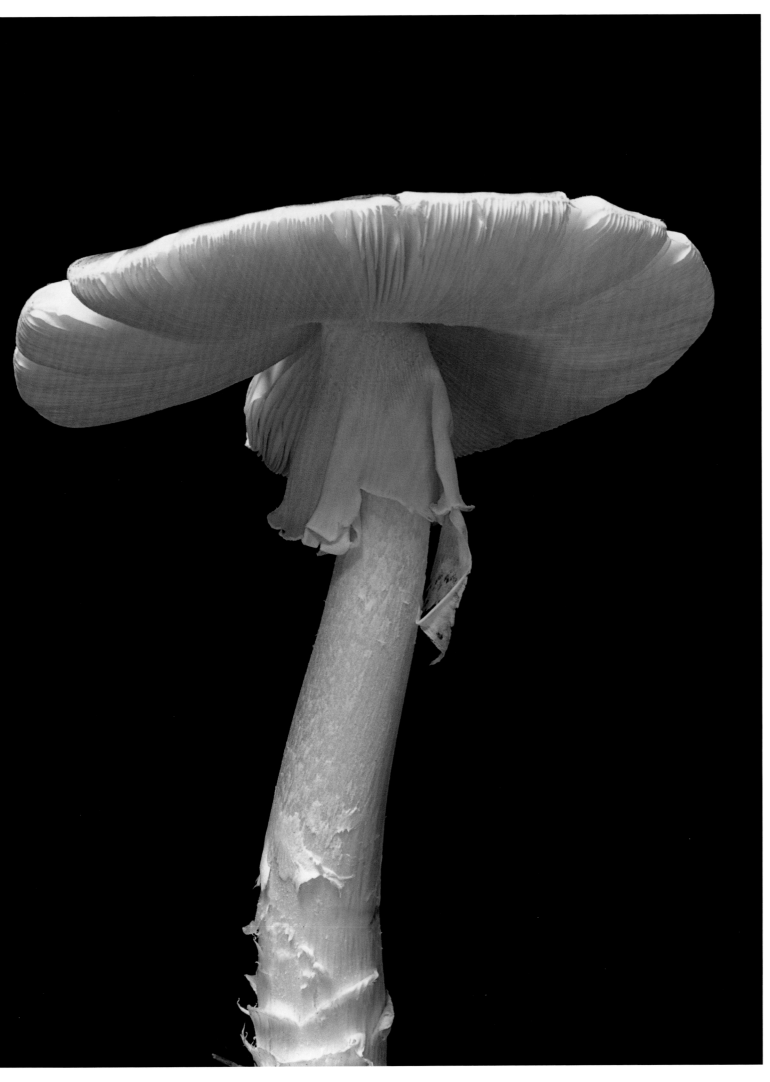

PLATE 101 *White Mushroom* (from the Farmhouse series), 2004

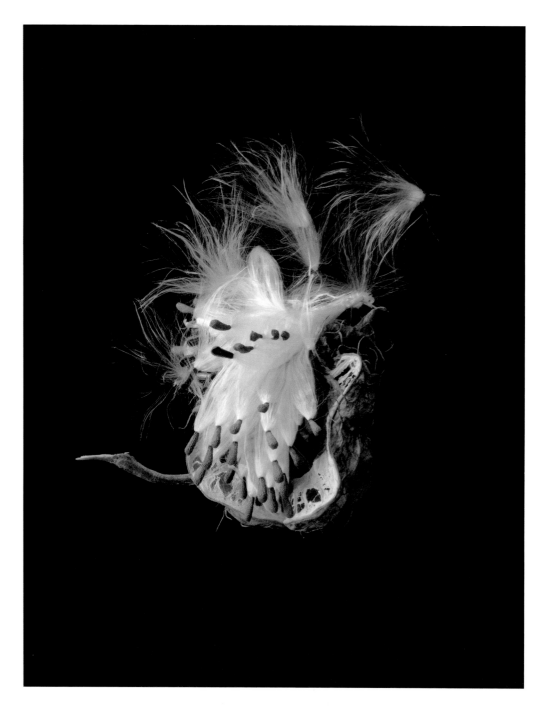

PLATE 102
Early Milkweed Black-and-White Study, 1997

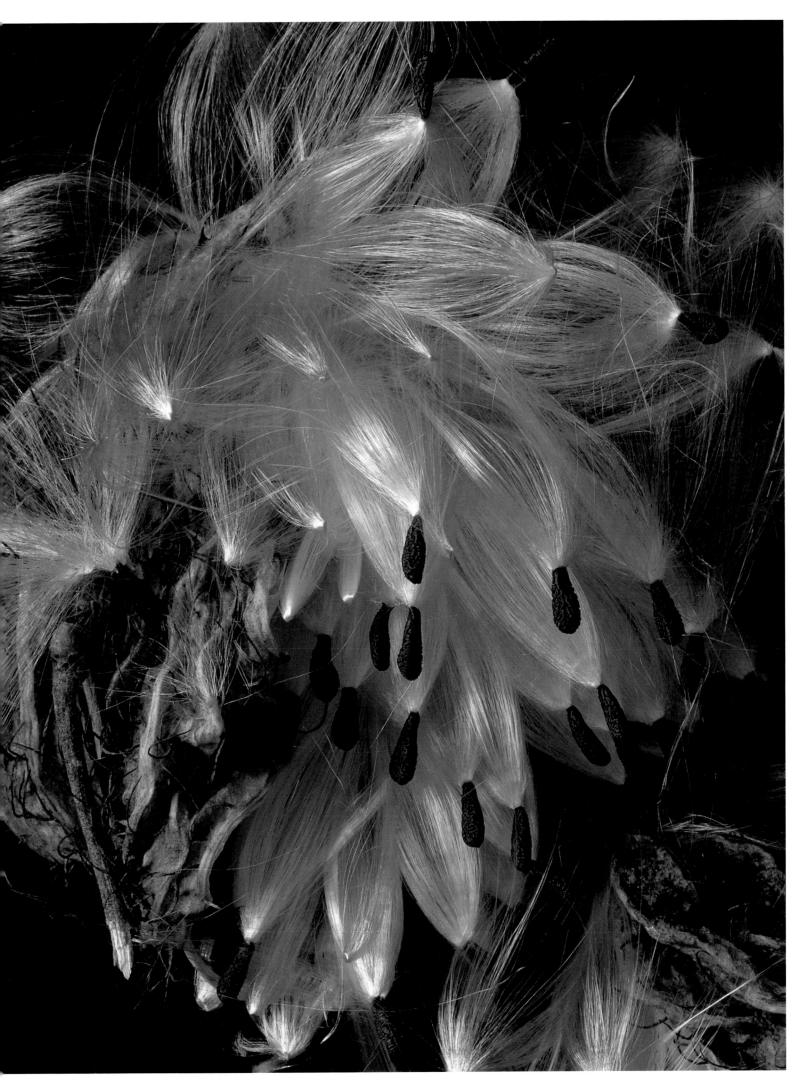

PLATE 103 *Milkweed Study #2*, 2000

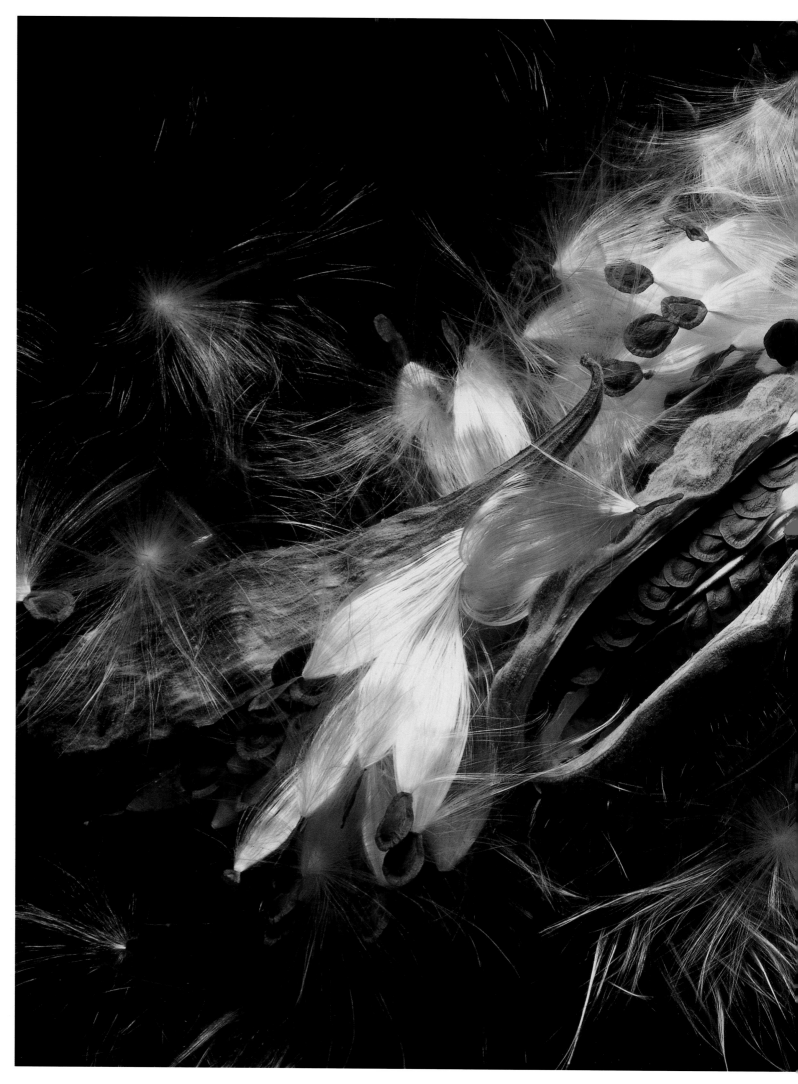

PLATE 104 *Milkweed Study* (from the Farmhouse series), 2004

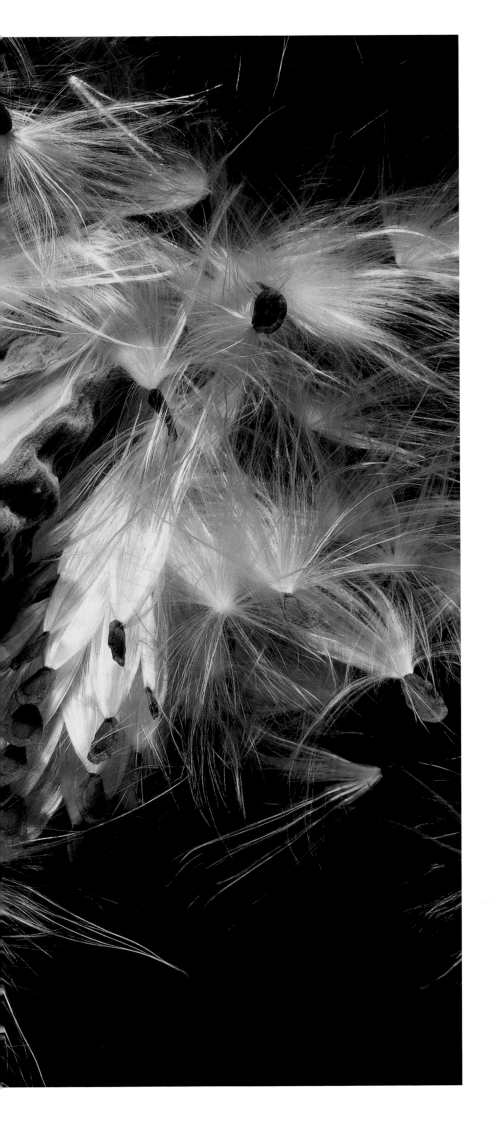

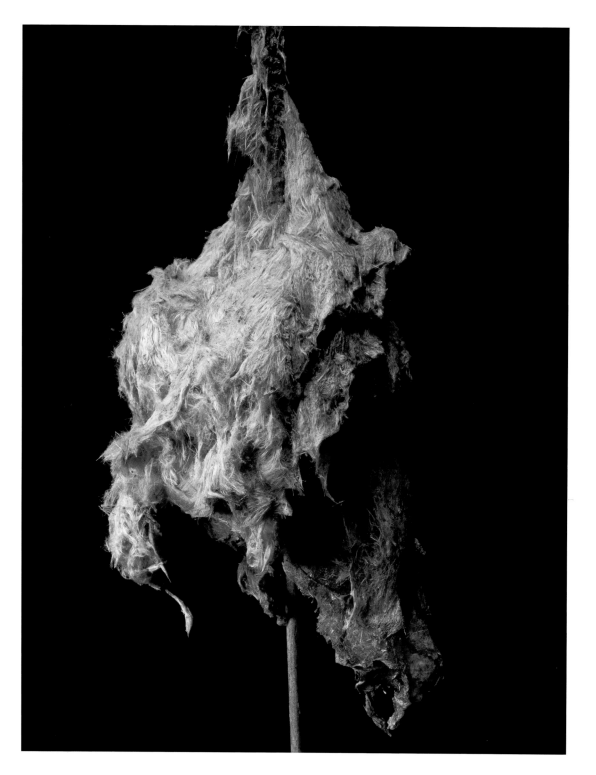

PLATE 105
Petrified Cattail #1 (from the Farmhouse series), 2004

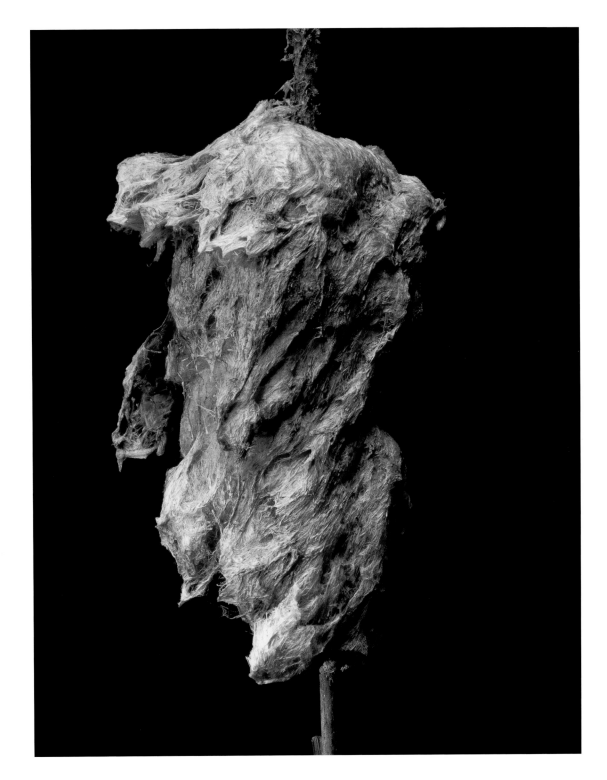

Petrified Cattail #2 (from the Farmhouse series), 2004

Down the lane from the farmhouse in Connecticut, there was a pond on a neighboring farm where I spotted cattails among the tall green reeds. Usually, cattails don't disperse their seeds until fall. A closer inspection revealed that these cattails were left from the previous season, weathered and frozen in time.—cb

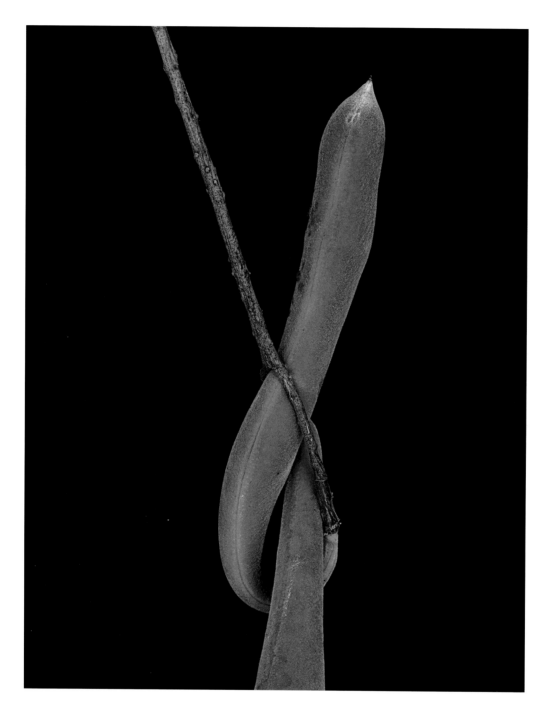

PLATE 107
Ingrown Wisteria Pod, 2003

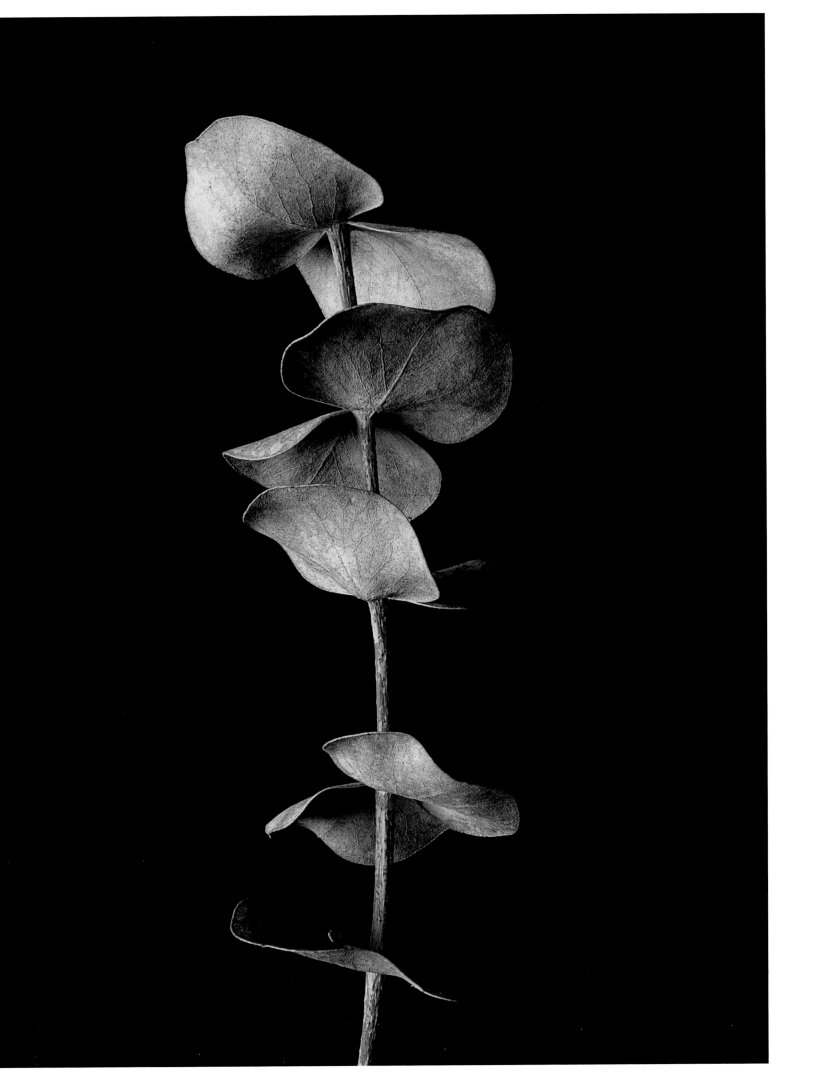

PLATE 108 *Eucalyptus Vertebra,* 2003

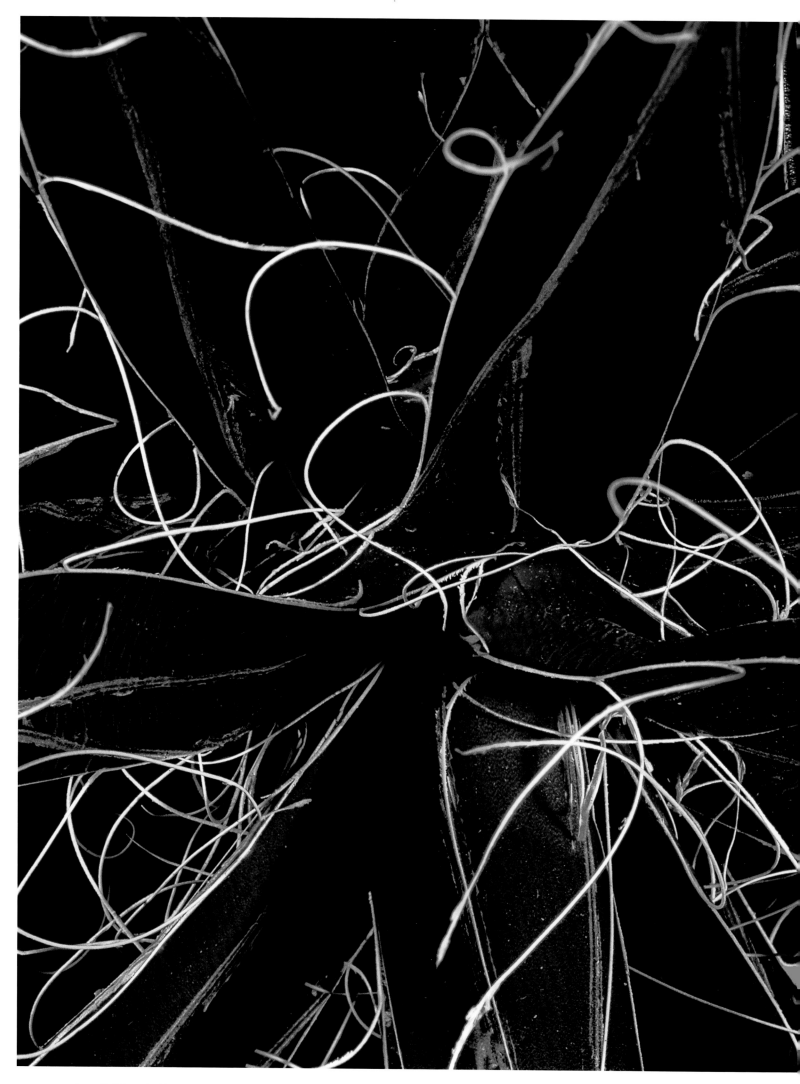

PLATE 109 *Bromeliad Strands,* 2000

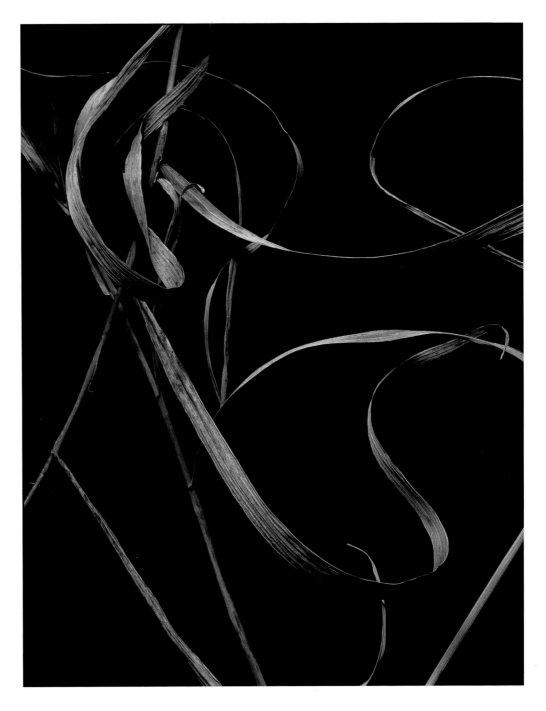

PLATE 110
Field Grasses (from the Farmhouse series), 2004

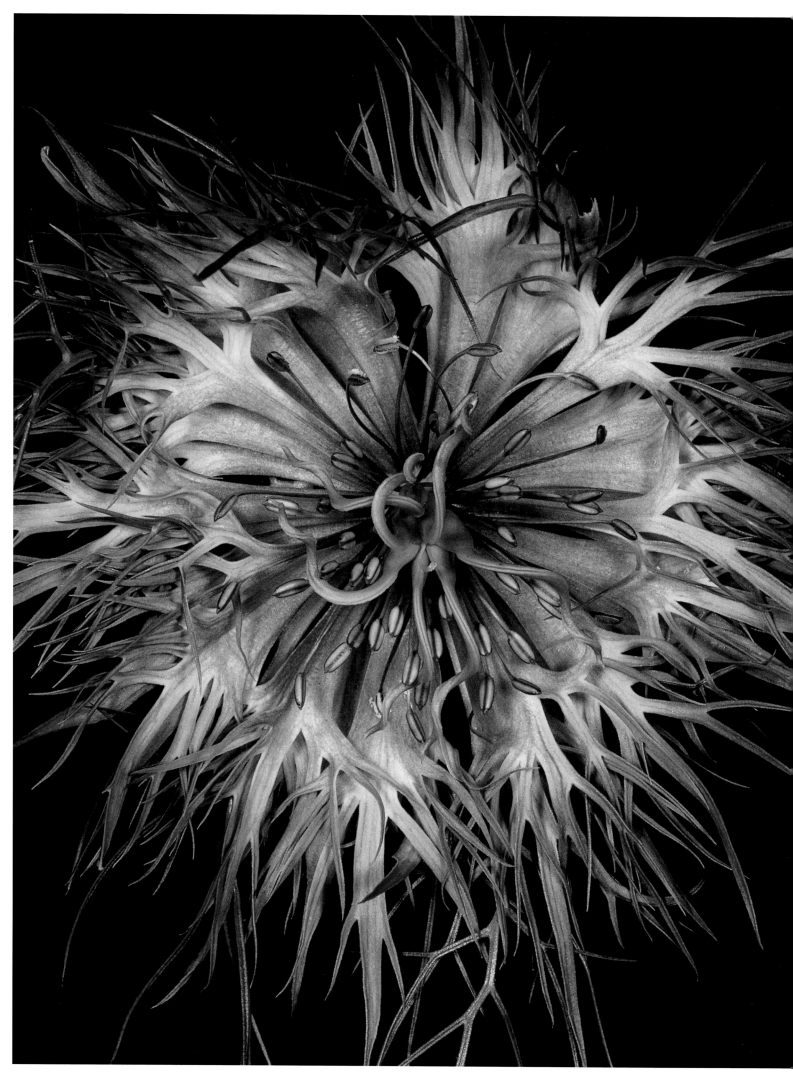

PLATE 111 *Nigella,* 2003

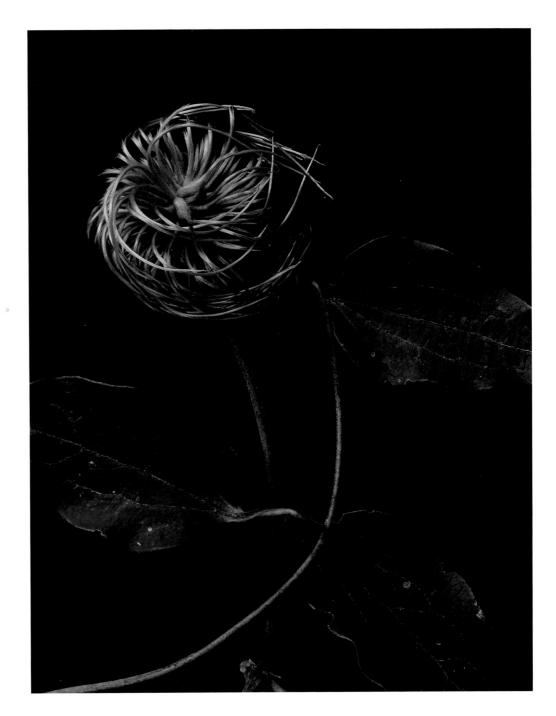

PLATE 112
Bloomed Clematis (from the Farmhouse series), 2004

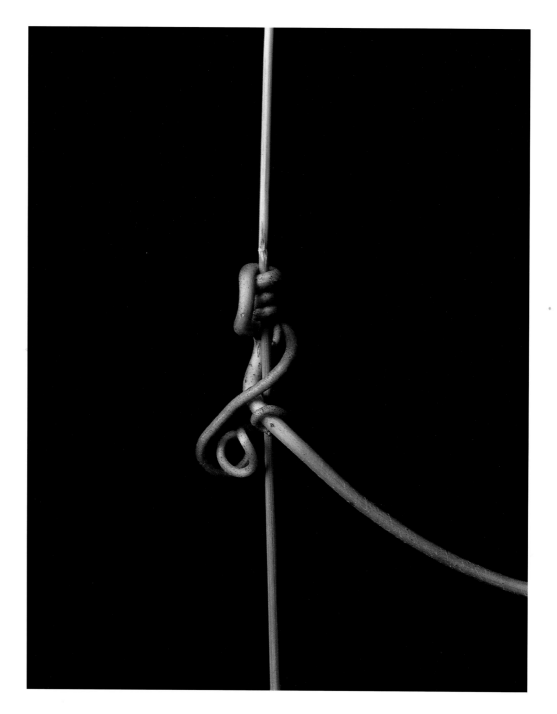

Knotted Vine (from the Farmhouse series), 2004

OPPOSITE: *Standing tall and overshadowing the front of the Connecticut farmhouse was a very large conifer. With its brown needled soil and dead branches on the underside, it was more of an eyesore than anything else. But one branch had a wildflower growing on its outer perimeter. The purple flowers, in contrast to the emerald-green berries, were like jewels. Later in the season, the berries turned from green to red.—cb*

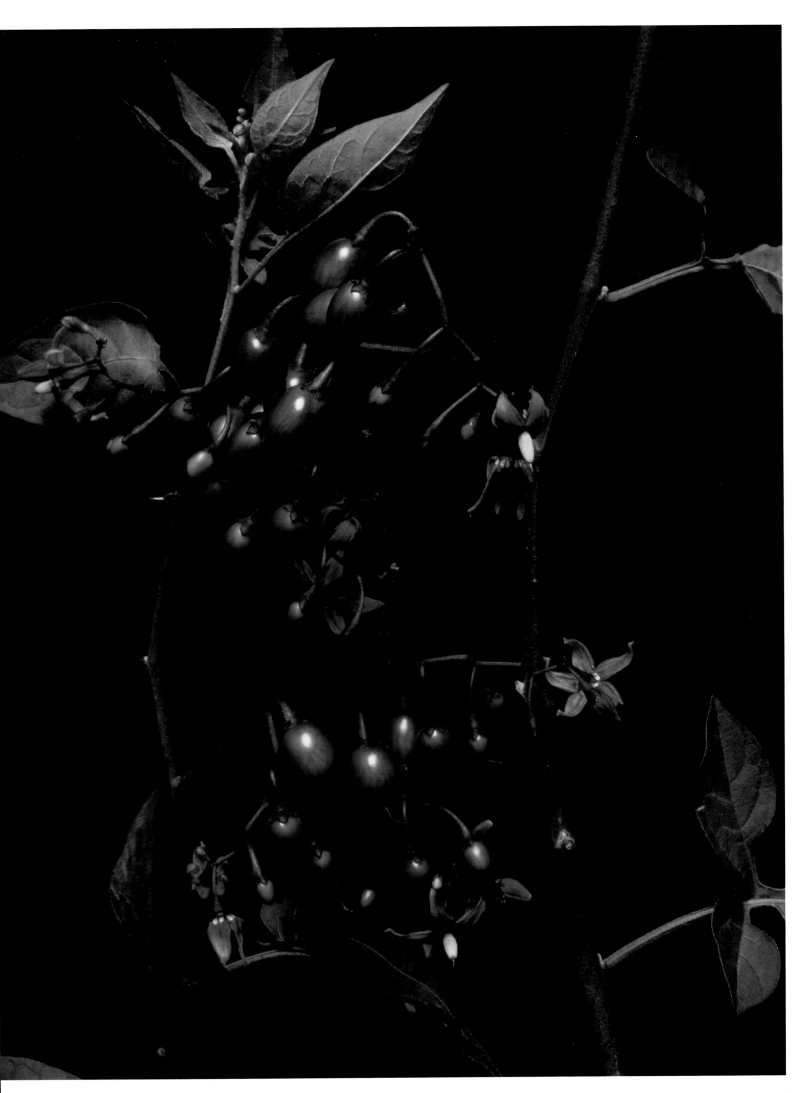

PLATE 114 *Emerald Berries or Nightshade* (from the Farmhouse series), 2004

OF BRANCHES, VINES, AND DECORATIVE PANELS

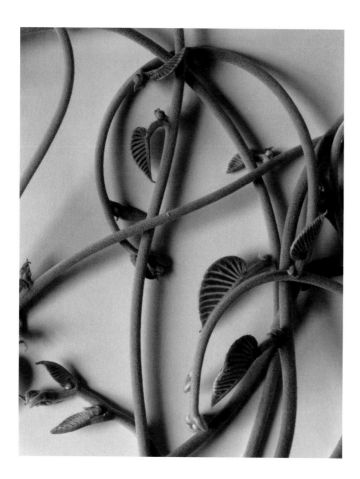

PLATE 115
Black-and-White Morning Glory Vines, 1995–96

After all Beane's deconstruction and reconstruction, and his manipulations to create floral fictions, it is astonishing to see "normal" photographs. Nearly all the blossoms in this section grow on branches or vines. However, this kind of photo seldom stands alone.

Beane's earliest photograph of this type (that I know of) is a black-and-white image of a section of a morning glory vine from around 1995–96 (at left). Printed in the low-contrast, velvety grays that Beane prefers, the photograph is a bit of a puzzle. Even before deconstruction gave him liberty to strip the leaves of a bromeliad and rearrange them under the inspiration of Richard Serra's sculpture (see plate 14), he leaves us unsure whether we are looking at a plant or a piece of metalwork. He accomplishes this by focusing on the abstract design and omitting further visual clues that would help us determine whether the object is natural or man-made.

Beane did not have another opportunity to photograph morning glories until August 2002, when he was invited to the North Fork of Long Island. Because of the intense wind, the flowers had to be shot in a white tent using only the available natural daylight under extremely uncomfortable conditions, as in *Morning Glory Study* (plate 116). Once again we find Beane expanding his range of interests in other styles. The inspiration of Japanese art is readily apparent in this photo.

Beane's first photographs of vines with flowers on them are a fiction that he concocted in about 1999–2000 by combining implausible parts so convincingly that we hardly question the result. The fritillarias in *Checkerboard Fritillaria* (plate 124), identifiable by their bell shape and

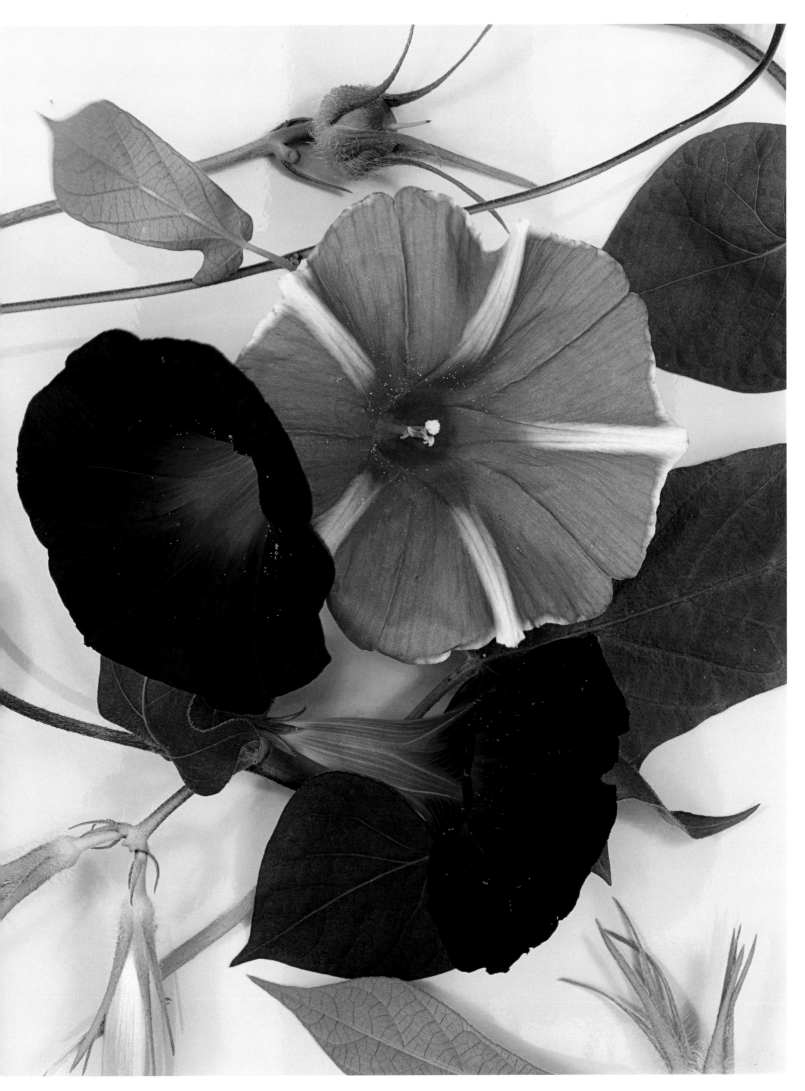

PLATE 116 *Morning Glory Study*, 2002

checkerboard lining, don't grow from vines at all but hang downward singly from stalks (other varieties hang in clusters). The purpose behind this conceit is decorative: the image is one of nine panels that form a photo mural, the first one he undertook. The mural was mainly an experiment, since no commission was involved. The only way he could unify that many panels with so many flowers in them was to create a meandering linear pattern, which only a vine could provide. Possibly the idea was borrowed from handmade wallpaper using carved and inked woodblocks, one block for each color. Such designs have been traditional in France since the late seventeenth century, but the source may lie much nearer. William Morris, the founder of the Arts and Crafts movement in England, used a similar device to integrate several of his designs for wallpaper, notably *The Pimpernel Wallpaper* of 1876.

Beane's second effort involved no such chicanery. The two studies of sweet pea vines (plates 8 and 9), from later in 2000, grow on vines before they are cut off for harvesting. All he had to do was arrange them in a suitable pattern and light them. It sounds simple enough. However, a closer look reveals how Beane has selectively highlighted the colorful pod-bearing blossoms without allowing the pattern of vines to become submerged into the dark background, which would destroy the coherence of the design. Furthermore, each frame must have been taken individually, without losing sight of the overall effect. To maintain such perfect balance across each photograph so that together they form a unified whole requires technical perfection and painstaking work. No wonder few photographers attempt multipaneled photomurals.

The reverse black-and-white image is a photogram of a bittersweet (see plate 122). It uses the same basic technique that William Henry Fox Talbot invented in the mid-1830s to make "photogenic drawings" of flowers by placing them against paper coated with silver oxide salts and exposing them to light. The difference is one of scale. Bittersweets are mostly vines that are capable of climbing trees thirty or more feet tall; moreover, some can produce branches of their own. This photogram includes several sizable branches from a tree, with the fruit-bearing vines forming a dense network. Now, try to guess how big the image really is. It's close to five by six feet! Dating from the autumn of 2002, this is not Beane's first photogram, nor is it his most ambitious undertaking.

He once covered almost an entire wall with forty panels of wandering bittersweet vines, which resembled vegetation floating lazily down a stream. The result is as fluid and decorative, yet economical in means, as a painting by a master Japanese artist. We also see the influence of art nouveau and the aesthetic movement, both of which used arching designs based on nature. The mural is the photographic equivalent of the water lily canvases (in the rotunda of the recently renovated Orangerie, in Paris) that Claude Monet painted at the estate that the French government donated to him near Giverny. In both photograph and painting, time and motion follow a leisurely course, without concern for the pressures of the outside world. The mural also compares well with any of Jackson Pollock's classic "drip" paintings, such as *Autumn Rhythm: Number 30* (1950). Although Pollock's canvases are far denser in their network of lines and texture, the resemblance is unmistakable.

The wall mural is a remarkable accomplishment because of its rich associations. We get a hint of this accomplishment in the single large piece (see page 147). No wonder Beane has done more than forty bittersweet photograms, making them his largest single body of work, for they provide him with limitless possibilities to explore linear abstraction. He is a photographer who explores linear abstraction with a camera in much the same way a painter or a draftsman would.

Beane made a handful of photographs—in fits and starts—showing flowers growing on branches. For example,

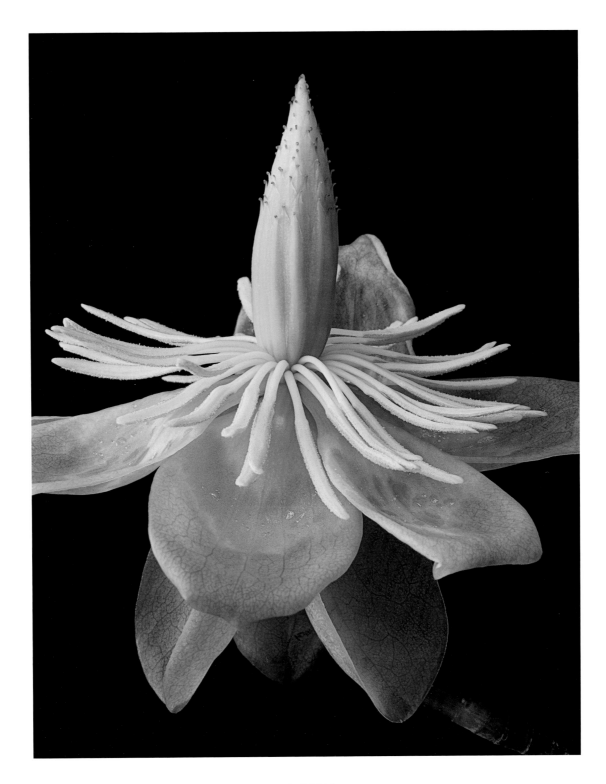

PLATE 117
Flowering Tulip Tree Branch, 1998

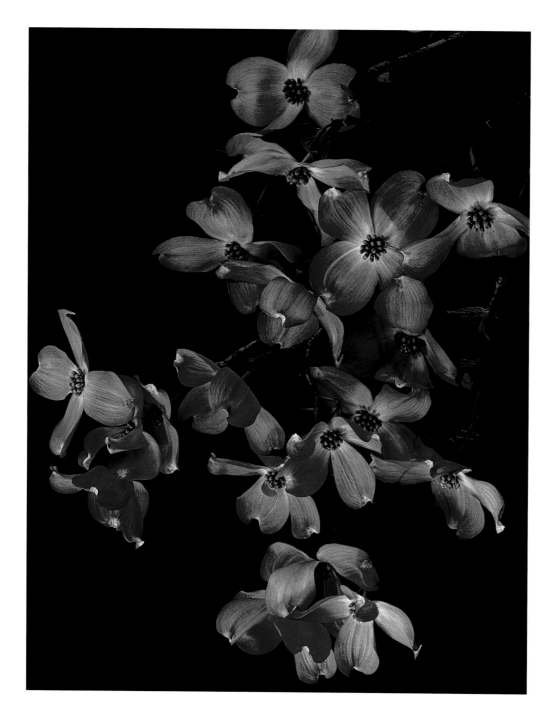

PLATE 118
Red Dogwood (one of nine panels), 2003

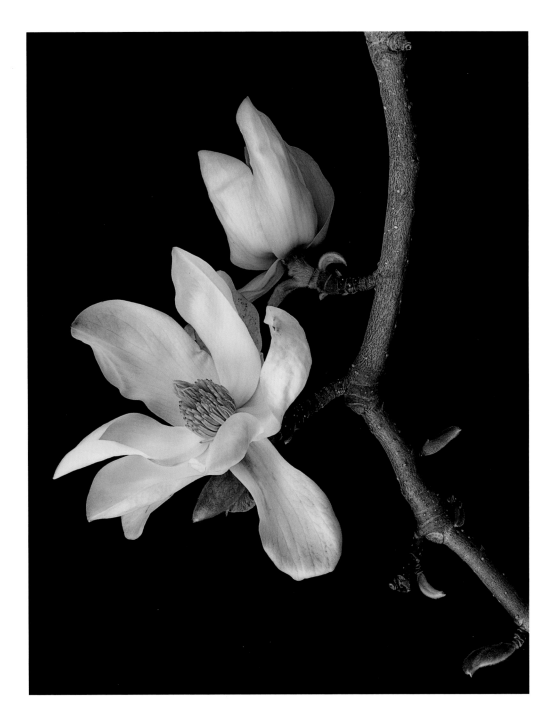

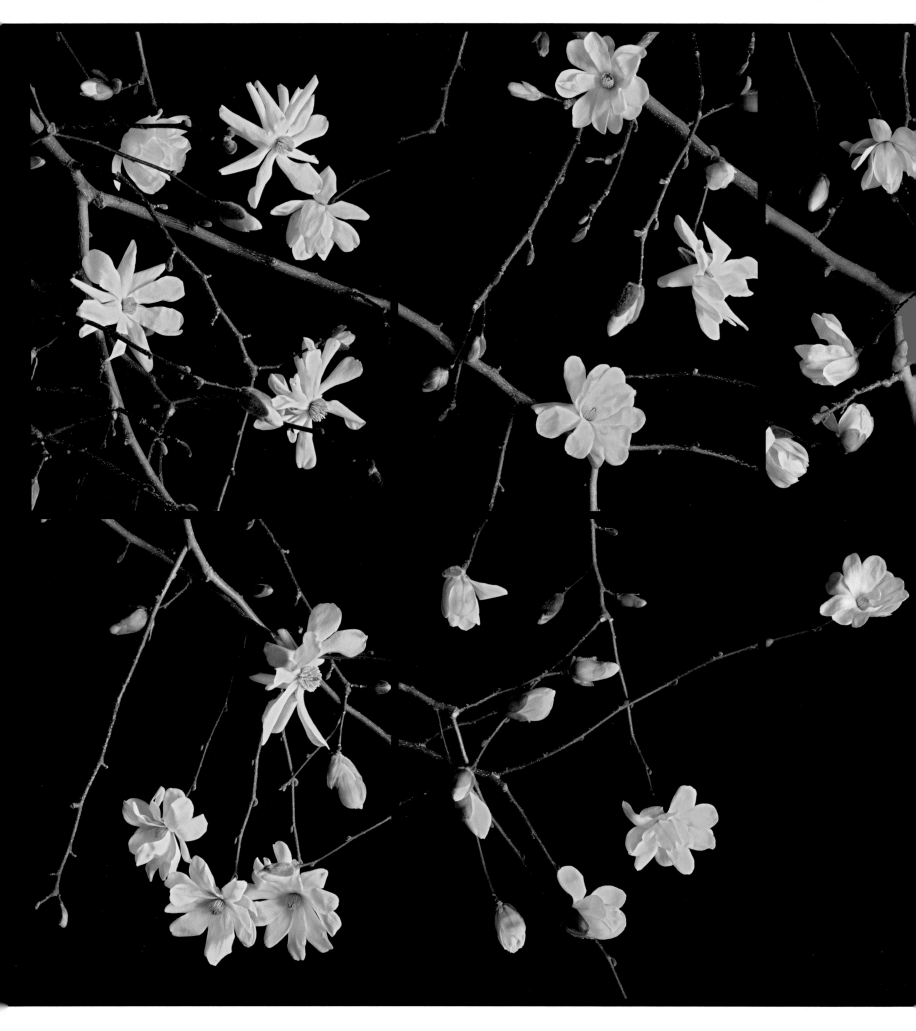

PLATE 120 *White Magnolia Branch Photomontage*, 2004

There's a white magnolia at the 83rd Street entrance of Riverside Park. In early spring, it flowers and stands alone, before any other tree shows signs of life.—cb

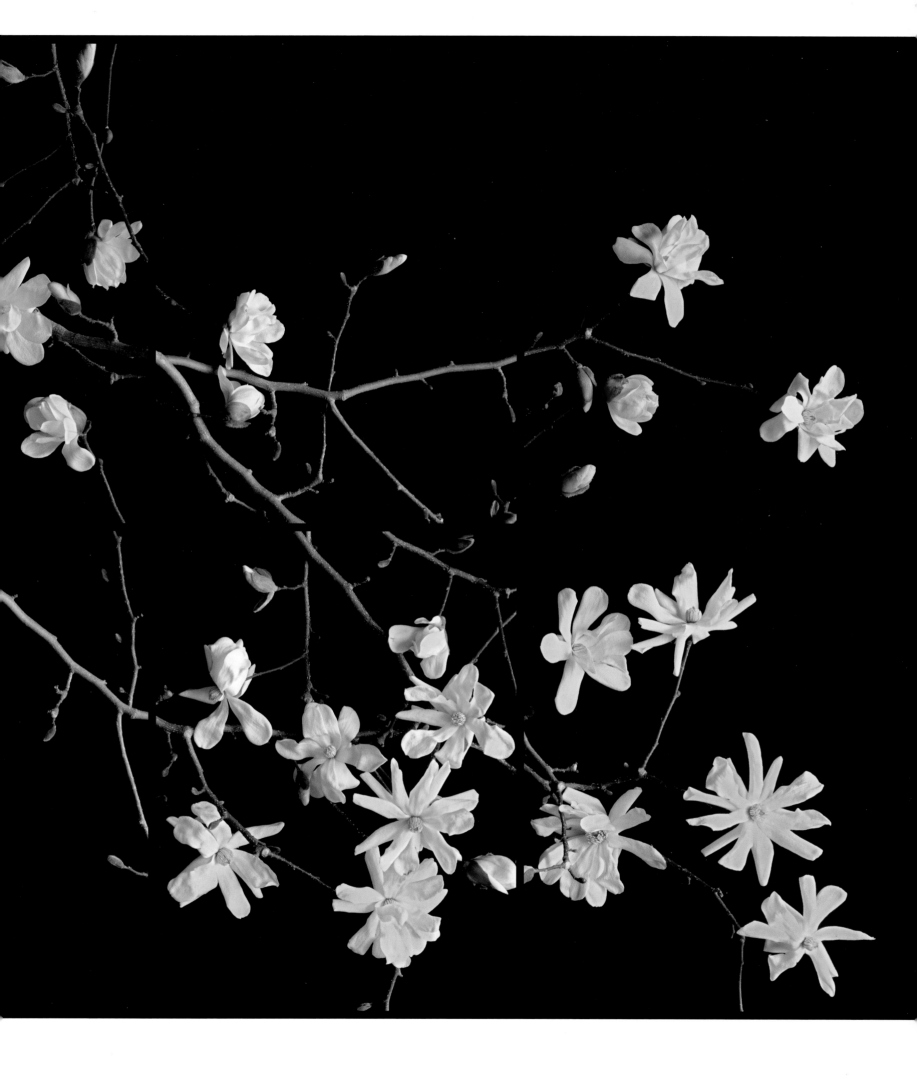

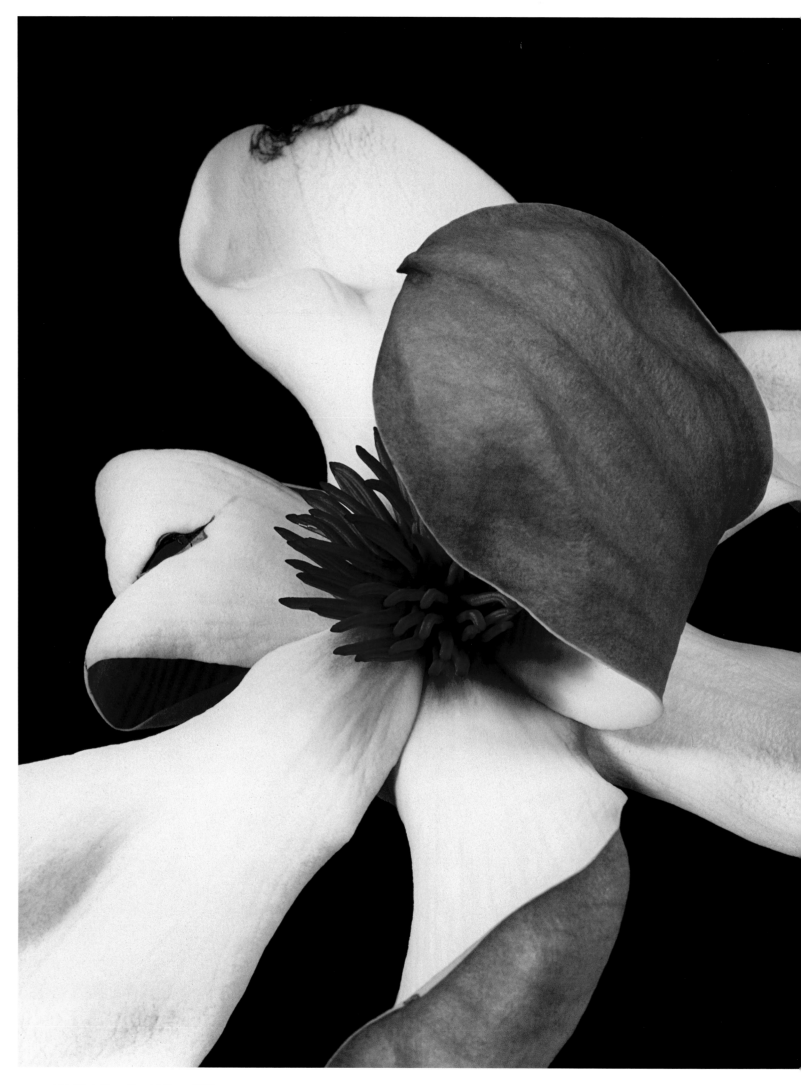

PLATE 121 *Pink Magnolia with Scars*, 2000

the pink magnolia in *Pink Magnolia with Scars* (opposite) is one of a series that he took in the summer of 2000. Unlike classic white magnolias, pink magnolias have sharply separated petals, with strongly contrasting colors between the exterior and interior of the blossom. Because each petal is free to fold or unfurl in response to changes in temperature, humidity, sunlight, and nutrients, these flowers often assume striking poses, as if they were dancing. *Yellow Magnolia* (plate 119) was photographed in 2002 during a visit to the Long Island home of a friend. Here the light is natural, because the photograph was taken outdoors, yet the flower's features seem so fully modeled that we assume Beane used additional lighting to control the effect.

In 2003 Beane took a photo of dark-pink flowers on a dogwood tree, where the branches are nearly invisible against the black background (see plate 118). Unlike the pictures of the magnolias, this photograph is one of a nine-piece panel. The morning glory blossoms and the bittersweet photogram are tentative efforts compared with this image, in which the blossoms cascade as freely as in a Japanese painting. You can readily imagine the effect created by the full nine-panel photomural, which multiplies the sense of motion.

The influence of Japanese art culminates in a large, handsome photomural of white magnolia branches (see plate 120), commissioned by the Bergdorf Goodman store for its haute couture department. It consists of ten panels arranged in two rows of five each. Like the wall-size bittersweet mural, it is a photographic tour de force, both technically and aesthetically. Despite the carefully planned sequence of branches and white flowers, which creates a forward momentum from upper left toward bottom right, the overall effect is deliberately quite static. The reason is that Beane is consciously imitating the most formal aspect of Japanese art.

Beane used only natural daylight to photograph these panels. Because each one took careful planning and re-quired considerable preparation and time, he had to take the photos at about the same time in the afternoon over several days in order to maintain consistency of color temperature, which shifts throughout the course of a day according to the amount and angle of sunlight. He also had to keep the flowering branches alive long enough to complete the work. In a few places, the branches don't quite line up properly across the relatively wide strips of the metal frame. These deviations are trivial. The photomural as a whole is a magnificent achievement.

After the white magnolia mural was completed, Beane began (and nearly finished) a new series. As he jokingly put it, "I had an epiphany and made a Tiffany." Created in conscious emulation of glass screens and windows by Louis Comfort Tiffany, the leading designer of art nouveau glass and jewelry in America, they consist of paired photos showing tulip magnolias against a pseudoglass background (see plate 126). They are mounted in two rows within two square frames, for a total of eight images. Each row extends across the divide of the frame. Through the network of branches, Beane has made an attempt to suggest continuity between the upper and lower rows as well, but on closer inspection it becomes apparent that there is no direct connection. The magnolia branches are arranged on marbleized paper that is lighted from behind. The result comes remarkably close to recreating the effect of strong sunlight streaming through Tiffany stained-glass windows featuring delicate floral designs. Not until 2007, when he saw several similar panels with magnolia blossoms at an exhibition of Tiffany's work at the Metropolitan Museum of Art, did he realize just how close he had come.

Beane had been experimenting with the technique since at least the beginning of 2005. It is, after all, a cross between the Camouflage and the Tutti Frutti series, because it takes the marbleized paper of the former out of the water and puts it on the light table often used to illuminate the

PLATE 122 *Bittersweet Photogram* (one of forty panels), 2002

Murano glass. As nearly always happens, what looks simple at face value turns out to be difficult. The effect is somewhat tentative in two photographs of fritillarias and maidenhair ferns against delicately tinted green-and-yellow Thai paper (see plates 127 and 128), some of his first efforts in this vein. They suggest, at first, the reflection of trees and other vegetation overhanging a creek as sunlight plays across its slow-moving water.

The stems of fritillarias rising from the bottom edge of both photos give rise to visual confusion. Are we supposed to read the images from above? If so, on what plane do these flowers lie, since they have clearly been placed over the ferns? Their relative distance is difficult to gauge. A second intervening layer is not uncommon in nature, however. What is unexpected are floral forms rising at a different angle. Contemporary art is filled with paradoxes and contradictions like these.

A more mature photograph from 2005 successfully establishes the basis for the Tiffany series: *Fall Meets Spring* (plates 129 and 130), composed of dogwood and birch. Again, there is an art nouveau relationship, although it is less apparent. At first we may be reminded of what was once a popular pastime: pressing flowers, leaves, and other bits of nature between two pieces of paper that were usually glued together. Designs like these were produced as book covers, endpapers, illustrations, and prints in Europe during the late nineteenth century. Beane's photographs compare closely with a leather binding by René Wiener, after a lithographic design by Camille Martin, for a portfolio of original prints from 1894.

The confluence of Beane's growing interest in both Japanese art and art nouveau, beginning in 2002–3 and culminating in 2005, can hardly be a coincidence. These art movements have been absorbed so thoroughly into our culture that they are part of our shared heritage, whether we realize it or not. For many artists who had gathered around the realist painter Gustave Courbet—including Edouard Manet, Edgar Degas, and James McNeill Whistler—Japanese art and design provided a point of departure for developing new highly individual styles. For Whistler, it became the entire basis of his art and then of the aesthetic movement as a whole. Seen in this light, Beane's panels with branches and vines (also inspired by modern painting such as that of the minimalist artist Brice Marden) constitute one of the most interesting phases of his career.

OPPOSITE: *Each summer I grew a passionflower vine outside my darkroom window, over and around the fire escape. I would train the vine with wire, and overnight the springlike tendrils would latch on to whatever they could. Unfortunately, the blooms of this beautiful and complex flower last only one day—and my downstairs neighbor would always complain about the water dripping through her kitchen window.—cb*

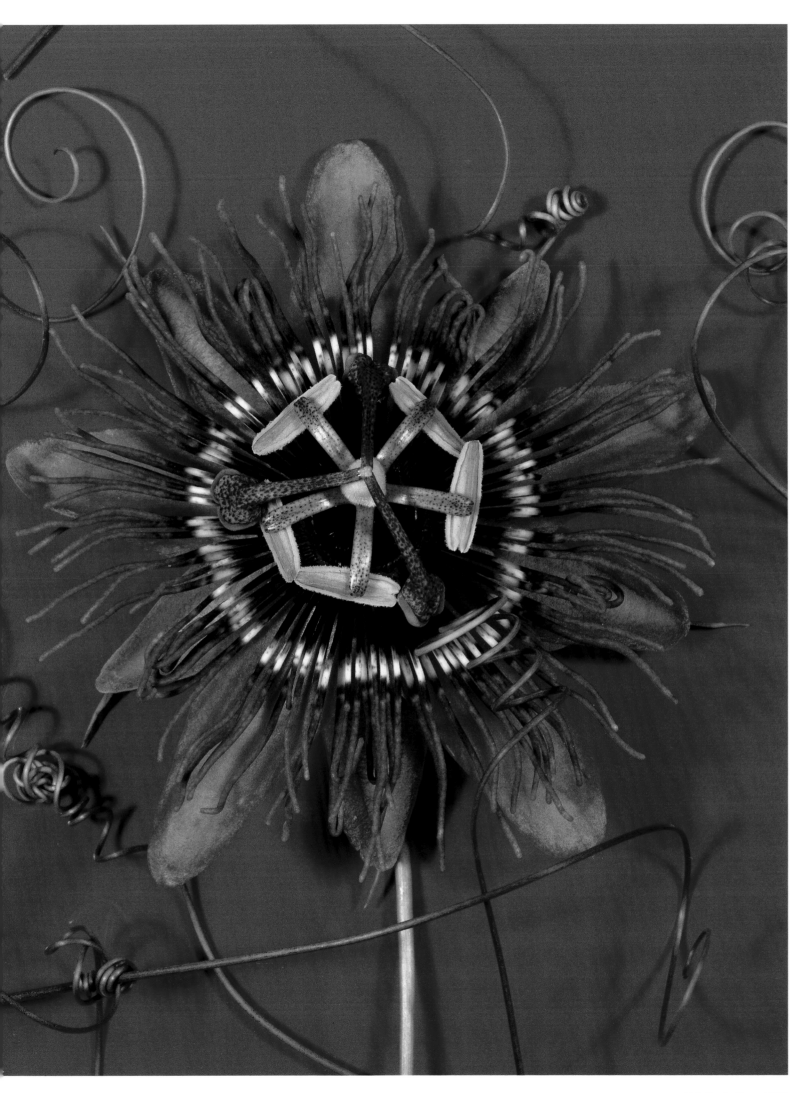

PLATE 123 *Passionflower,* 2002

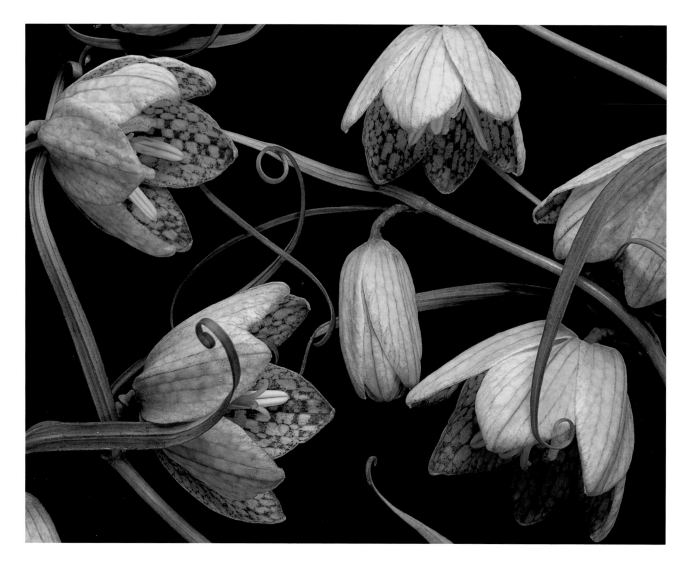

Checkerboard Fritillaria (one of nine panels), 1999

OPPOSITE: *When I was a wholesaler, Peggy and Zezé were always my first customers in the morning. I would boast of my photographs and Zezé would talk up the beautiful white clematis from his upstate garden. One day he brought it to me.—cb*

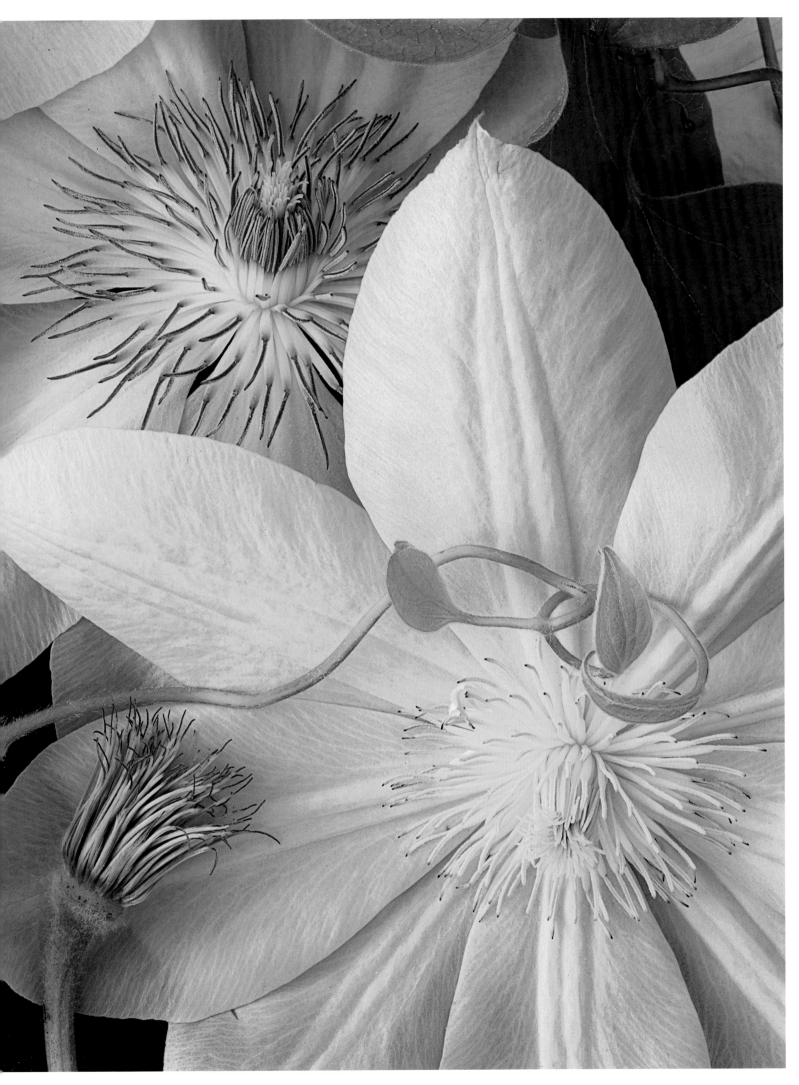

PLATE 125 *Zezé's Clematis*, 1998

PLATE 126 *Tulip Magnolia and Dogwood Photomontage* (from the Tiffany series), 2005

PLATE 127
Fritillaria with Maidenhair Fern (from the Tiffany series, panel #1), 2005

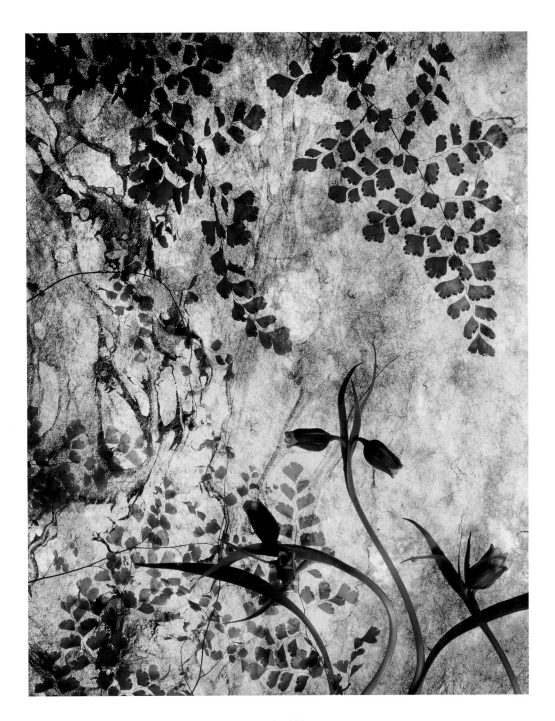

PLATE 128
Fritillaria with Maidenhair Fern (from the Tiffany series, panel #2), 2005

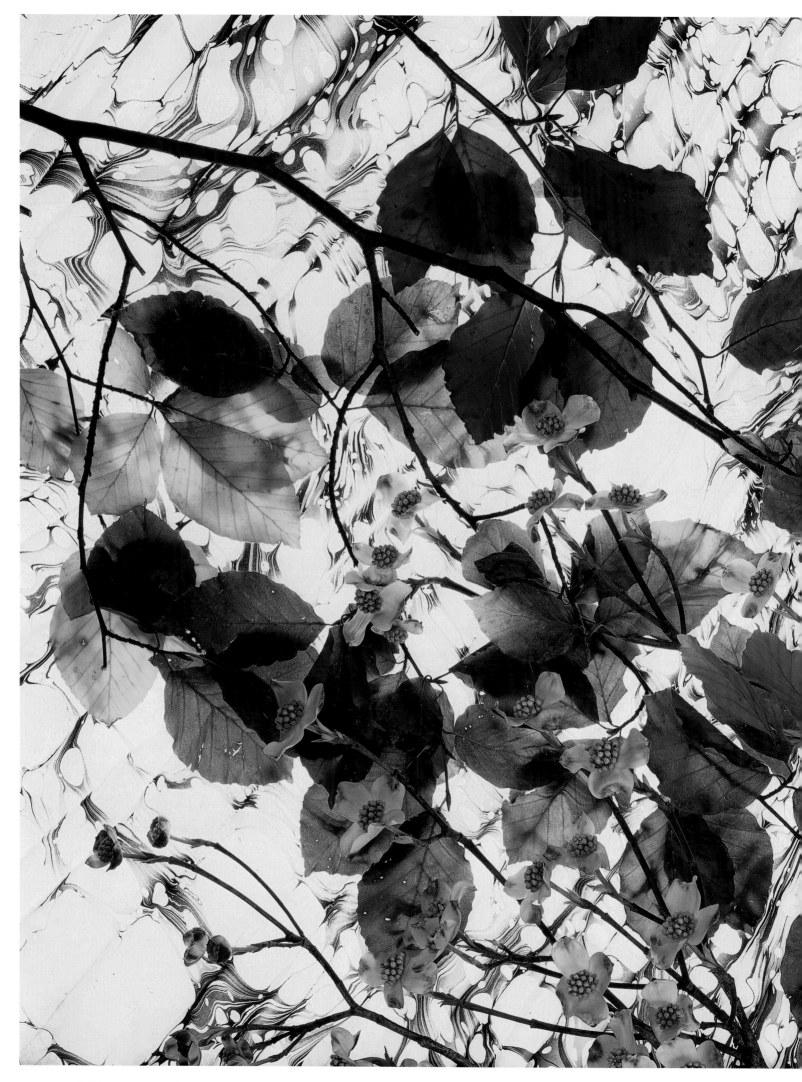

PLATE 129 *Fall Meets Spring Panel #1*, 2005

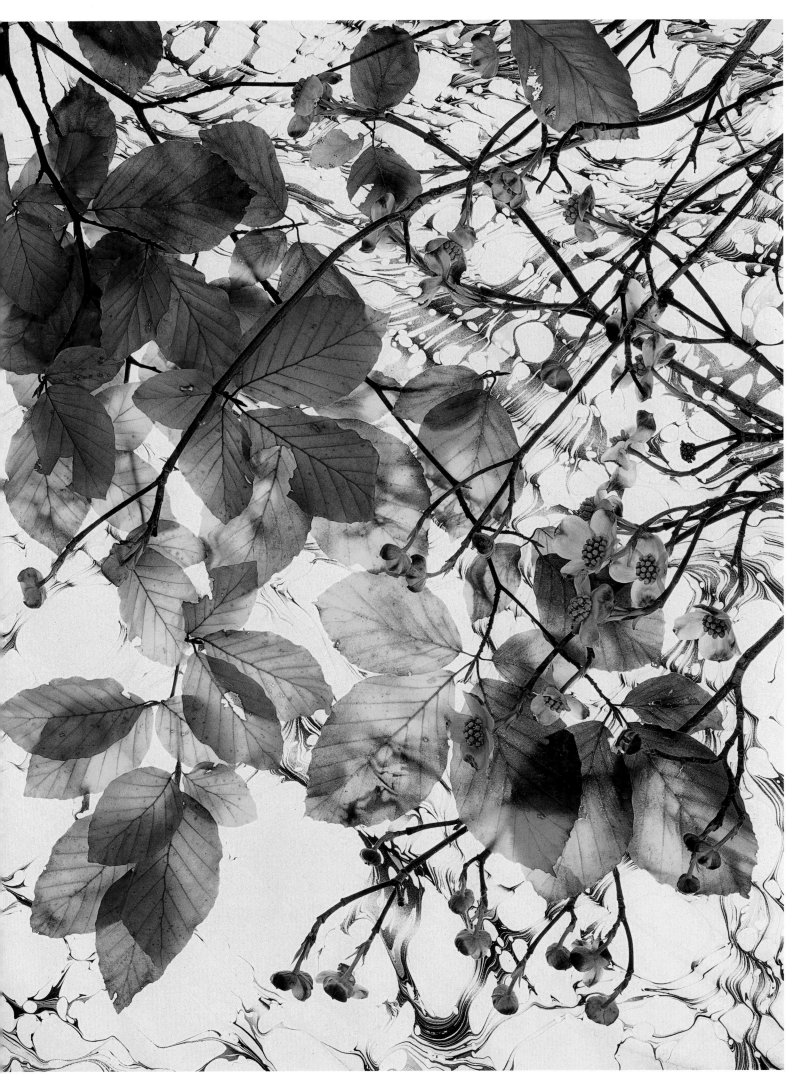

PLATE 130 *Fall Meets Spring Panel #2*, 2005

postscript

THROUGH A LOOKING GLASS DARKLY

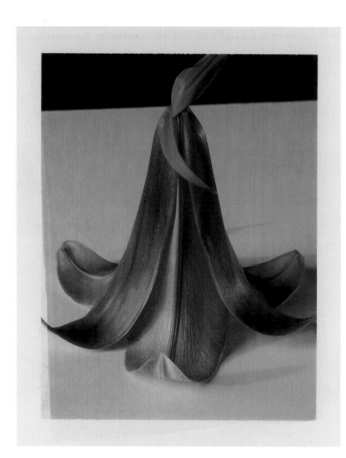

<div align="center">

PLATE 131
Early Lily Study, 1995–96

</div>

On July 2, 2005, Beane entered Mount Sinai Hospital with stage four lymphoma and several conditions stemming from it. Miraculously, he returned to his apartment on the Upper West Side exactly eight months later, handicapped but alive, after six rounds of chemotherapy that left him wasted. Descriptions of him at the time conjure up the image of the clematis (see plate 112), which "still stands defiantly, if barely—mute testimony to the powerful will to survive in all of nature." It helped that he was thirty-eight at the time and six foot three. Otherwise he might not have survived the cancer or the treatment.

His survival is also testimony to his unbreakable will and the determination of his doctors, nurses, and therapists. Although he no longer needs a wheelchair, Beane still requires frequent physical therapy and help with his daily life. Nevertheless, in June 2007, he was finally able to resume taking photographs in his studio on a part-time basis, hunched over his cumbersome equipment.

We end with what may be the most remarkable image in this entire volume: *Lilies under Apocalyptic Sky* (opposite), taken a month later, while this book was being prepared for publication. The photograph marks both an end and a new beginning on both an artistic and a personal level. It looks, Janus-faced, to the past and to the future. It is a mysterious and challenging picture. It is a work that demands a personal interpretation based on the insight that only a lifetime of experience yields. It is just as well that such images are so rare, because they place extreme demands on both the viewer and the critic.

Lilies under Apocalyptic Sky has to be understood within the context of Beane's long stay in the hospital and arduous

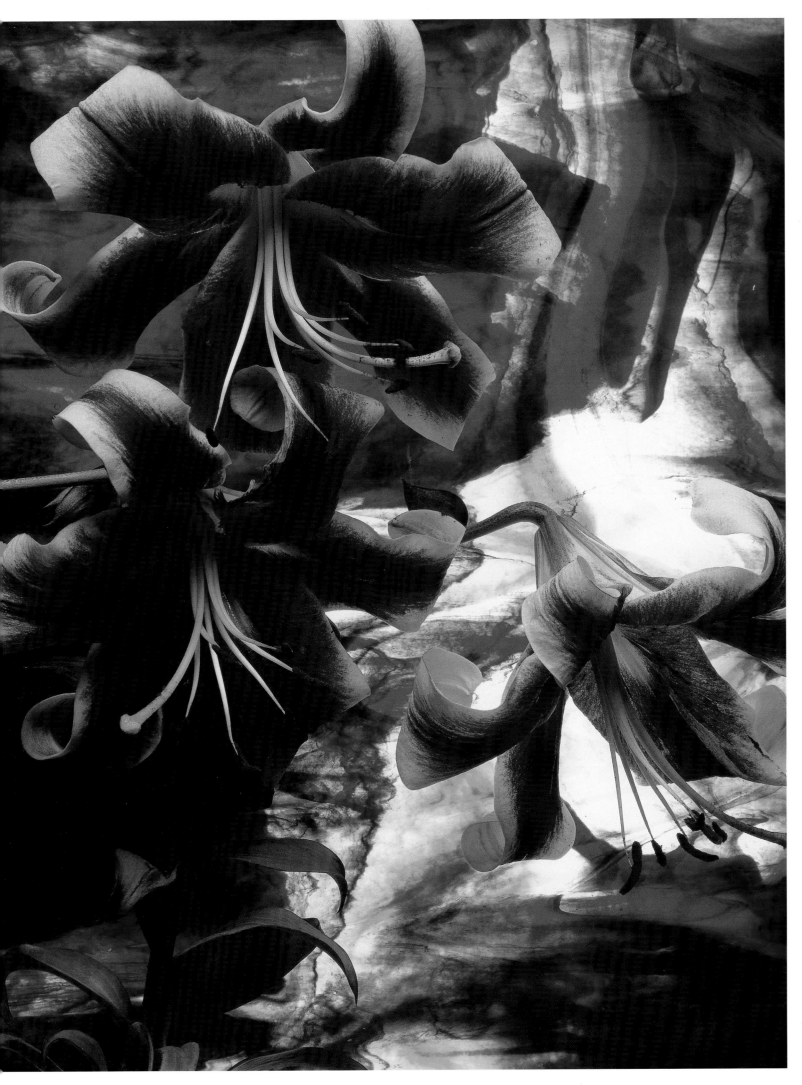

PLATE 132 *Lilies under Apocalyptic Sky, 2007*

post-recuperative course of physical therapy. The return to his apartment was perhaps the most important event. To see his own home, to be with his own furnishings and art, to be in familiar surroundings again, made him break down in tears.

Lilies under Apocalyptic Sky profoundly moves me, triggering the elation and relief I felt when I returned from Vietnam and saw my wife for the first time in eight months. Like most Vietnam vets, I was embittered by the experience, because, among other grievances, I contracted a debilitating disease from which I have never recovered. What most people who have been torn away from their everyday lives by war or illness for long periods, or who have escaped terrible tragedy, want above all else is to resume normal lives: to return to what they had been doing.

Coming home, Beane could not simply resume normal life. Coming home meant learning how to make his way through a world inhospitable to people in wheelchairs or on crutches. He has often been asked, "How did the experience change you?" He is certainly a changed person, yet the fundamental man remains the same. However, Beane does look at life differently now. Why become easily upset by the kinds of minor incidents that used to annoy him, as they do most people? They're not worth the bother. Beyond pain and anger, he is grateful to be alive.

We have seen two sides of Beane as a photographer that tell us much about him. They coexist, as two sides of one person. One is devoted to creativity and the aesthetic realm. The other is fascinated by death. The world of flowers that Beane celebrates in his photographs reflects these two sides: the flowers, fresh for only a few days, are sold to decorate a living room or a dining table, then wilt and are thrown away. At the flower market, then, Beane was in the perfect environment to document the inevitable transformation of life into death, and of order into chaos.

He used camouflage and transformation, even when the image is apparently quite literal, to highlight his own "antiaesthetic" vision, which was enabled by deconstruction. Thus, it is not a far stretch from the early black-and-white photo of a deconstructed Weber tulip (see plate 11) to the study of two dying tulips from 2002 (see plates 88 and 89). Deconstruction also made possible the Orgy series, which proved a turning point in his development through the addition of color. Although Beane continued to take each image in both color and black and white for several years, color decisively altered his photographs in favor of the aesthetic because of the sensuous appeal it brings out in the hues, textures, and forms of flowers. His first fully mature color photographs, the Poppy and Peony series, are masterpieces of flower photography, but quickly they, too, utilize deconstruction to make fictitious flowers, of which the most ingenious is surely *Multicolored Mum* (plate 7), the combined bodega chrysanthemum "pinned" against a painted background of bright nail polishes.

It is interesting that the precursor of the Camouflage series, *Aubergine Water Lilies Swirling with Algae* (plate 63), was part of Beane's Black Flower phase. What brought these dark, foreboding images to an end and gave rise to the colorful images of the Camouflage, and later the Tutti Frutti, series were the events of 9/11. Thus, despite his seemingly morbid fascination with dead and dying plants, when faced with tragedy Beane affirmed life.

When Beane returned to his studio in June 2006, still confined to a wheelchair, he could not stand up to use his four-by-five camera and set up his lighting equipment. Instead, he had prints made of three out of the forty-nine photos of gardenias he had shot in 2005, including *Gardina with Horn* (plate 3).

The photos had been taken in his darkroom, which he outfitted with a set of movable shutters to control the amount and angle of natural light with the same precision as studio lights. The difference is that natural daylight captures the subtle nuances of textures and variations in the

color of flowers that studio lights fail to pick up. The kind of creamy color and velvety texture seen in this photograph has been achieved by only a handful of painters and never by a photographer, though a few have come close. The images that spring most readily to mind are the giant white magnolia blossoms by Martin Johnson Heade and the water lily watercolors by John LaFarge. These are iconic images in American nineteenth-century painting. Their nearest equivalents in European art are certain flower paintings by Gustave Courbet, Henri Fantin-Latour, Edouard Manet—especially the late watercolors—and Claude Monet.

It is significant that Beane chose gardenias to print after returning to the studio. They are his personal calla lily: a flower of beauty, purity, and love. For Beane, the flower carries the same religious symbolism as white lilies in general: death and resurrection.

At the same time as the gardenia, Beane ordered the photogram print of a bittersweet (see plate 122). The huge five-by-six-foot image is the result of taking a single twenty-by-twenty-four-inch panel from the autumn of 2002 and having it digitally enlarged, something he had long wanted to do. It is the equivalent of a painting in scale and visual impact. Stylistically, it lies somewhere between abstract expressionism and Japanese calligraphy. The choice of image is once again filled with personal meaning. Like the bittersweet photo mural described earlier, there is nothing static about *Bittersweet Photogram*. It is infused with the energy of life. In his choice of both the gardenia and the bittersweet, Beane affirmed life in the face of death.

There is a big difference between *printing* a photograph and *taking* one—after all, taking a photograph requires the use of a camera. It was not until June 2007, a full year after returning from the hospital, that Beane was finally able to stand, with the aid of crutches, and use his camera again. One of the first images he took was *Yellow Rose* (above).

Then, out of nowhere, comes *Lilies under Apocalyptic Sky*.

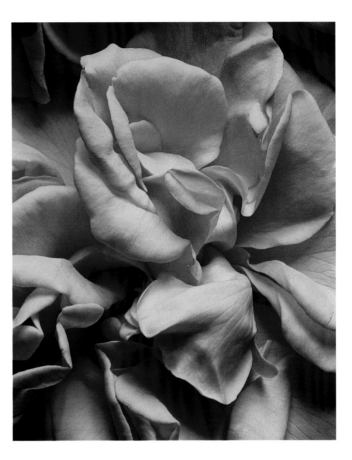

PLATE 133
Yellow Rose, 2007

We've never seen a photograph by Beane like this before—although we have seen elements of it. The scene is chaotic. It makes the free arrangement in his early black-and-white montage of lilies (see plate 25) look like leftover party favors. Flowers are also placed against glass in the Tutti Frutti series. But here the lighting is almost entirely from behind, with only enough from the sides to create highlights on the tips of a few petals. In this murky atmosphere, it is impossible to clearly identify the flowers, except that they are lilies from a single plant. (You can just make out the dark stem and its leaves rising from the bottom of the photograph.) The space is equally ambiguous. Although we know that the blossoms

have been placed on the glass, and that we must be viewing the scene from above, we read the background as a terrifying storm in which even the sky has caught fire, consuming everything in its path. The only apparent avenue of escape, the blue clearing with white clouds to the right, is blocked visually by a lily that has been severed from the other two lilies by the violent storm passing overhead. The smallest of the three, it lies limply, indicating that it has been seriously, perhaps fatally, damaged. Because the two lilies to the left are engulfed in darkness, we cannot determine their exact condition. It is nonetheless a hopeful sign that they are still attached to the stem. More important is the fact that the stamens remain intact, complete with pollen sacs at their tips, for they carry the seeds of life. Beane has said they were left on intentionally, which we can hardly doubt, given the selective highlighting of the stamens against the illegibly dark flowers.

Lilies under Apocalyptic Sky carries a heavy burden. Even reproduced on this scale, it is an image of frightening intensity. It expresses the full horror of Beane's previous two years. For people who endure such dreadful experiences, there almost always comes a moment of truth, when it is no longer possible to maintain any pretenses about how terrible things actually were, because the convenient fictions no longer work. The shell cracks.

What triggered this moment for Beane? I hazard a guess that it had something to do with his return to active camera work. The yellow rose that he shot a month or so earlier is a beautiful photograph of the sort he used to take. Seen next to *Lilies under Apocalyptic Sky,* however, it is clear that *Yellow Rose* is a retrospective image: it comes from another time and place in Beane's life, and picks up where he left off, as if nothing had happened. At some point, Beane must have become increasingly aware that his former approaches to photography no longer suited the man he had

become. Without Beane's knowing it, his images had a lot of catching up to do, as quickly as possible.

Lilies under Apocalyptic Sky signifies Beane's decisive break from his photographic past. It is a determined effort, too, for the carnage is nearly complete. Yet the image holds the promise of a new creative life in the form of the life-generating stamens and anthers. The picture also suggests the future direction Beane might follow. Instead of close-up views of flowers such as *Yellow Rose,* will he pull back and photograph from a distance against fictitious landscapes and swirling atmospheric backgrounds?

That is exactly what seems to be happening. He spent nearly all of Friday before Labor Day weekend of 2007 taking photographs. When we talked on that Monday, he was overflowing with enthusiasm for his new images, which he promised to send me in both black-and-white and color as soon as possible so that I could see for myself. They arrived Thursday morning: two photos of clusters of various flowers seen just above ground level silhouetted against orange sunsets created by lighting glass from behind. In one, some of the flowers seem to be talking among themselves, as others listen in eagerly, the way neighbors often do on summer evenings. In the other, the entire group is turned in silent awe to watch the last rays of the setting sun against a magnificent sweep of clouds in the sky. In their own quiet way, these photographs are hauntingly beautiful. They radiate a sense of inner peace and expansiveness. Beane's treatment stretches from the translucent to the more solid, rounded, and colorful.

Best of all, in discussing his new work, Beane said he felt that his creative juices were returning full force and that no physical handicaps could get in the way. It's that aforementioned *fortezza,* which means far more than the tepid translation "fortitude." It really denotes an unbreakable will of iron in achieving one's goals. We call it "real guts." And Beane has it in spades.

ANTHONY F. JANSON

Anthony Janson is well known as the long-standing coauthor of the world-famous art history text *History of Art,* which he worked on with his father, H. W. Janson. Janson has forged a distinguished career as an author, museum curator, and professor.

Because of his background in Dutch seventeenth-century art, which marks the beginning of flower painting as a major genre in the West, and in American art, which has a strong flower tradition of its own, he is the perfect choice to guide both novices and art professionals through Christopher Beane's work. His appreciation of Beane's photographs is felt on both a professional and a personal level.

Janson was the first person to incorporate the history of photography into a survey textbook. Because this had never been attempted before, he had to invent it—not the basic facts, which were well known, but the fundamental ideas about how the photographic medium moved from being viewed merely as "mechanical replication" of objects to an art form in its own right.

On a personal level, he has always felt a compelling attraction to photography, although he has tried his hand at nearly every other art form and is himself a talented paint-er. Of equal significance, he is familiar with the New York flower district. He lived at 28th Street and Second Avenue during most of his college years, and often took the subway from the flower district, because it was so much more alive than the much nearer Lexington Avenue line. Still, it was his late wife, Helen, who helped him truly appreciate flowers. Janson recalled, "This was just one of the many worlds of experience and understanding she opened to me that would otherwise have remained a closed book. I buy a fresh bou-quet every week in her honor."

Helen was an avid gardener and plant expert. When her health began to decline and she could no longer contin-ue gardening, Janson decided to bring her garden indoors. He said, "I began to take photographs of everything that bloomed throughout the year. Soon, much of her study became covered with my best efforts, suitably framed, in a dizzying array of types, sizes, and colors."

Thus, Janson was open to viewing the work product of an unknown artist who came recommended by a friend. Why? "There are no coincidences in life," said Janson. "If that be so, then can it be a coincidence that I am writing about Christopher at the end of my life after caring for my ailing wife?" Surely not; chance and two lifetimes of study, dedication, and passion for the arts have brought Beane and Janson together, with Janson uniquely positioned to create this initial survey of Beane's work. As Janson noted: "When I agreed to write this essay sight unseen and on short notice at the request of a mutual friend, I had no idea I would be writing about one of the greatest photographers I have ever run across. It was easy enough for me to locate Beane's posi-tion in the history of photography and art as a whole. I saw its importance immediately. But such an approach hardly begins to meet the challenge of explaining his work." The publisher and Christopher Beane are grateful for Janson's erudite contributions, of which, regrettably, only a portion could be used in the book.

LIST OF PLATES

PLATE 1
Upside Down Gardenia, 1995–96
(page 1)

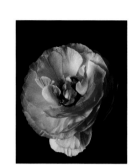

PLATE 2
Ranunculus Gold, 2003
(page 2)
 PLATE 3

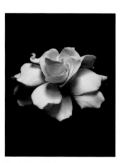

Gardenia with Horn, 2005
(page 4)

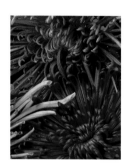

PLATE 4
Spider Chrysanthemums, 1999
(page 7)

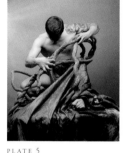

PLATE 5
Forrest with Bittersweet Vines, 1992
(page 9)

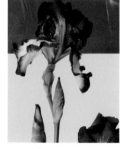

PLATE 6
Iris Study, 1996
(page 10)

PLATE 7
Multicolored Mum, 2003
(page 11)

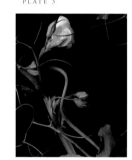

PLATE 8
Study of Sweet Pea Vines #1, 2000
(page 14)

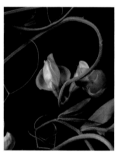

PLATE 9
Study of Sweet Pea Vines #2, 2000
(page 14)

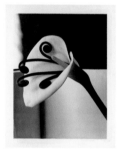

PLATE 10
Calla Lily with Fiddleheads,
1995–96 (page 16)

PLATE 11
Weber Tulip, 1995
(page 17)

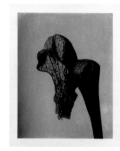

PLATE 12
Swamp Lily, 1995–96
(page 18)

PLATE 13
Unfolded Tree Ferns, 1995–96
(page 18)

PLATE 14
Black-and-White Bromeliad, 1999
(page 21)

PLATE 15
Fisherman's Friend Garden Rose,
1998 (page 22)

PLATE 16
Campanula, 1997
(page 23)

PLATE 17
Pope's Balls Dissection #1, 1997
(page 24)

PLATE 18
Pope's Balls Dissection #2, 1997
(page 24)

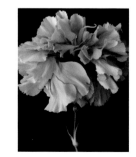

PLATE 19
Study of Carnation #1, 1997
(page 25)

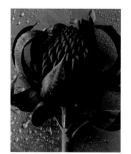

PLATE 20
Study of Carnation #2, 1997
(page 25)

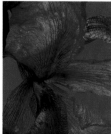

PLATE 21
Wanatah Protea, 1996
(page 26)

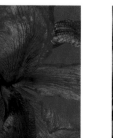

PLATE 22
Cattleya Veins, 2000
(page 27)

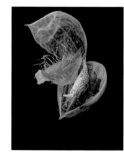

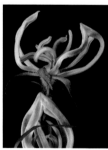

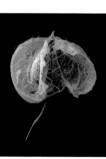

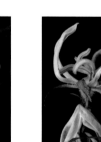

PLATE 23
Bearded Iris in Late Afternoon, 1999
(page 28)

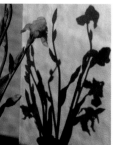

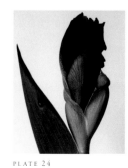

PLATE 24
Iris Bud, 1995–96
(page 29)

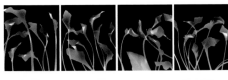
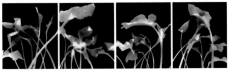

PLATE 25
Calla Border at Château Laroque,
2003 (pages 30–31)

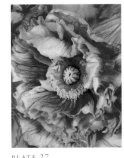

PLATE 26
Icelandic Poppy, 1999
(page 32)

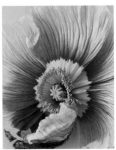

PLATE 27
Poppy Flamenco, 2002
(page 33)

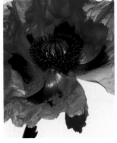

PLATE 28
Oriental Poppy with Gray Dust,
1997 (page 34)

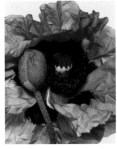

PLATE 29
Oriental Poppy Helen Elizabeth,
1997 (page 35)

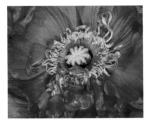

PLATE 30
Poppy Orange Frill, 2001
(pages 36–37)

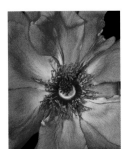

PLATE 31
Garden Rose Playboy, 2000
(page 38)

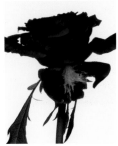

PLATE 32
Black Magic, 1997
(page 39)

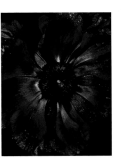

PLATE 33
Sprayed Anemone, 2001
(page 40)

PLATE 34
Double Cyclamen, 2002
(page 41)

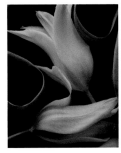

PLATE 35
*Black-and-White Study of Pencil
Tulips,* 1997 (page 42)

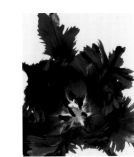

PLATE 36
Parrot Tulip Flame, 2000
(page 43)

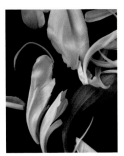

PLATE 37
*Black Parrot Tulip with Cobalt
Center,* 1997 (page 45)

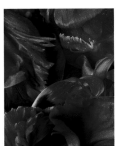

PLATE 38
*Peony Petals Black-and-White
Study #1,* 1997 (page 46)

PLATE 39
Tulip Orgy, 2003
(page 47)

PLATE 40
First Color Tulip Orgy, 1998
(page 48)

PLATE 41
Tulip Orgy Black and White, 1997
(page 49)

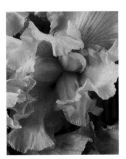

PLATE 42
Bearded Iris Blue, 2002
(page 51)

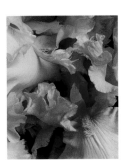

PLATE 43
Orange Iris, 2003
(page 52)

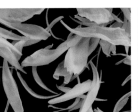

PLATE 44
Iris Orgy, 2003
(page 53)

PLATE 45
*Peony Petals Black-and-White
Study #2,* 1997 (page 54)

PLATE 46
Peony Petals Orgy, 2003
(page 55)

PLATE 47
Petunia Orgy, 1999
(pages 56–57)

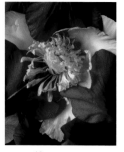 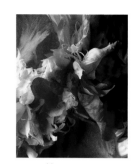 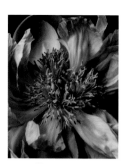 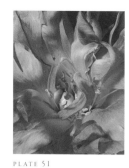 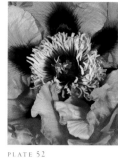 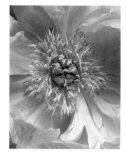

PLATE 48
Painting with Petals Peony Study #2,
2004 (page 58)

PLATE 49
Painting with Petals Peony Study #1,
2004 (page 59)

PLATE 50
Early Peony Study, 1996
(page 60)

PLATE 51
Coral Charm Peony, 1999
(page 61)

PLATE 52
Fashion Pink Tree Peony, 2003
(page 63)

PLATE 53
Coral Magic, 2004
(page 64)

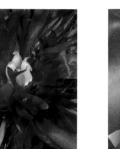 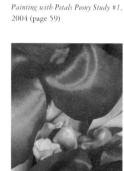 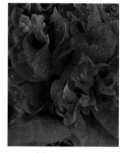

PLATE 54
Burgandy Peony Gold Center, 2001
(page 65)

PLATE 55
Peony Study with Petals of Flame #4,
2001 (page 66)

PLATE 56
Zezé's Peony, 2006
(page 67)

PLATE 57
Bowl of Cream, 2004
(page 68)

PLATE 58
Fringed Ivory, 2004
(page 69)

PLATE 59
Peony Falcon Red Ruffles, 2001
(page 70)

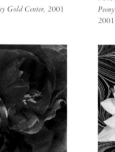 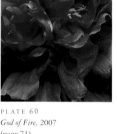 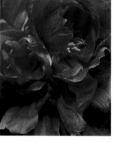 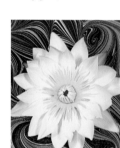 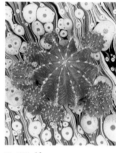

PLATE 60
God of Fire, 2007
(page 71)

PLATE 61
Pucci's Water Lily, 2003
(page 72)

PLATE 62
Lavender Water Lily, 2000
(page 73)

PLATE 63
Aubergine Water Lilies with Swirling
Algae, 2000 (pages 74–75)

PLATE 64
Double Gloxinia, 2004
(page 76)

PLATE 65
Fluorescent Orange Cactus, 2003
(page 78)

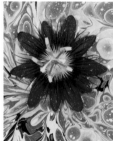 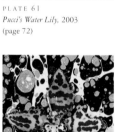 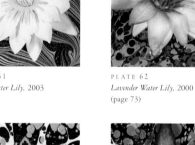 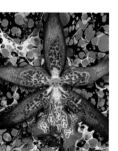 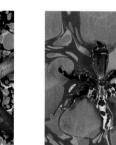 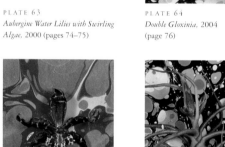 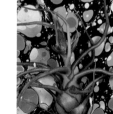 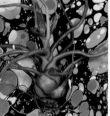 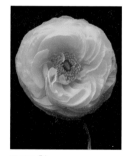

PLATE 66
Burgundy Passionflower, 2003
(page 79)

PLATE 67
Odontoglossum Milkyway, 2001
(page 80)

PLATE 68
Odontoglossum Pink Spot, 2001
(page 81)

PLATE 69
Oncidium Red, White, and Blue,
2001 (page 82)

PLATE 70
Bromeliad Sci-Fi, 2001
(page 83)

PLATE 71
Yellow Ranunculus with Stem, 1998
(page 84)

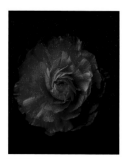 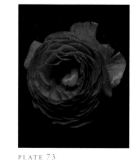 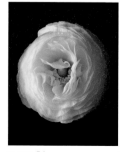 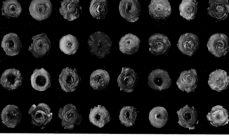 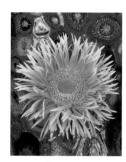

PLATE 72
Ranunculus Fuchsia, 2003
(page 85)

PLATE 73
The Tongue, 2003
(page 86)

PLATE 74
Ranunculus White, 2003,
(page 87)

PLATE 75
Ranunculus Grid, 1998–2003
(pages 88–89)

PLATE 76
Gerber on Venini, 2002
(page 90)

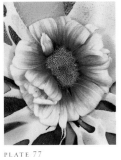

PLATE 77
Cineraria, 2003
(page 91)

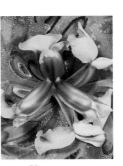

PLATE 78
Siberian Iris, 2004
(page 92)

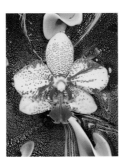

PLATE 79
Chagall's Phalaenopsis, 2004
(page 94)

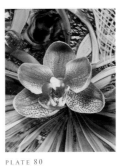

PLATE 80
Phalaenopsis on Lace, 2004
(page 95)

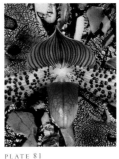

PLATE 81
Lady's Slipper, 2004
(page 97)

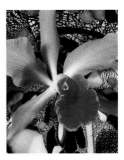

PLATE 82
Orange Cattleya, 2004
(page 98)

PLATE 83
Cattleya in Midnight Sky, 2004
(page 99)

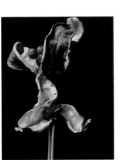

PLATE 84
Iris Pod Black-and-White Study,
1998 (page 100)

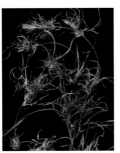

PLATE 85
Spider Grass, 2004
(page 101)

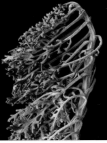

PLATE 86
Air Swirls, 2000
(page 102)

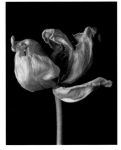

PLATE 87
Dusty Miller after Winter Thaw,
2002 (page 105)

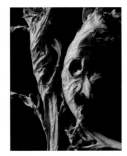

PLATE 88
Study of Dried Tulip #1, 2002
(page 106)

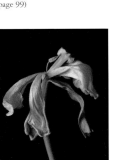

PLATE 89
Study of Dried Tulip #2, 2002
(page 107)

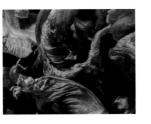

PLATE 90
Orgy of Dried Tulip Petals, 2000
(pages 108–109)

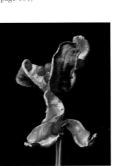

PLATE 91
Iris Pod Color Transition, 1998
(page 110)

PLATE 92
Fabergé Egg, 2001
(page 111)

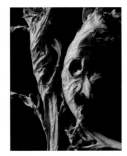

PLATE 93
Hops Camouflage, 2000
(page 112)

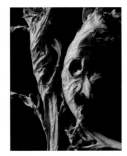

PLATE 94
Kale after Frost, 1998
(page 113)

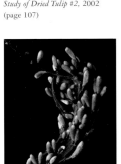

PLATE 95
Deformed Pussy Willow, 2002
(page 114)

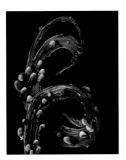

PLATE 96
Deformed Pussy Willow, 2002
(page 115)

PLATE 97
Baby's Cotton #1, 2000
(page 116)

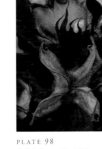

PLATE 98
Baby's Cotton #2, 2000
(page 117)

PLATE 99
Dye-Injected Sweet Peas, 2000
(pages 118–119)

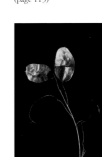

PLATE 100
Luneria #3, 2002
(page 120)

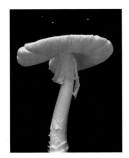

PLATE 101
White Mushroom (from the
Farmhouse series), 2004
(page 121)

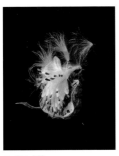

PLATE 102
*Early Milkweed Black-and-White
Study*, 1997 (page 122)

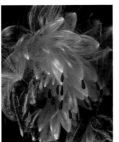

PLATE 103
Milkweed Study #2, 2000
(page 123)

PLATE 104
Milkweed Study (from the
Farmhouse series), 2004
(pages 124–125)

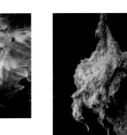

PLATE 105
Petrified Cattail #1 (from the
Farmhouse series), 2004
(page 126)

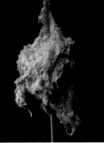

PLATE 106
Petrified Cattail #2 (from the
Farmhouse series), 2004
(page 127)

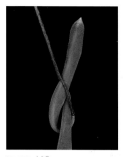

PLATE 107
Ingrown Wisteria Pod, 2003
(page 128)

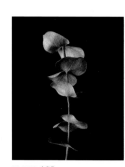

PLATE 108
Eucalyptus Vertebra, 2003
(page 129)

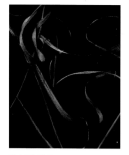

PLATE 109
Bromeliad Strands, 2000
(page 130)

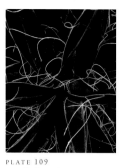

PLATE 110
Field Grasses (from the Farmhouse
series), 2004 (page 131)

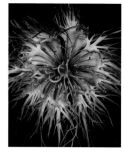

PLATE 111
Nigella, 2003
(page 132)

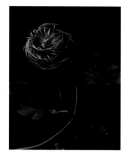

PLATE 112
Bloomed Clematis (from the
Farmhouse series), 2004
(page 133)

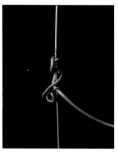

PLATE 113
Knotted Vine (from the Farmhouse
series), 2004 (page 134)

PLATE 114
Emerald Berries or Nightshade
(from the Farmhouse series), 2004
(page 135)

PLATE 115
*Black-and-White Morning Glory
Vines*, 1995–96 (page 136)

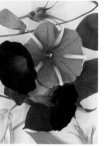

PLATE 116
Morning Glory Study, 2002
(page 137)

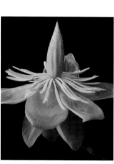

PLATE 117
Flowering Tulip Tree Branch, 1998
(page 139)

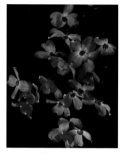

PLATE 118
Red Dogwood (one of nine panels),
2003 (page 140)

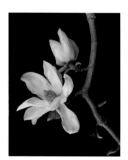

PLATE 119
Yellow Magnolia, 2002 (page 141)

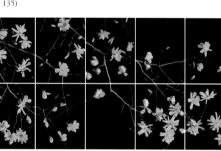

PLATE 120
White Magnolia Branch Photomontage, 2005
(pages 142–143)

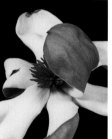

PLATE 121
Pink Magnolia with Scars, 2000
(page 144)

PLATE 122
Bittersweet Photogram (one of forty
panels), 2003 (pages 146–147)

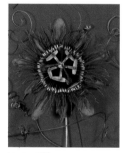

PLATE 123
Passionflower, 2002
(page 149)

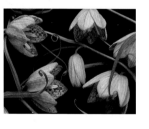

PLATE 124
Checkerboard Fritillaria (one of
nine panels), 1999 (page 150)

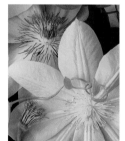

PLATE 125
Zezé's Clematis, 1998 (page 151)

PLATE 126
Tulip Magnolia and Dogwood Photomontage
(from the Tiffany series), 2005 (pages 152–153)

PLATE 127
Fritillaria with Maidenhair Fern
(from the Tiffany series, panel #1),
2005 (page 154)

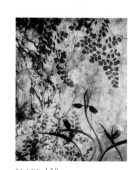

PLATE 128
Fritillaria with Maidenhair Fern
(from the Tiffany series, panel #2),
2005 (page 155)

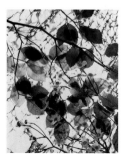

PLATE 129
Fall Meets Spring Panel #1, 2005
(page 156)

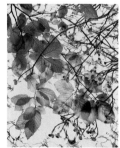

PLATE 130
Fall Meets Spring Panel #2, 2005
(page 157)

PLATE 131
Early Lily Study, 1995–96
(page 158)

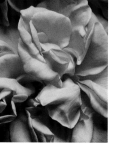
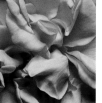

PLATE 132
Lilies under Apocalyptic Sky, 2007
(page 159)

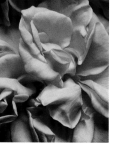

PLATE 133
Yellow Rose, 2007
(page 162)